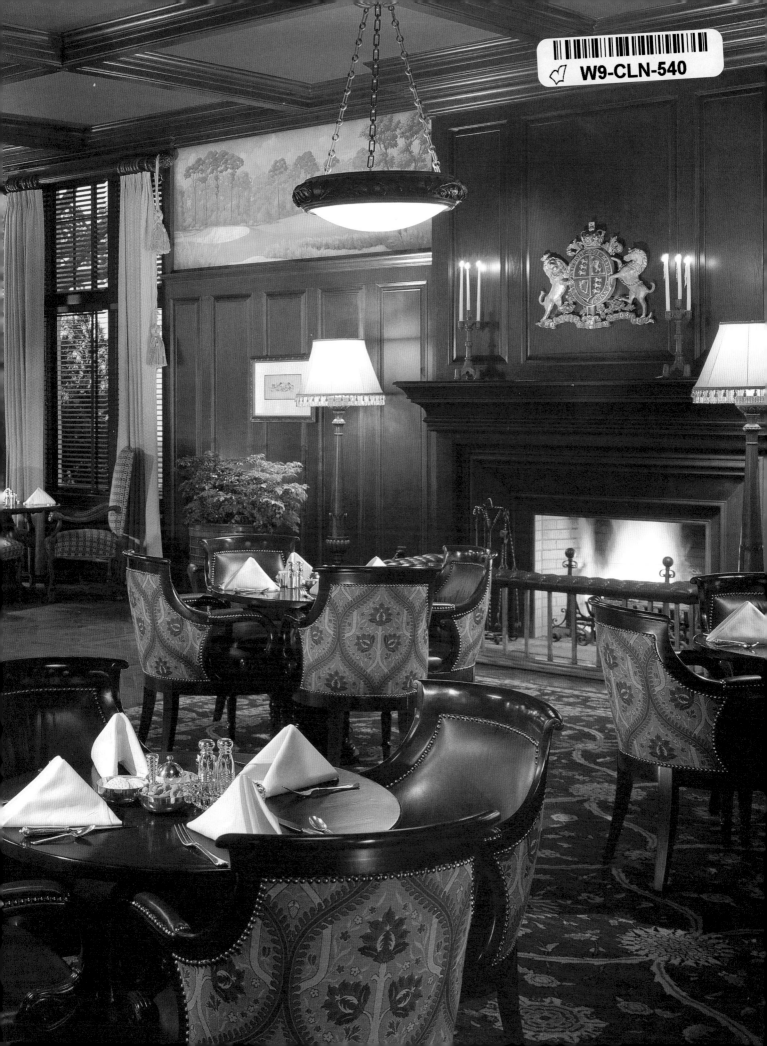

Designs for Restaurants & Bars

Inspiration from Hundreds of International Hotels

Tina Skinner

Schiffer Publishing Ltd

4880 Lower Valley Road, Atglen, PA 19310 USA

Copyright © 2002 by Schiffer Publishing Ltd.
Library of Congress Card Number: 2002113621

Designed by Bonnie M. Hensley
Cover design by Bruce M. Waters
Type set in Swiss 721 BdCnOul BT/Zurich BT

ISBN: 0-7643-1752-0
Printed in China

Published by Schiffer Publishing Ltd.
4880 Lower Valley Road
Atglen, PA 19310
Phone: (610) 593-1777; Fax: (610) 593-2002
E-mail: Schifferbk@aol.com
Please visit our web site catalog at **www.schifferbooks.com**
We are always looking for people to write books on new and related subjects. If you have an idea for a book please contact us at the above address.

This book may be purchased from the publisher.
Include $3.95 for shipping.
Please try your bookstore first.
You may write for a free catalog.

In Europe, Schiffer books are distributed by
Bushwood Books
6 Marksbury Ave.
Kew Gardens
Surrey TW9 4JF England
Phone: 44 (0) 20 8392-8585; Fax: 44 (0) 20 8392-9876
E-mail: Bushwd@aol.com
Free postage in the U.K., Europe; air mail at cost.

Contents

Acknowledgements

Many talented professionals who specialize in the design of hotels and restaurants participated in this book. It was an honor to work with them and experience the pride they have in their craft.

Jenna Palecko Schuck jumped happily into the fray during the assembly of this book, happily making and answering calls and doing her best to keep the project going during a lull in my health. I feel blessed to have had her on hand.

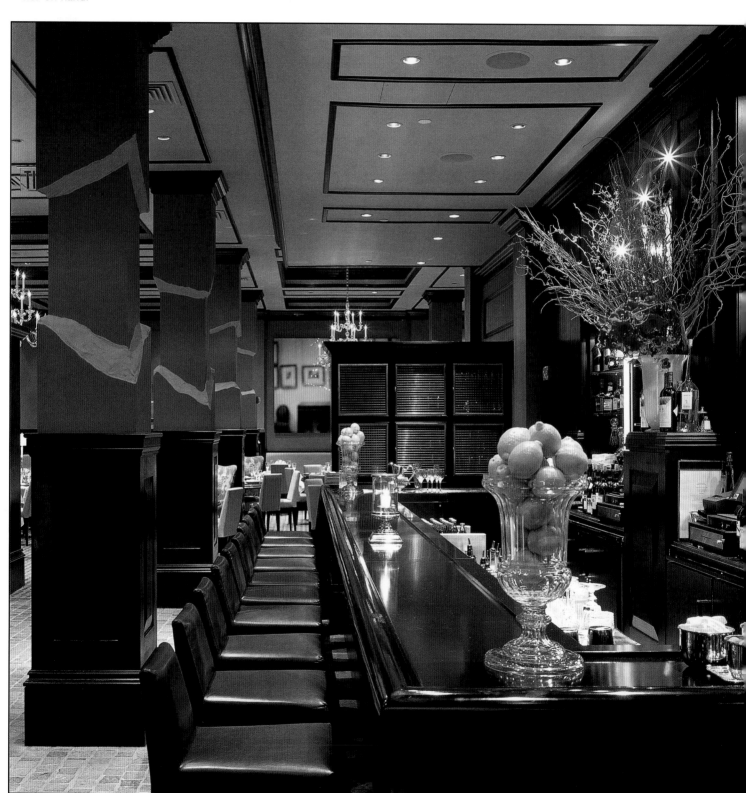

Introduction

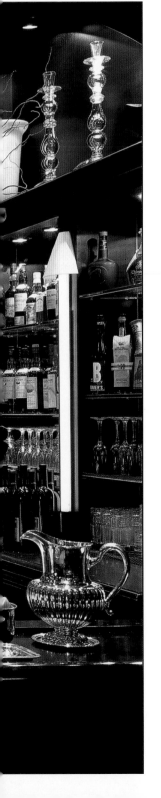

Enter a world of pure pleasure, where some of the world's leading designers, chefs, and hospitality professionals ply their trades to make sure that every guest enjoys the best in comfort, visual appeal, and appetite appeasement. A sampling of restaurants, bars, and lounges from leading hotels and inns around the world illustrates endless ideas for designing public dining and drinking areas.

Planned purely as a visual guide, vignette shots take you through the gamut of design possibilities, from cutting edge contemporary to classical baroque and Victorian designs. The atmospheres vary as greatly, from ethnic enclaves to open conservatories drenched in sunshine, from sleek lipstick-red and stainless-steel, blue-lit bars to old-world men's clubs, trendy wine cellars, and the latest fad – "libraries" where businessmen meet and drink among banks of books.

This world tour touches down on every continent, and explores many similarities in design concepts. Perhaps this is not so surprising, on reflection, when one considers the inherent discomforts of world travel, and the value of finding yourself in familiar surroundings far from home. An enduring message of civility and permanence is portrayed in old world, richly paneled wood walls. The straightforward lines of contemporary architecture and clean, bold colors convey a sense of arrival. Those escaping on vacation want the exotic, the tropical, or the nostalgic. Those meeting for business need to impress with grandeur and establishment. Often the designers have taken a backseat to the primary attraction – the view of ocean or park or city beyond. In other cases, the design is a collaboration between architect, interior designer, and a chef who work to create a consistent theme that is launched visually and culminates on the palette.

In any and all cases, it is hoped that those who come to this book for inspiration find all that they need and more on these pages.

Contemporary

Bar EST | Premier Lodge | Brighton, UK

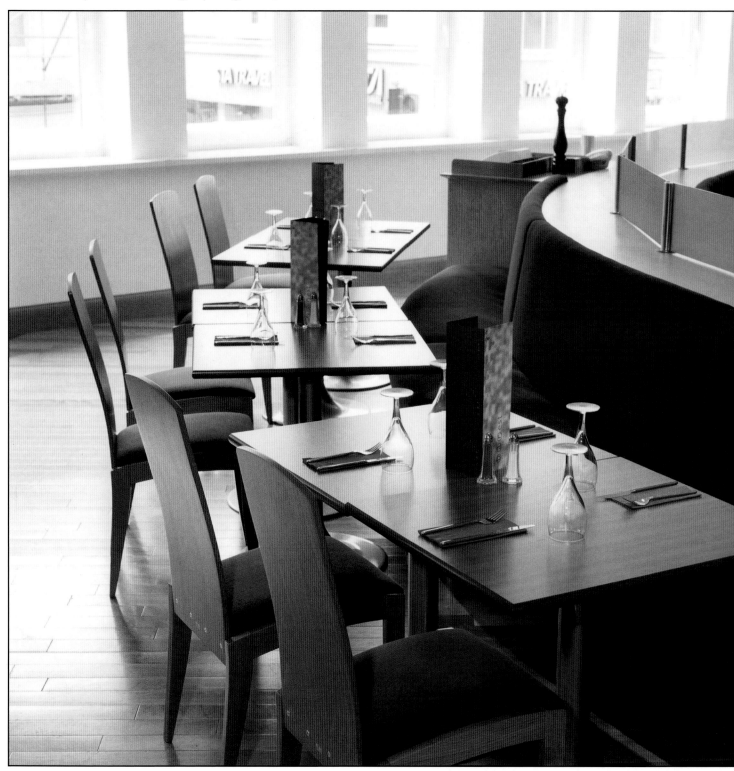

A second-floor bar and café offers casual, contemporary atmosphere.
Courtesy of Graham Leonard Associates, Ltd.

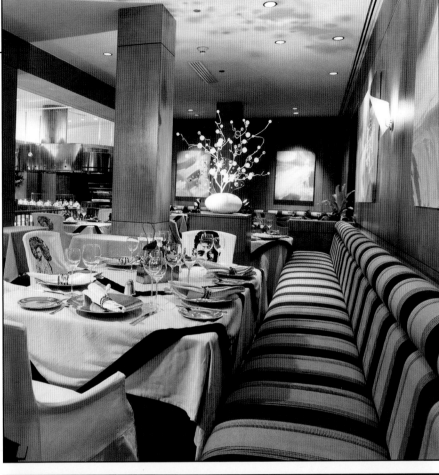

Homespun linens and block prints in black and white create an interesting fusion of contemporary and folk in this fusion restaurant. *Courtesy of The Peninsula Manila*

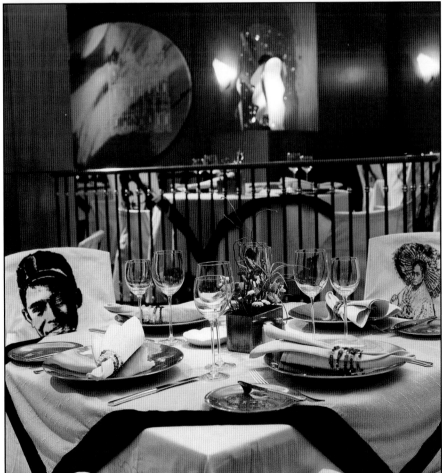

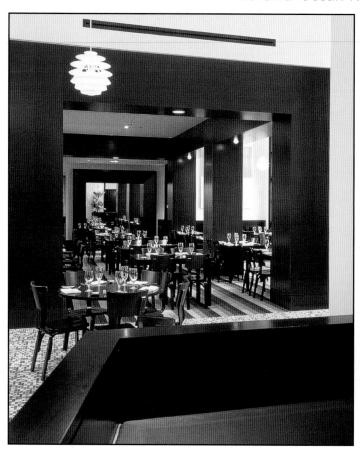
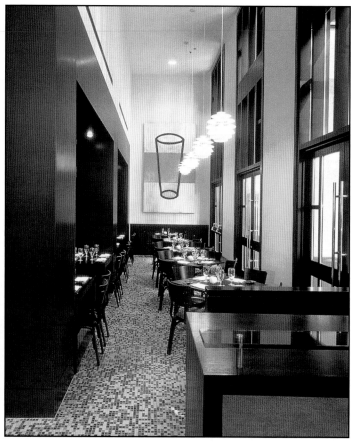

Contemporary architecture establishes the setting for award-winning, Pacific Northwest cuisine. *Courtesy of W Seattle*

W Bar, Seattle

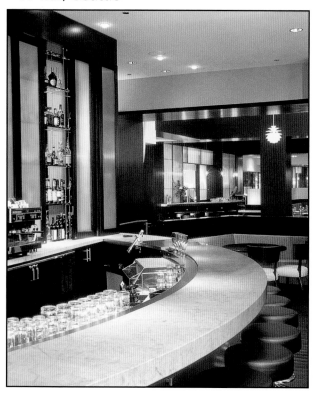

A curved marble bar is the focal point in a room enhanced by a mixture of woods and backlit frosted glass. *Courtesy of W Seattle*

Opposite page: Cultural sensitivity, a sense of place, contemporary architecture, and a warm color palette were four primary goals in creating the look and atmosphere of the Phoenix Marriott Airport. This bar off the main lobby epitomizes all four: Sandstone floors and backsplash were mined locally and provide color and warmth and a background for Native American pottery. An oversized dentil effect defines an impressive domed ceiling shown in the foreground. *Courtesy of DiLeonardo International, Inc.*

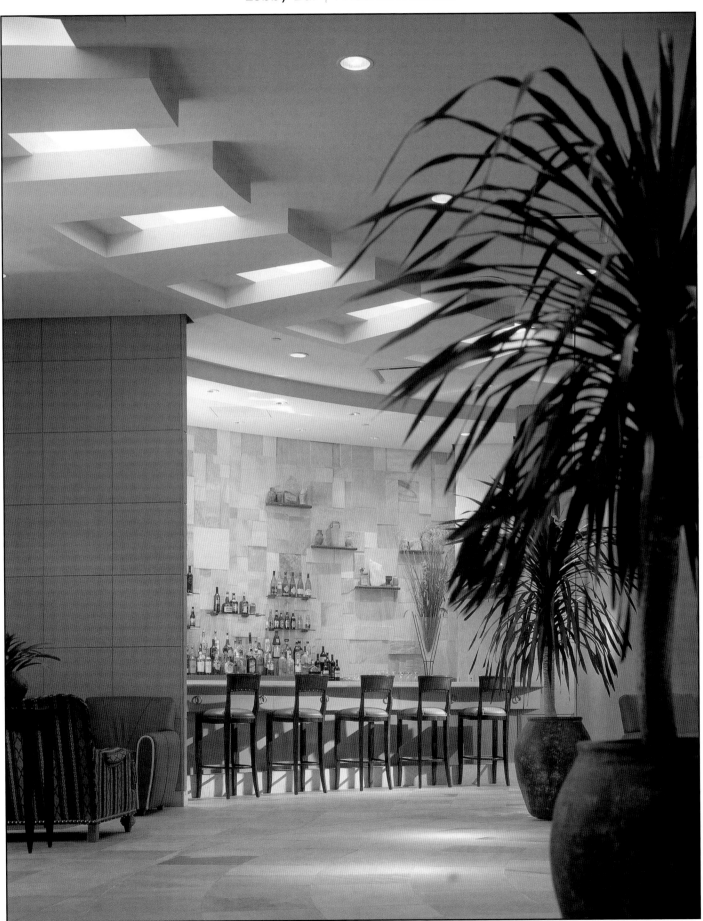

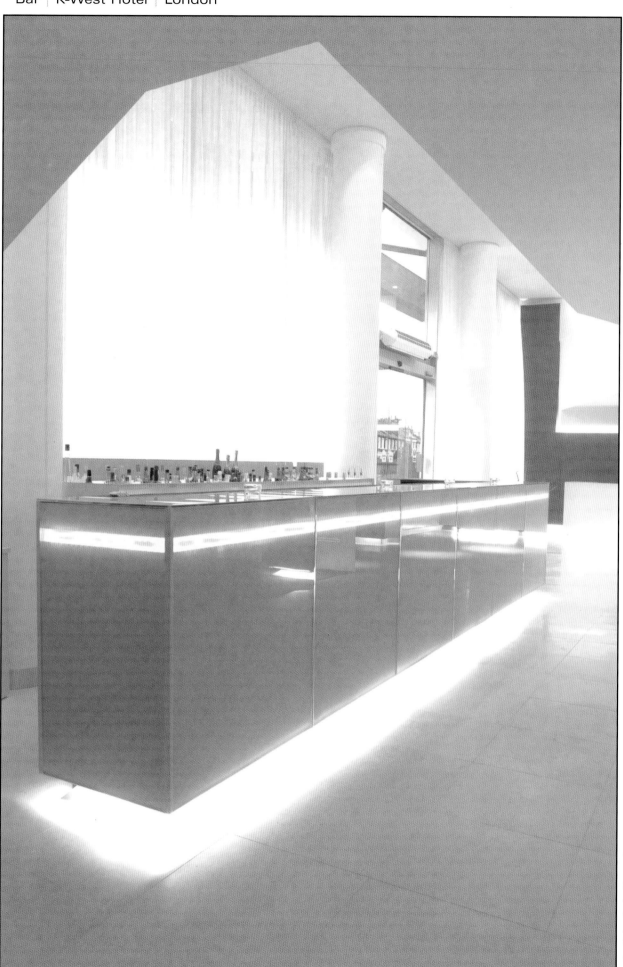

Stephen Hyde at London Photography

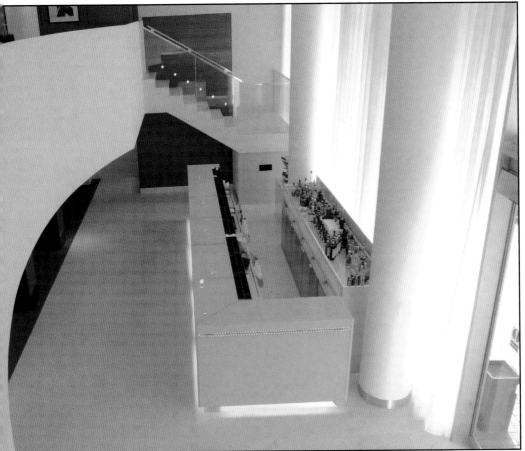

Seeming to rise on a band of light, a bar beckons patrons into its bright arena. Beyond, smaller pedestals mirror the bright effect in a more intimate seating area. *Courtesy of Portfolio Design International*

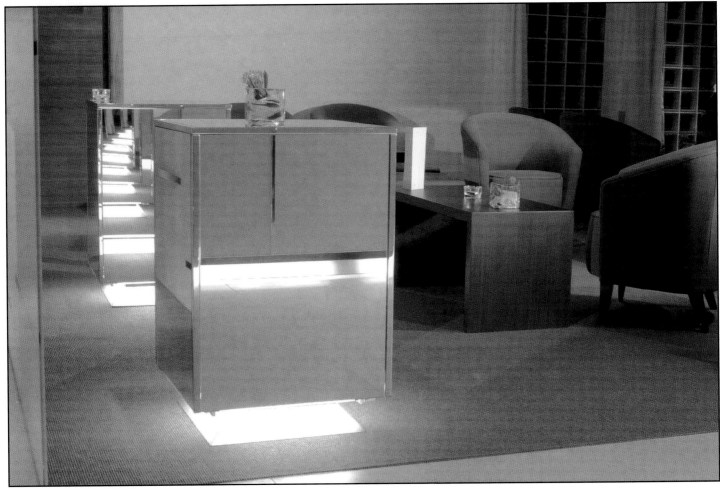

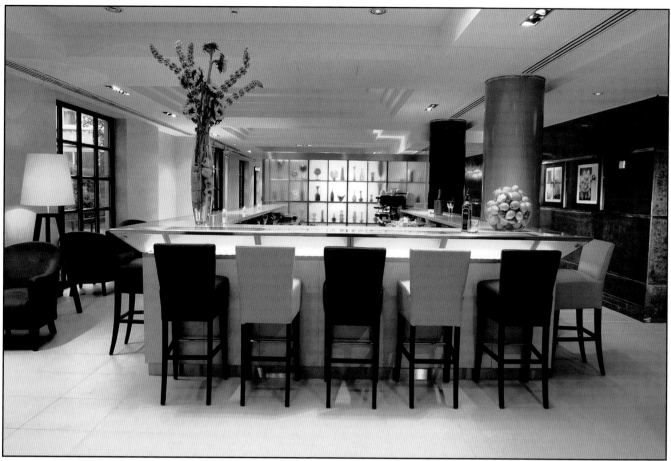

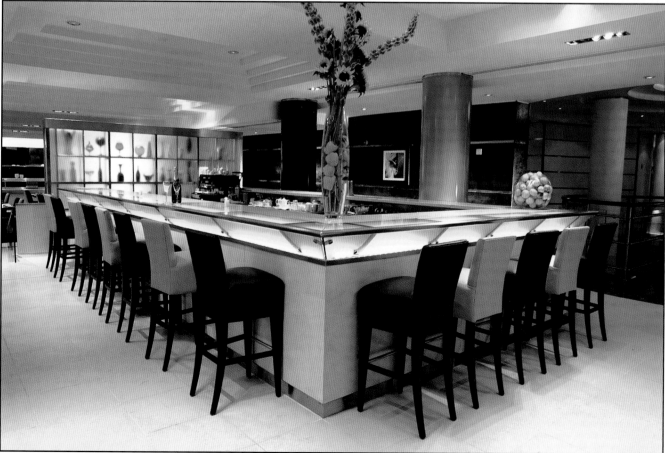

Stephen Hyde at London Photography

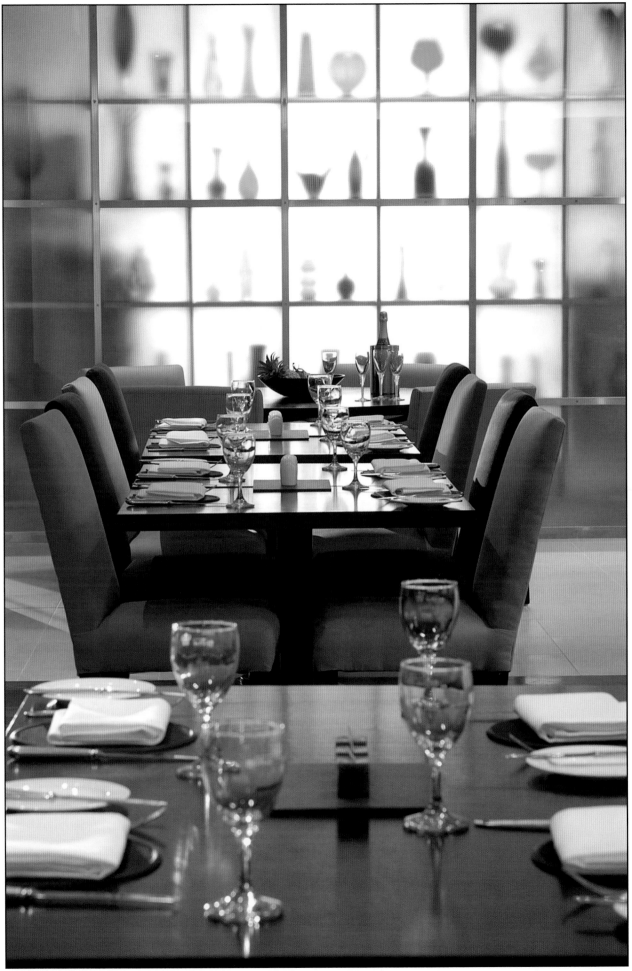

This glowing glass peninsula bar is a hallmark of the emphasis on creative lighting by designer Noel Pierce. A glass wall bejeweled with colorful ware unifies restaurant and bar. Contemporary decor is softened with off-white furnishings and graded recessed ceiling panels. *Courtesy of Portfolio Design International*

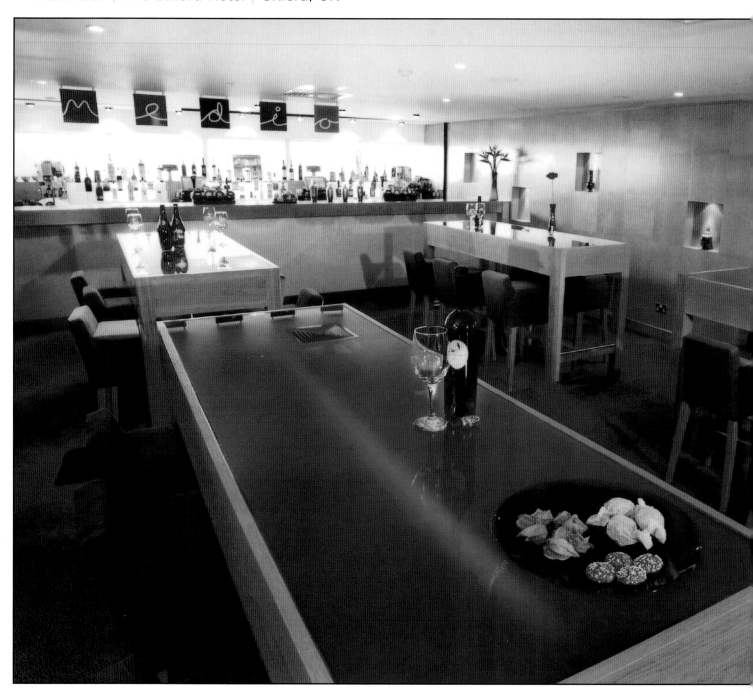

Family-style seating with a decidedly modern twist invites patrons to meet and greet in an open bar area. Nearby, more comfortable seating beckons for those who have time to linger. *Courtesy of The Ransley Group*

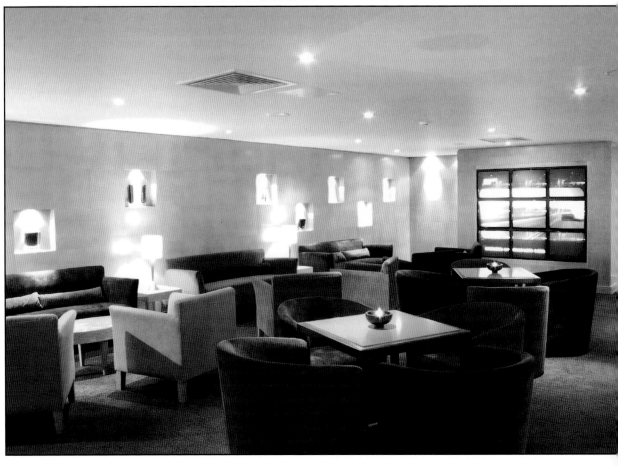

Bridge Bar | The Carlton Hotel | Edinburgh

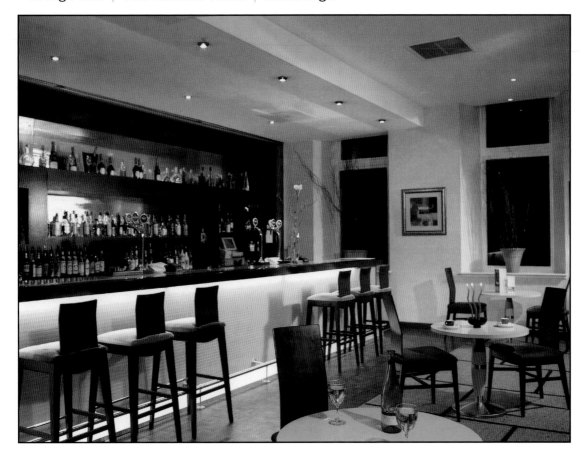

Rich earth tones evoke the spirit of the pubs that one might expect in this historic city, but the design is classically modern in its straightforward form. *Courtesy of The Ransley Group*

Centrium Bar | De Vere Daresbury Park | Daresbury, UK

A collection of striking, colorful, contemporary art brightens a warm, contemporary seating area. *Courtesy of The Ransley Group*

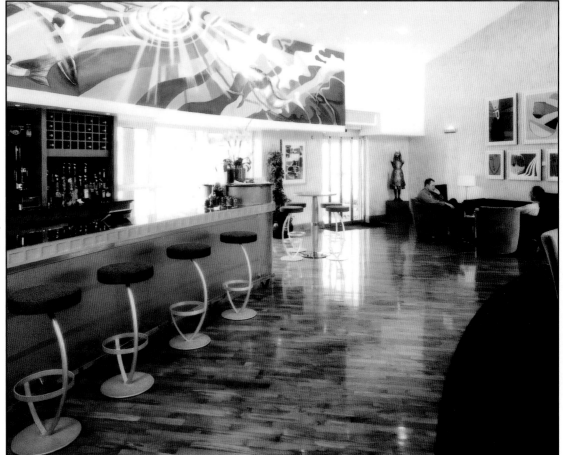

Restaurant Lakeside | Palmerston Golf Resort | Bad Saarow, Germany

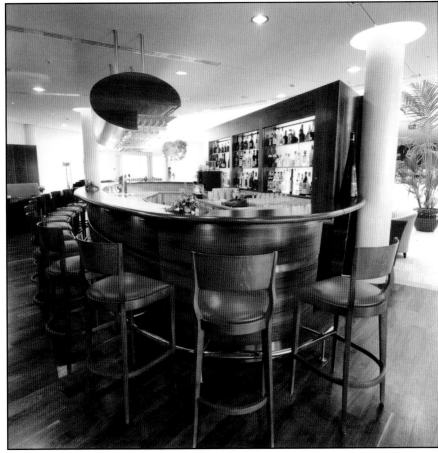

A curved bar allows for maximum seating capacity in the heart of the action. The woodwork is exemplary and consistent, from the chairs to the wine glass rack above. *Courtesy of Mahmoudieh Design*

Ms. Nicole Hollmann Photography

explora Restaurant | Santiago, Chile

Sleek wooden surrounds direct all eyes to the lakeside view. *Courtesy of explora Hotel Salto Chico*

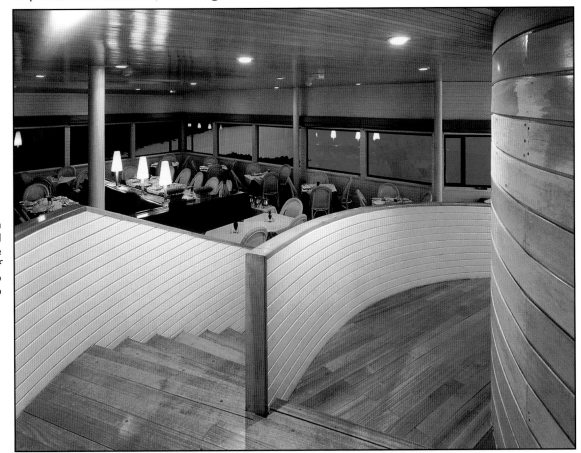

Edinburgh Bar and Brasserie | Malmaison Hotel | Edinburgh

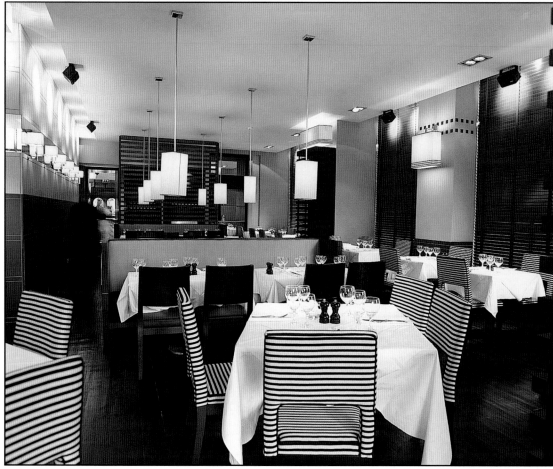

Horizontal stripes in upholstery and window treatments lend to the French Colonial atmosphere of this casual eatery. Lighting is aimed and toned to cast a complementary golden glow on diners. *Courtesy of Jestico + Whiles Architects*

Photographer: Rodger Spencer Jones

Restaurant | Haus Rheinsberg Hotel am See | Rheinsberg, Germany

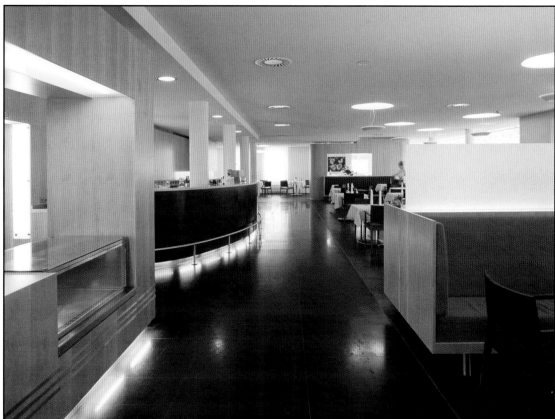

Wood, textile, and glass were put to use to divide a long, open restaurant into distinct zones. *Courtesy of Mahmoudieh Design*

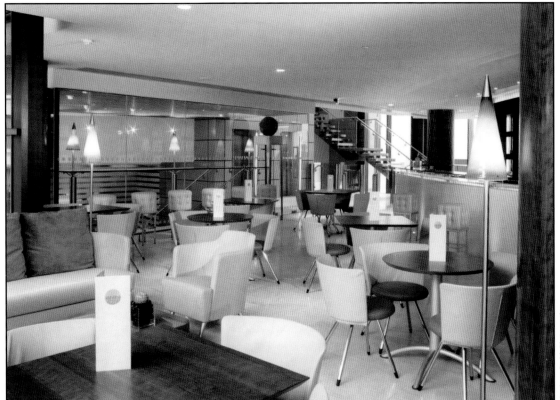

Newberg Smith Photography

Clean, open, and minimalist, this café reflects the healthful theme that draws guests to this specialized day spa facility.
Courtesy of The Syntax Group

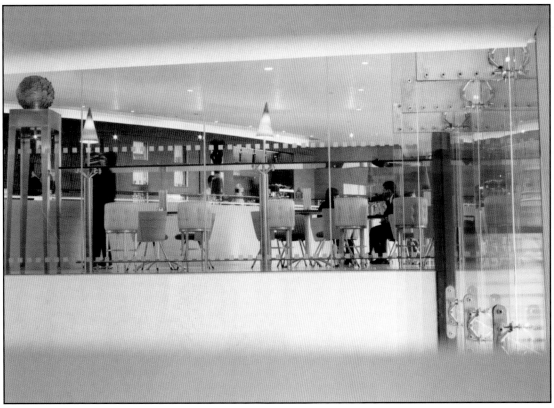

Newberg Smith Photography

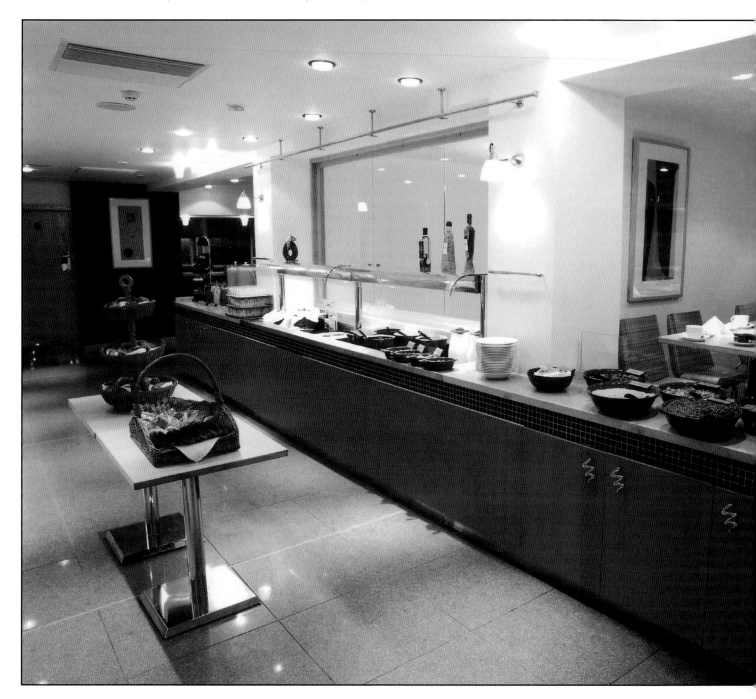

A sprawling eatery can seat up to 228 people during a morning rush hour, though the crowd is made less noticeable and noisome using sound-absorbing half walls. *Courtesy of The Ransley Group*

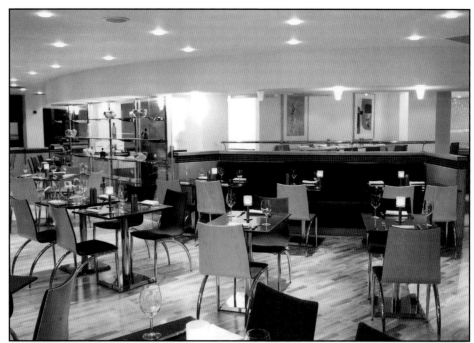

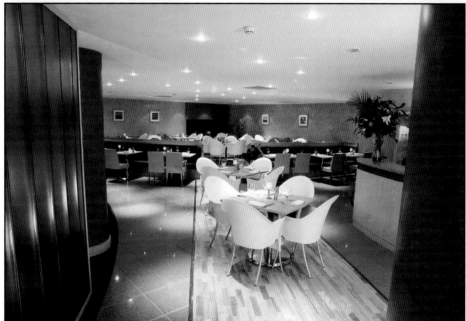

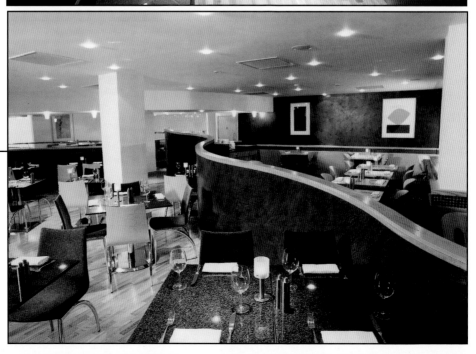

Jago Restaurant | The Trafalgar | London

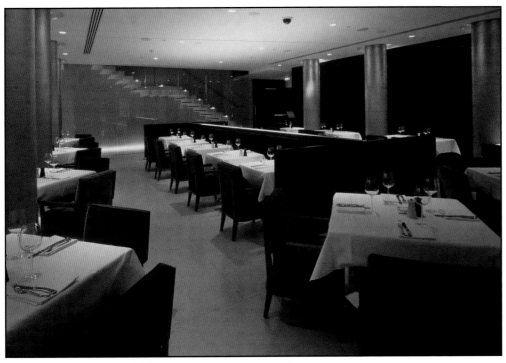

A modern atmosphere defined by stainless steel and glass is the setting for a menu based on nature's own best organic produce. *Courtesy of Harper Mackay Architects*

Orbis Restaurant | NH Brussels Airport Hotel | Brussels

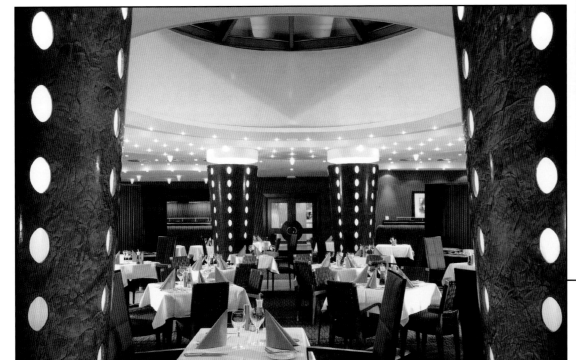

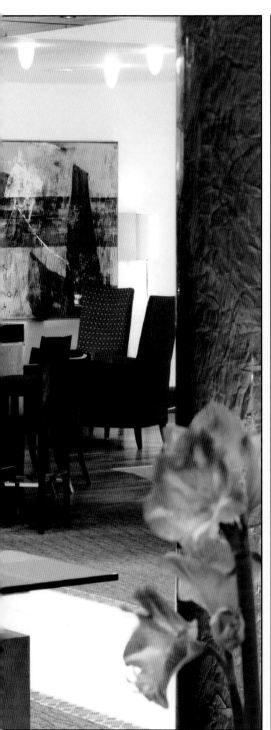
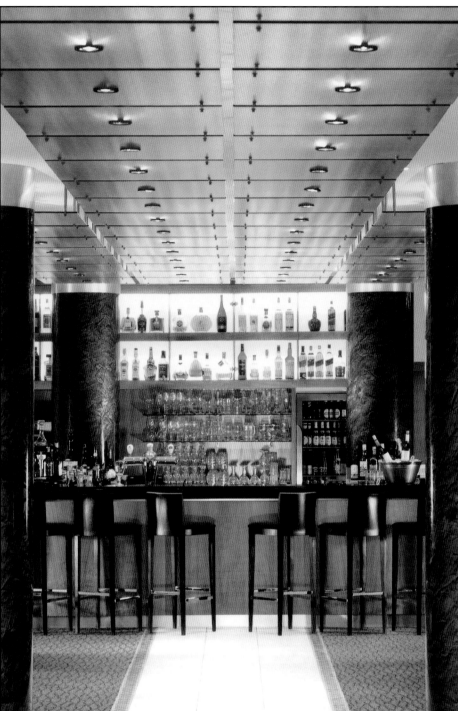

In this stunning new hotel, guests can enjoy a gastronomical experience enhanced by the spectacular astral-inspired surroundings. The markedly modern style interior reflects the modernity of the architecture. Purple accents, including tapered and lit columns of Armourcoat material characterize this notable gathering space. *Courtesy of The Ransley Group*

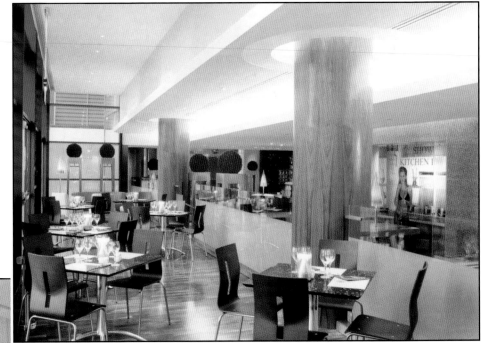

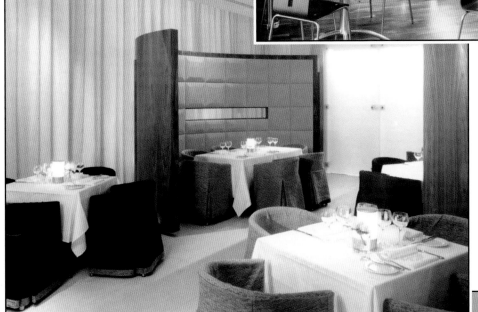

A 21st Century diner hosts the more casual crowd, while those who plan to linger are seated in a more formal restaurant beyond. A consistent color theme of natural tones contrasted with clean whites unifies the two areas. *Courtesy of The Syntax Group*

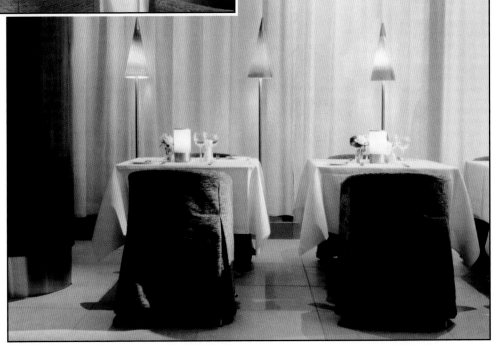

Le Café Rafael | Geneva

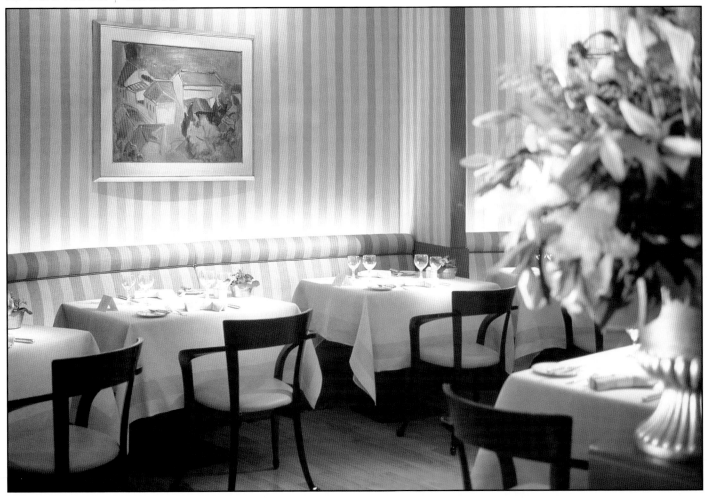

Sleek, contemporary lines in furnishings and stark white tabletop displays are offset by gay colors on the walls and surroundings. *Courtesy of Mandarin Oriental Hotel Du Rhône*

Les Faunes | Madeira | Portugal

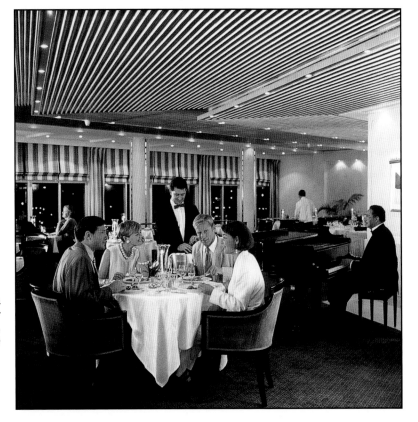

Contrasting colors add a contemporary atmosphere for this seasonal, seaside restaurant. *Courtesy of Reid's Palace*

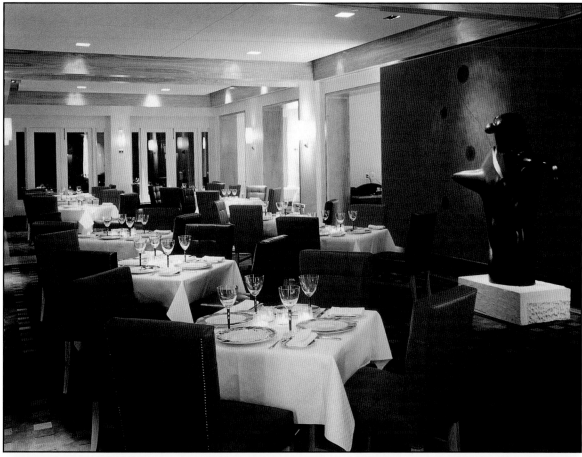

Inspired by abstract expressionist artist Joan Miró, this restaurant boasts three of his original bronze sculptures, while the tableware and wall coverings pay tribute to his colorful paintings. *Courtesy of Bacara Resort & Spa*

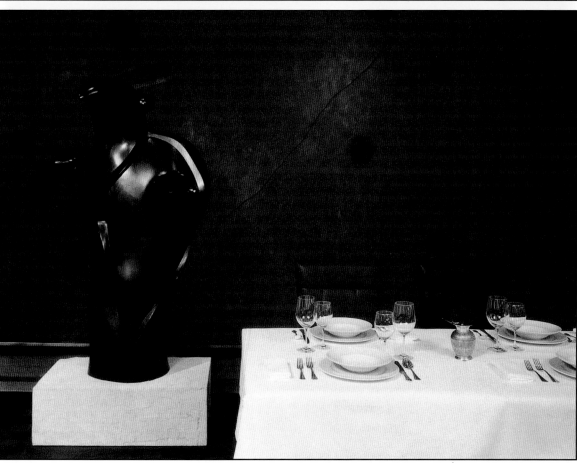

Marriott's Harbor Beach Resort & Spa | Ft. Lauderdale | Florida

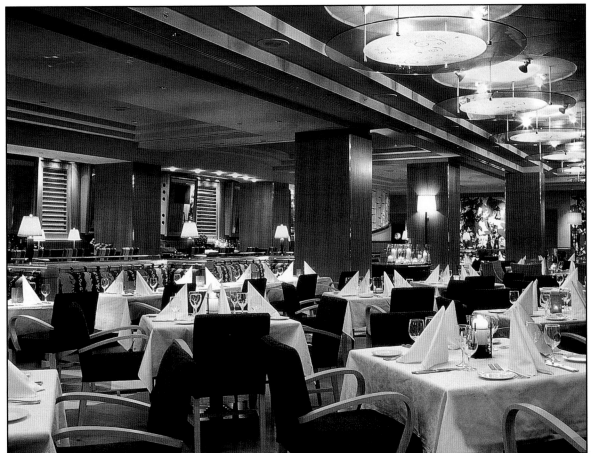

Flashy lighting and smooth-paneled columns add contemporary flair to a formal dining room. *Courtesy of RTKL*

Alan Veldenzer Photography

One Pico | Shutters on the Beach | Santa Monica, California

A gently sloped ceiling steers the eye seaside while adding warm ambiance to the ocean-view restaurant. *Architecture by Hill Glazier Architects; interior design by Paul Draper & Associates*

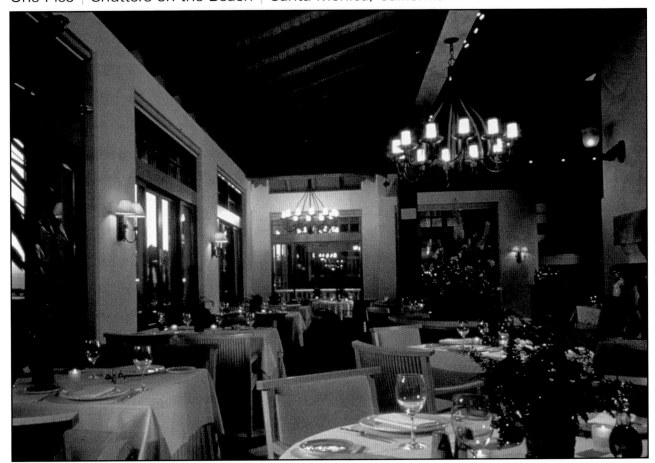

The Bistro at Bacara | Santa Barbara, California

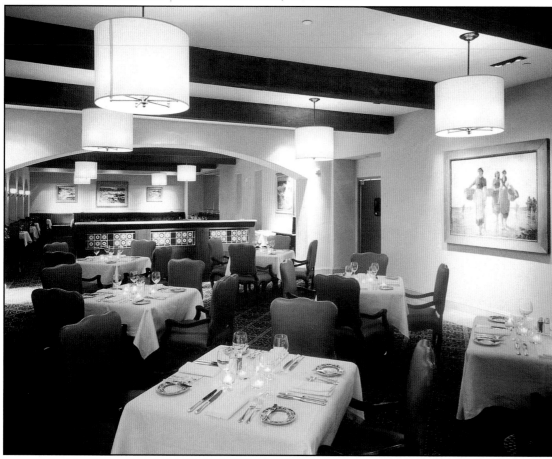

Soft sand tones invoke the Italian Riviera in a restaurant overlooking ocean and pool. *Courtesy of Bocara Resort & Spa*

Breakfast Room | Rome

Stylish blue seating makes a surprising statement in this informal room where guests begin their day. *Courtesy of Hotel dei Mellini*

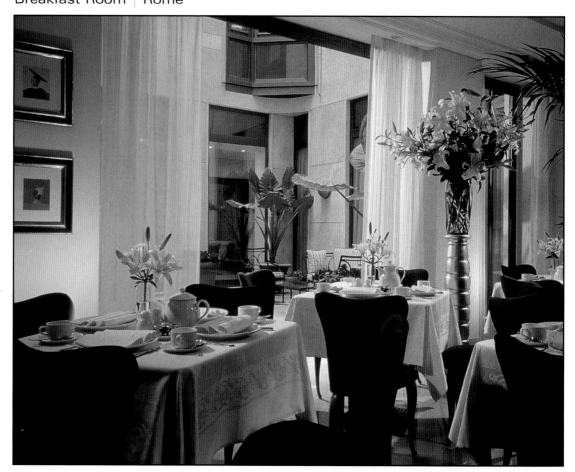

Mojito | Los Angeles, California

Hollywood set designer Dayna Lee collaborated with Starwood Design Group to create an integrated restaurant and bar area. The mood they created mixes elements of fun and liveliness into a sexy, intimate atmosphere. *Courtesy of W Los Angeles – Westwood*

Photography by Todd Eberle

Viking Crown Lounge | Royal Caribbean International's Sun King

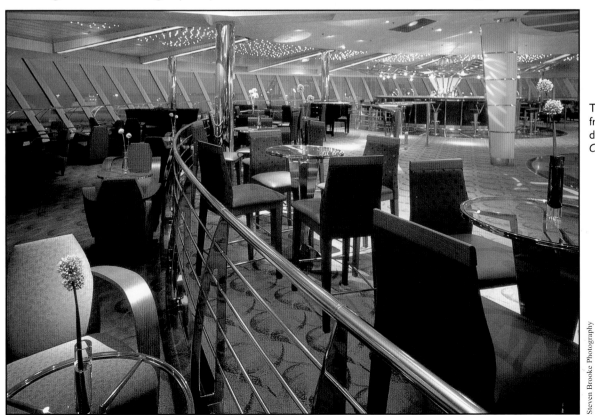

There's always a water-front seat aboard a sleek, double-decked lounge. *Courtesy of RTKL*

Steven Brooke Photography

29

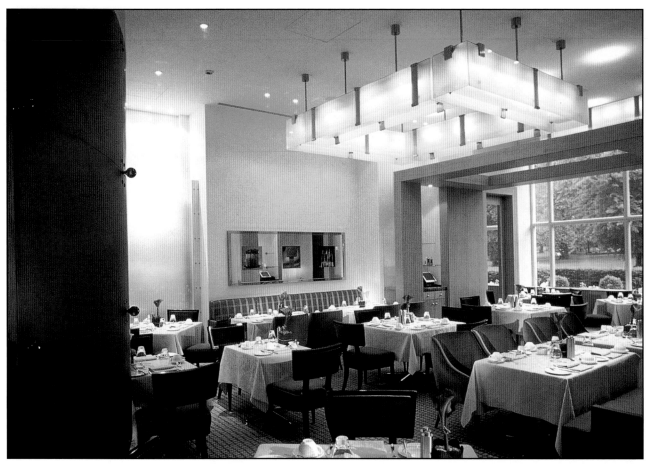

Natural shades complement emerald and jade in this design by New Yorker Adam Tihany, who designed the furniture to be comfortable. *Courtesy of Mandarin Oriental Hyde Park*

Sports Bar | Royal Caribbean International's Grandeur of the Seas

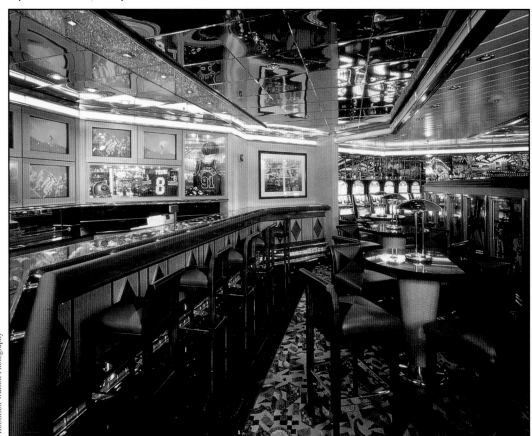

Red railings and seating help orient the consumer amidst an exciting barrage of lights and media in an ocean-going bar. *Courtesy of RTKL*

Nancy Robinson Watson Photography

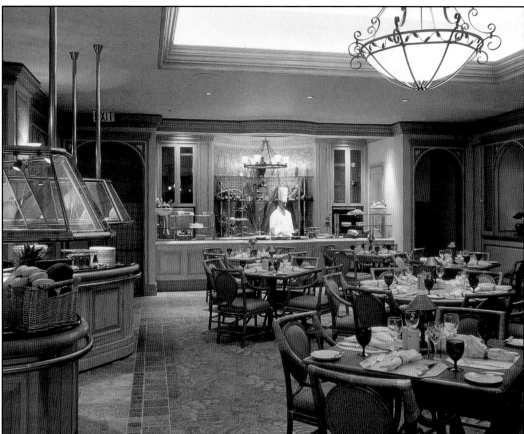

Café 4750
The Ritz-Carlton Hotel
Amelia Island, Florida

Nancy Robinson Watson Photography

Natural materials — wood, wicker, ceramic tile, and wrought iron — were combined for inviting effect in this buffet dining room. *Courtesy of RTKL*

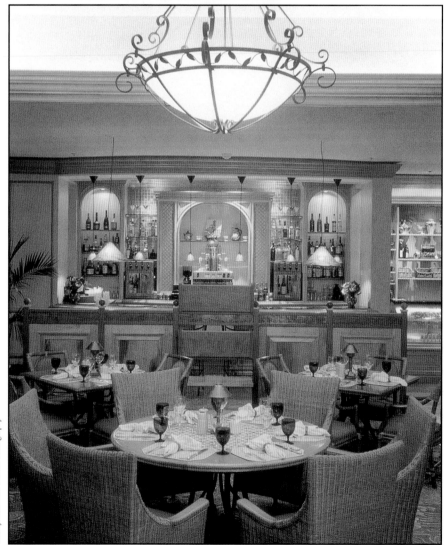

Nancy Robinson Watson Photography

31

Marriott's Harbor Beach Resort & Spa | Ft. Lauderdale, Florida

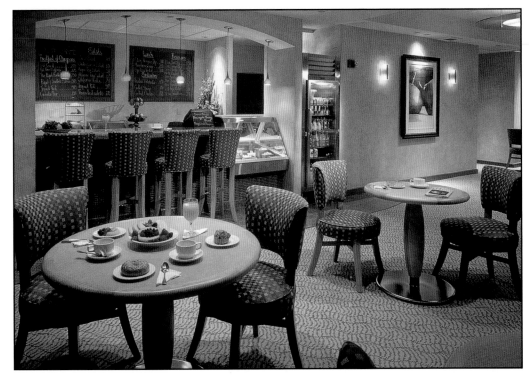

Homey upholstery and neutral tones create an inviting snack stop in this spa cafe. *Courtesy of RTKL*

Roy Quesada Photography

Seventy @ Third | The Westin Waltham | Boston

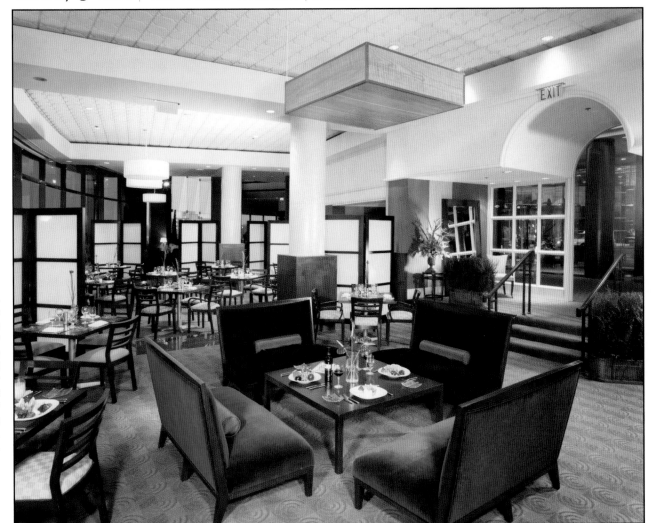

Bold, contemporary architecture is warmed by sea-blue tones in glass and upholstery for this upscale cafe. *Courtesy of Graham-Kim International, Inc.*

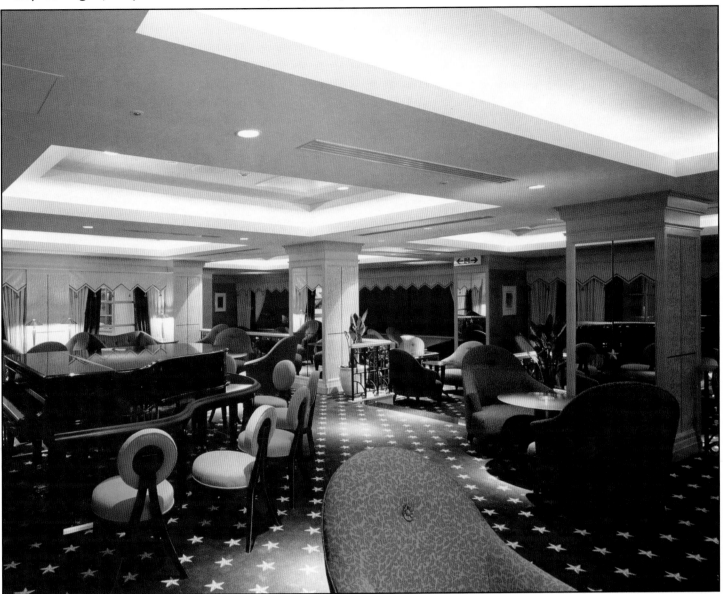

Seating at the piano invites participation in a comfortable bar/lounge.
Courtesy of Graham-Kim International, Inc.

Classical

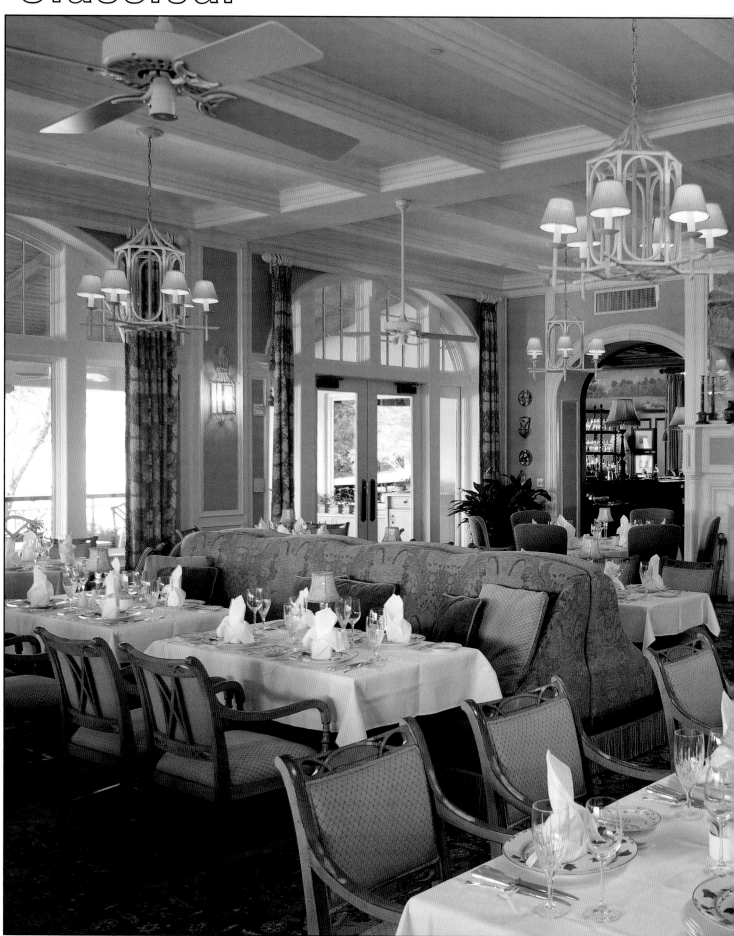

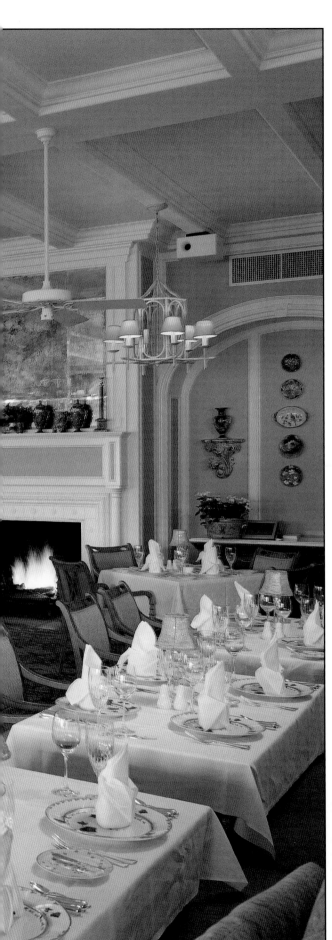

A country house "sun porch" look was orchestrated for this dining room, with painted walls contrasting with white molding. *Courtesy of Cole Martinez Curtis and Associates*

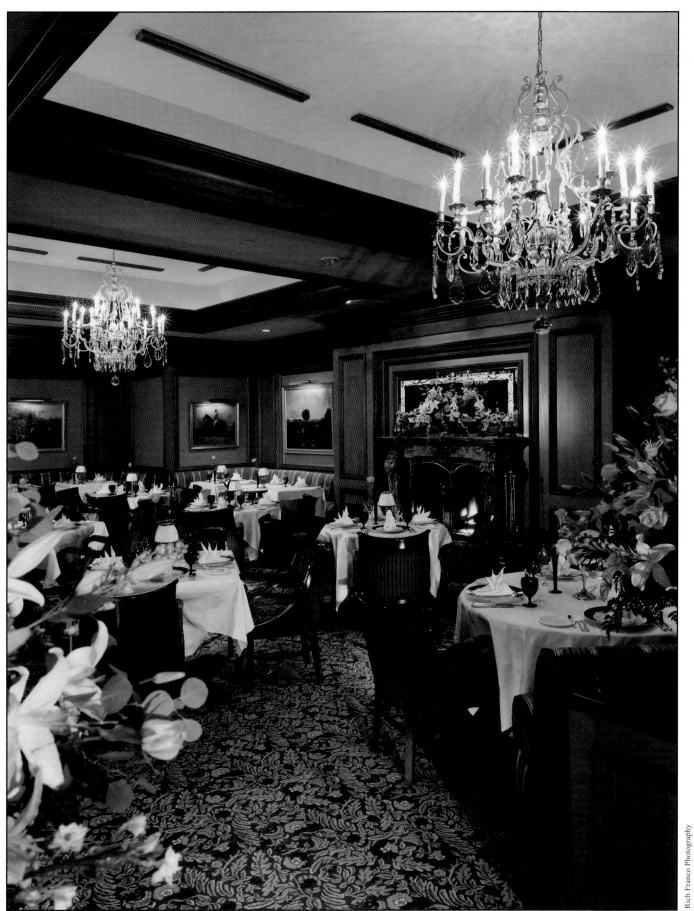

Wood paneling and beams scale a large room down to intimate size,
engendering an atmosphere for warm conversation. *Courtesy of RTKL*

Vivaldi Restaurant | Berlin

Designed by Karl Lagerfeld, who voluntarily undertook the interior decoration during renovations of this 1914 East Berlin landmark, the Vivaldi dining room reflects its authentic, original glory, defined by red velvet curtains, gilded wall panels, and a rug that ties them all together. *Courtesy of The Regent Schlosshotel*

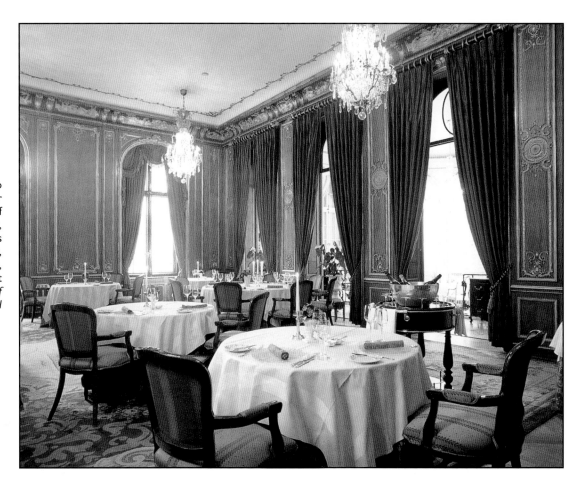

Dining Room | The Ritz-Carlton Hotel | Naples, Florida

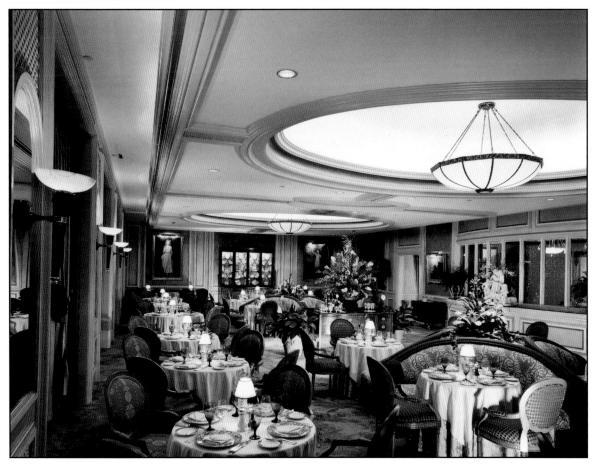

Recessed domes in the ceiling are mirrored in hanging half-globes and wall sconces, as well as arched chair backs and bench seating. *Courtesy of RTKL*

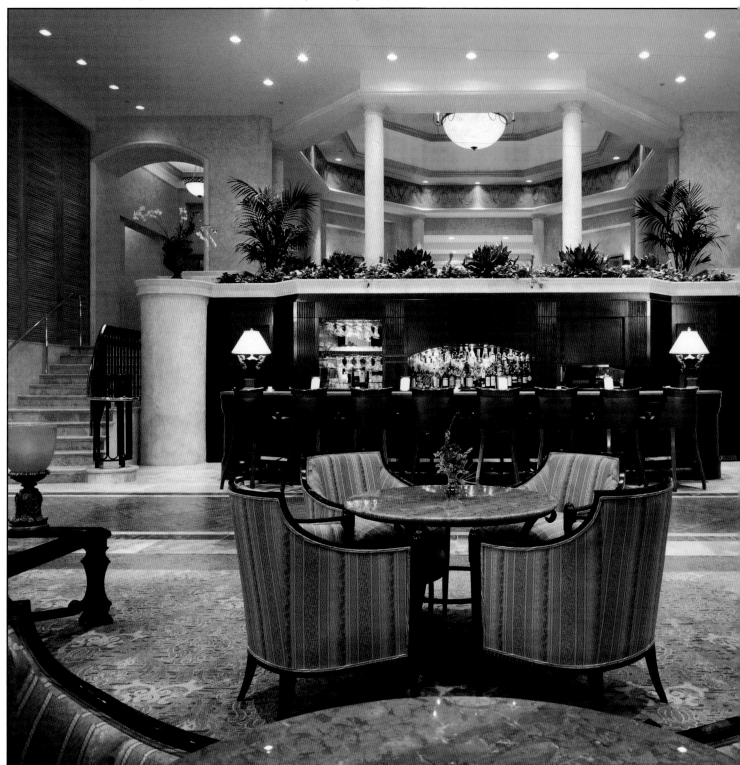

Kiko Ricote Photography

Nestled between a handsome set of stairs, an oak-paneled bar invites guests to step down for a drink. *Courtesy of RTKL*

Two levels of seating are enhanced by paneled dividers to establish more intimate spaces in a rich restaurant. *Courtesy of Empire Palace Hotel*

Restaurant Aureliano | Rome

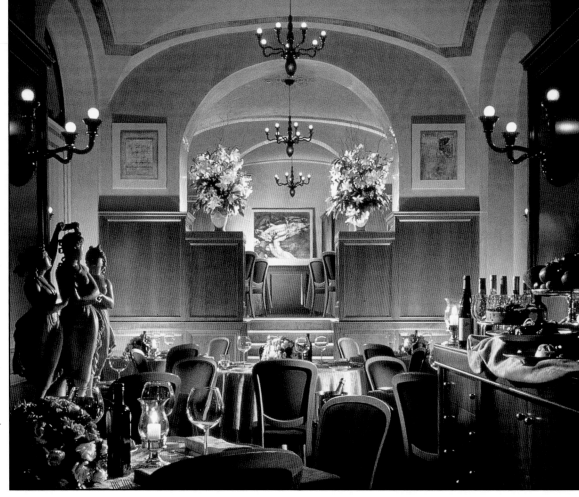

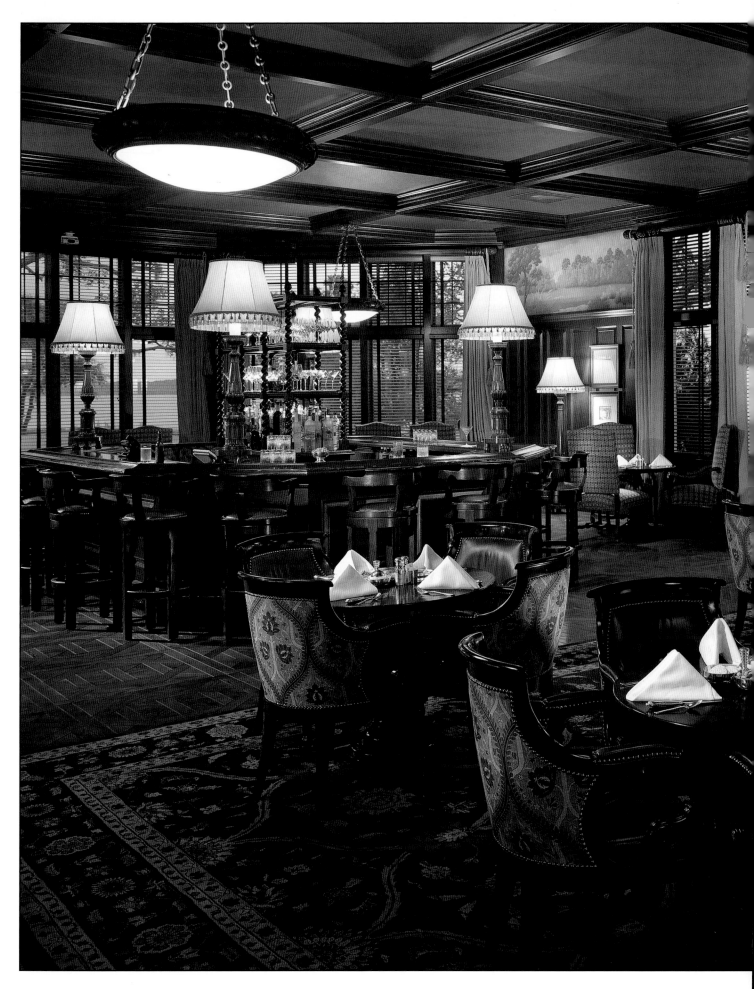

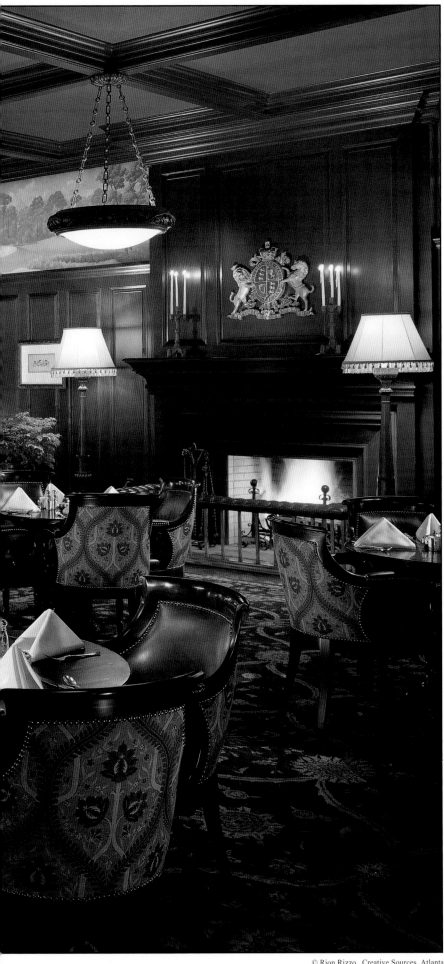

Oak Room Bar | The Lodge at Sea
Island Golf Club | Georgia

This rich bar area belies its brand-new youthfulness.
During a 24-month building process, interior designers
scoured antique fairs and shops for the perfect
furnishings and accessories to create an atmosphere of
timeless gentility. *Courtesy of Cole Martinez Curtis and
Associates*

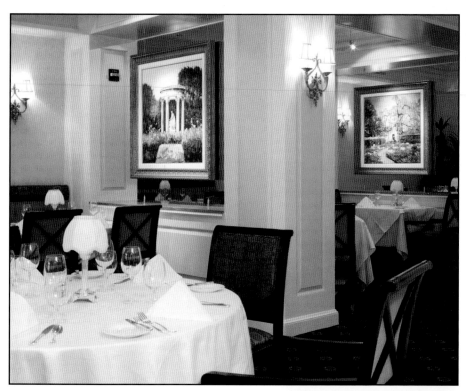

The Landmark Restaurant |
Washington, D.C.

A hotel restaurant must be all things at all times. In this case, it needed to be bright and cheerful for breakfast and lunch crowds, and to transform itself via lighting and tabletop displays to a romantic, special-occasion place for elegant evening meals. *Courtesy of The Melrose Hotel*

Symphony Room | Beijing

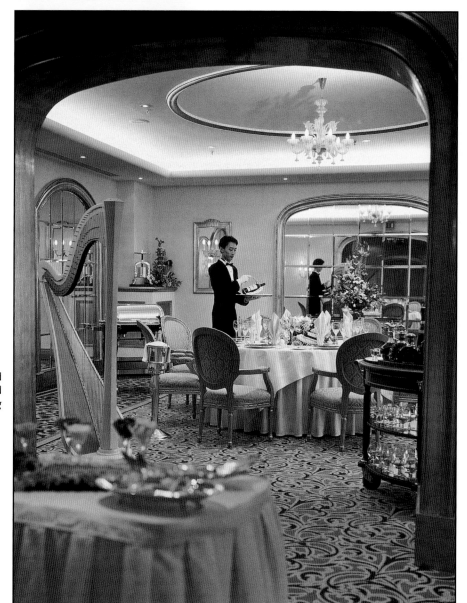

A soft, almost opalescent effect is created with back lighting and a blend of pinks and ivory. *Courtesy of Kempinski Hotel, Beijing*

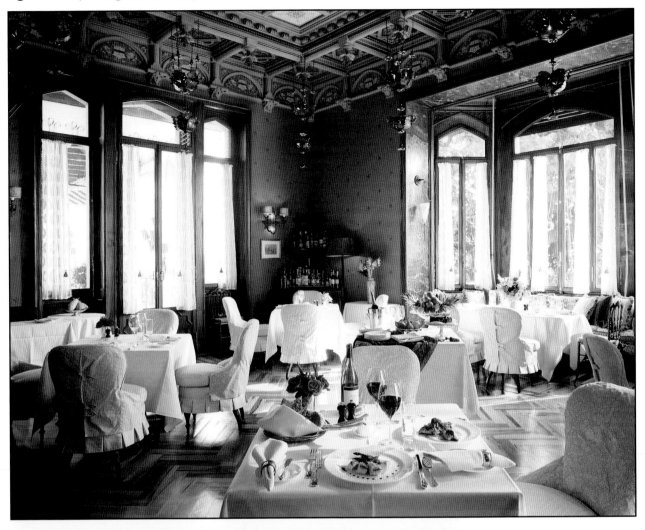

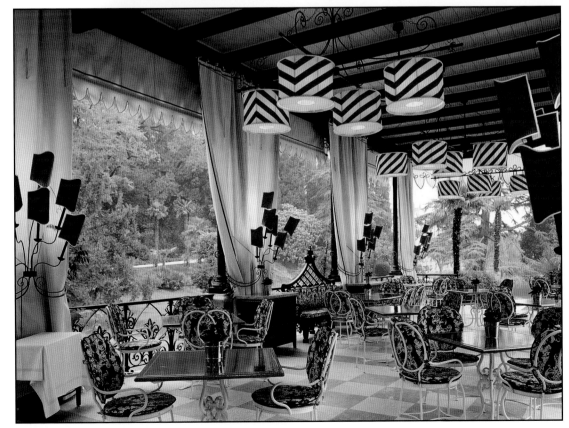

An elegant family dining room in a newly restored Italian castle is abandoned during good weather. Guests flock to the lake view in an adjacent covered pergola, where al fresco dining takes place under whimsical, bright orange Venetian lamps. *Courtesy of Grand Hotel a Villa Feltrinelli*

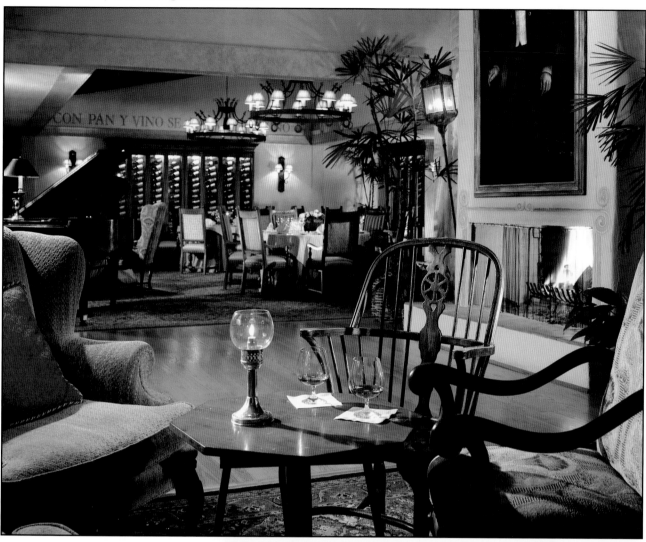

Piano music and firelight accompany diners in this intimate restaurant. Designer Carmel Magill, who helped design the restaurant, incorporated Monterey style for true California feel, as seen in the carved columns and chair backs. *Courtesy of Rancho Bernardo Inn*

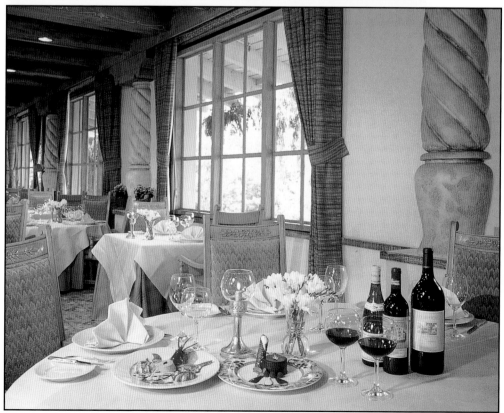

Lobby bar | Rose Hotel | Pleasanton, CA

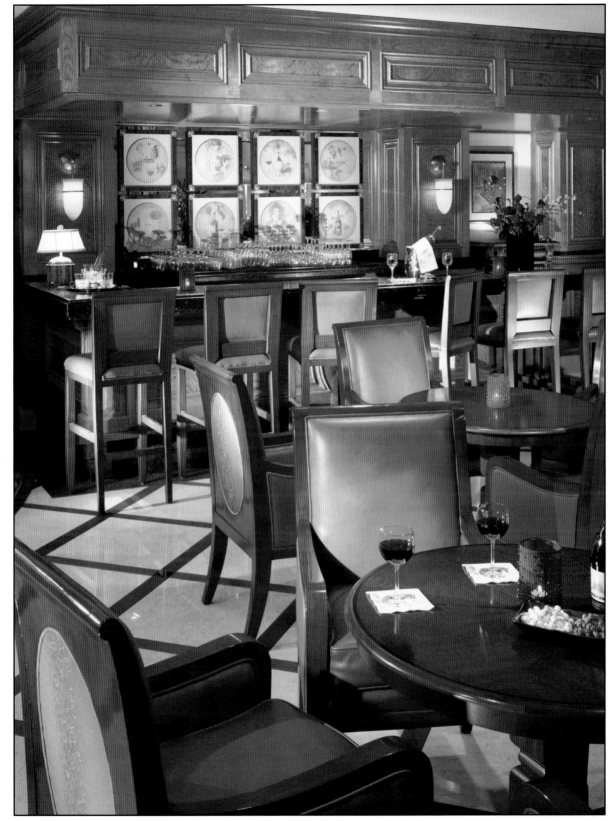

A cove-lit coffer finished in silver leaf sheds light on a seating area furnished in tan leather and walnut seating that complement the light cherry wood bar with marble top and footrest. A hint of regal red adds just a hint of flamboyance *Courtesy of Carl Ross Design, Inc.*

Photograph by Mary Nichols

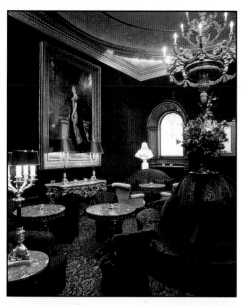

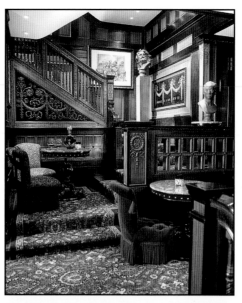

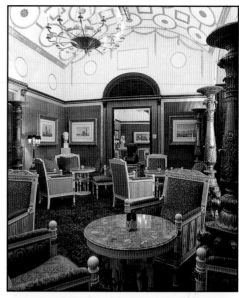

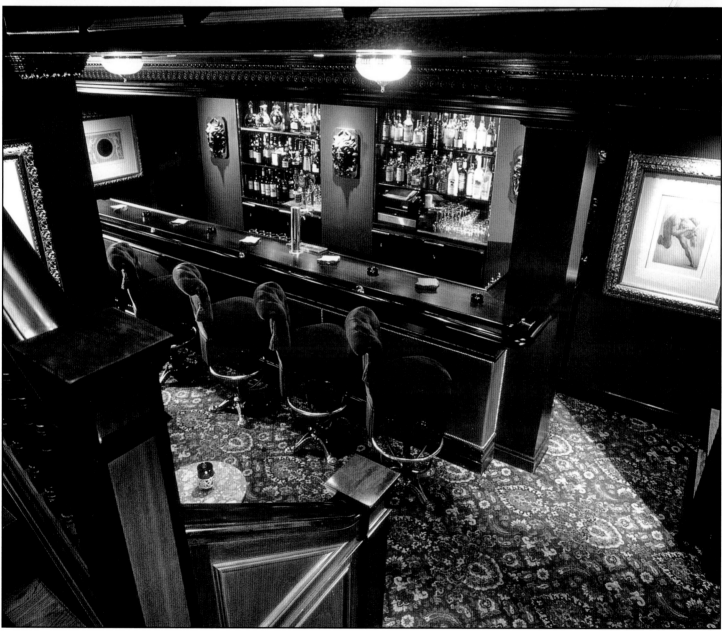

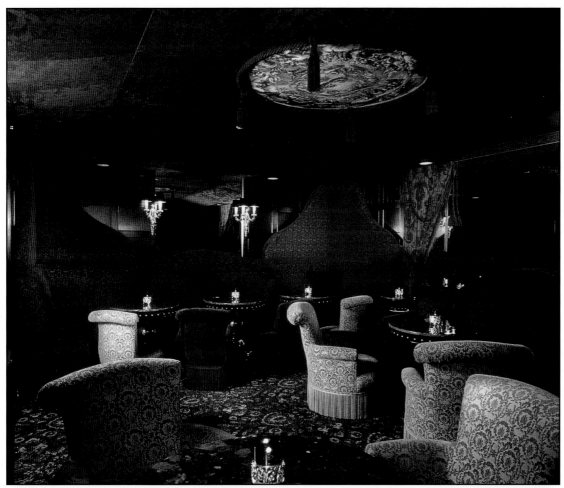

French designer Pierre Court had a $3 million budget when he set out to create the Villard Bar and Lounge in the New York Palace Hotel. Built in 1882 by railroad magnate Henry Villard, the historic landmark Villard House offers a series of interconnected rooms on two floors that provide a private, relaxing oasis to enjoy an evening cocktail and light snack. Original jewel-encrusted Tiffany windows and carved mahogany, along with new adornments of red velvet and gold leafing return this Louis XIV and Napoleon-inspired landmark to a time of Victorian opulence. *Courtesy of New York Palace Hotel*

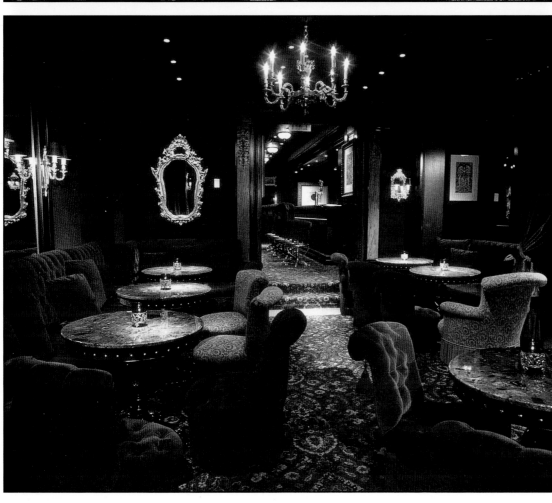

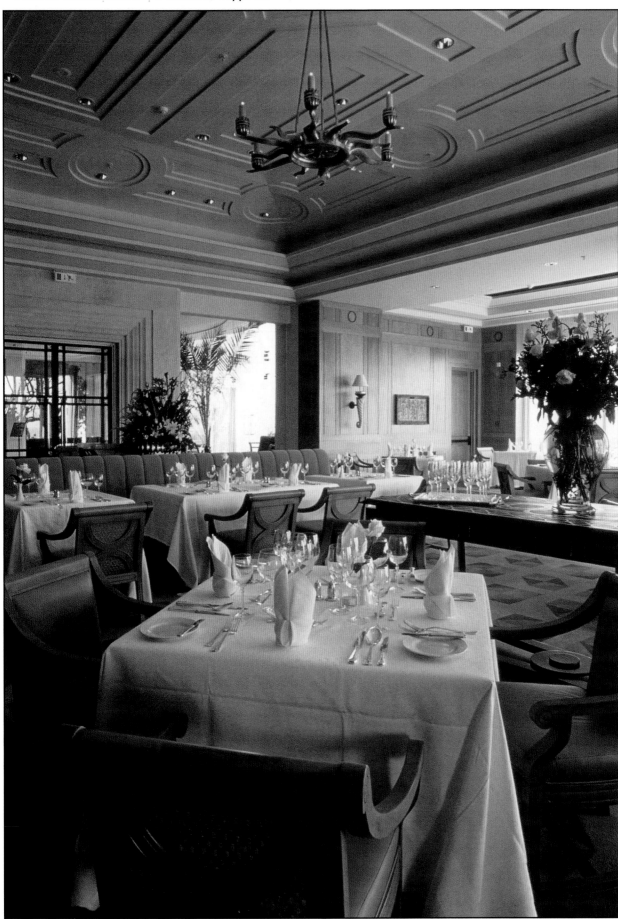

Classic elegance is achieved through architectural moldings, a timeless color scheme, and the simple beauty of fine furnishings. *Courtesy of Anassa Resort*

Rivoli Bar | London

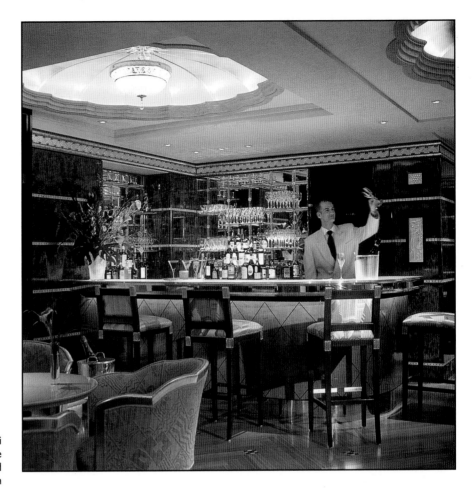

Here is a stylish, updated version of the original Rivoli Bar at The Ritz. The recent refurbishing stayed true to the early Art Deco period. The walls are paneled in polished camphor wood veneer enriched with Lalique glass panels and gold keystone nuggets. Clear and etched glass windows overlook Piccadilly. A polished Bamboo floor reflects light from golden ceiling domes. *Courtesy of The Ritz*

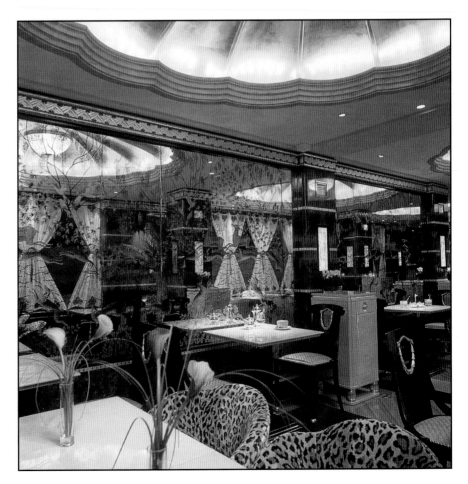

Loius XVI Restaurant | London

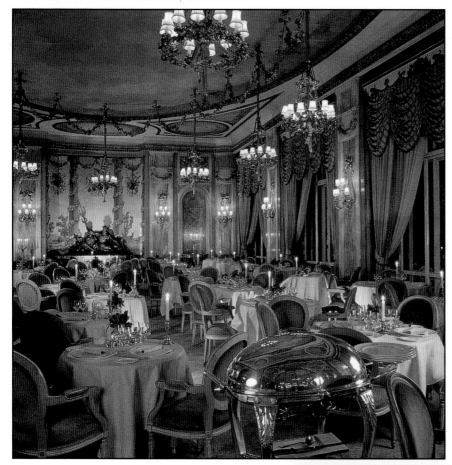

This restaurant was appointed appropriately for its namesake, Louis XVI , resplendent in painted wall panels and a masterwork on the domed ceiling, dripping with antique metalwork lighting, and heavily hung with curtains. *Courtesy of The Ritz*

The Palm Court | London

This restaurant imitates conservatory dining, with an artificially lit glass ceiling and a ring of foliage surrounding the tables. Elaborate moldings define the walls, topped by a generous helping of backlit crown molding. *Courtesy of The Ritz*

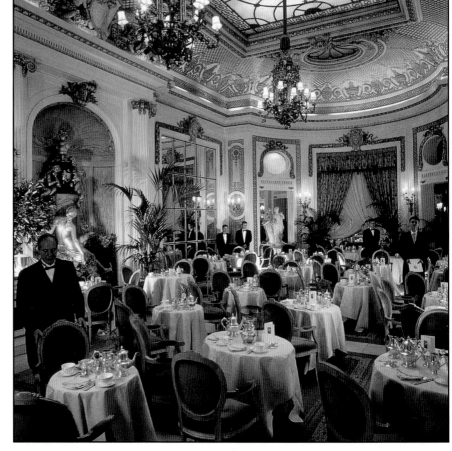

Byzantine Cocktail Bar | The Annabelle | Cyprus

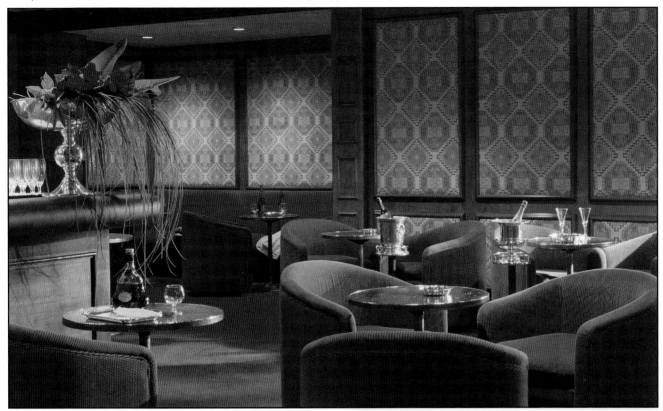

Textile wall panels add rich warmth of color, and muting effect for an area where guests can enjoy intimate seating. *Courtesy of The Annabelle*

Sala Rim Naam | The Oriental Bangkok | Thailand

A romantic boat ride across the river from the famous Oriental hotel in Bankok lands one in a pleasure garden of palatable and traditional Thai entertainments. A mix of Western refinery and lush Thai textiles characterize the river-front dining atmosphere. *Courtesy of The Oriental Bangkok*

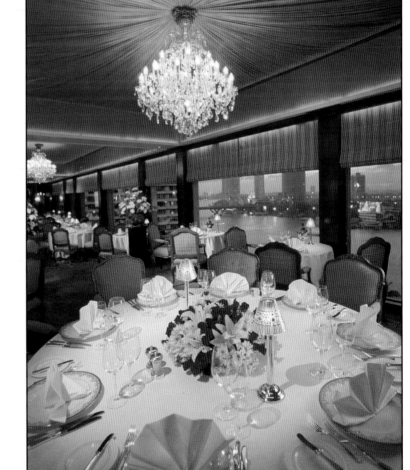

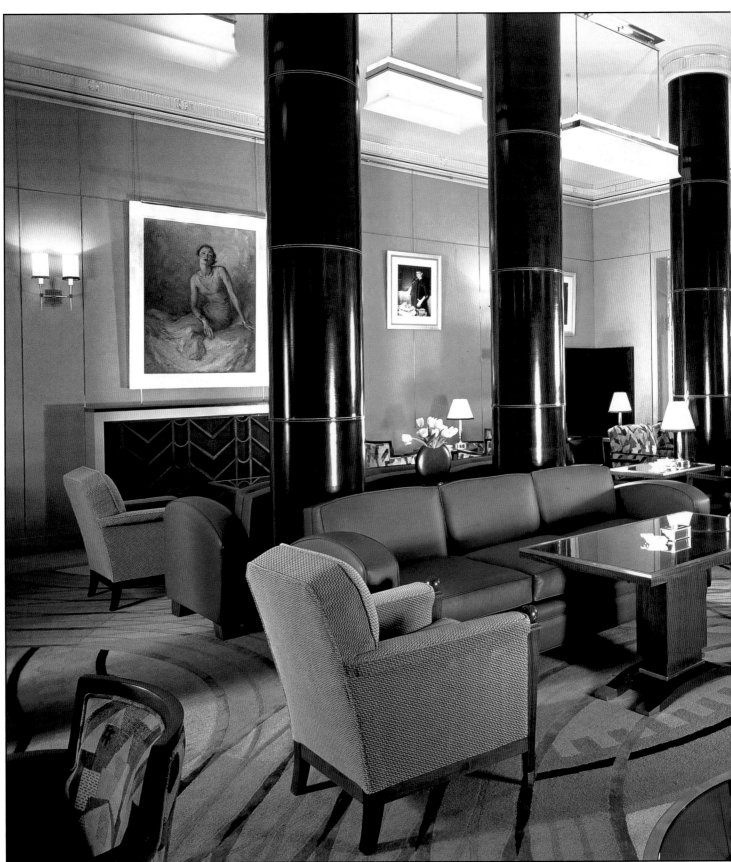

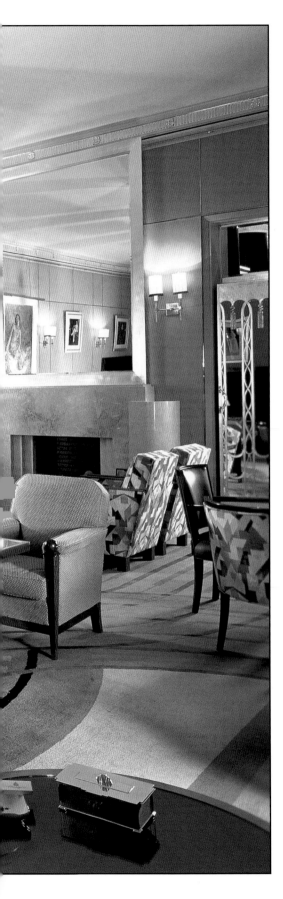

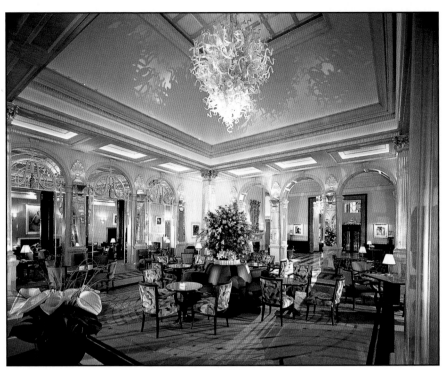

Light meals, afternoon tea, and cocktails are offered in the authentically restored art deco lobby and adjacent Reading Room. *Courtesy of Reardon Smith Architects*

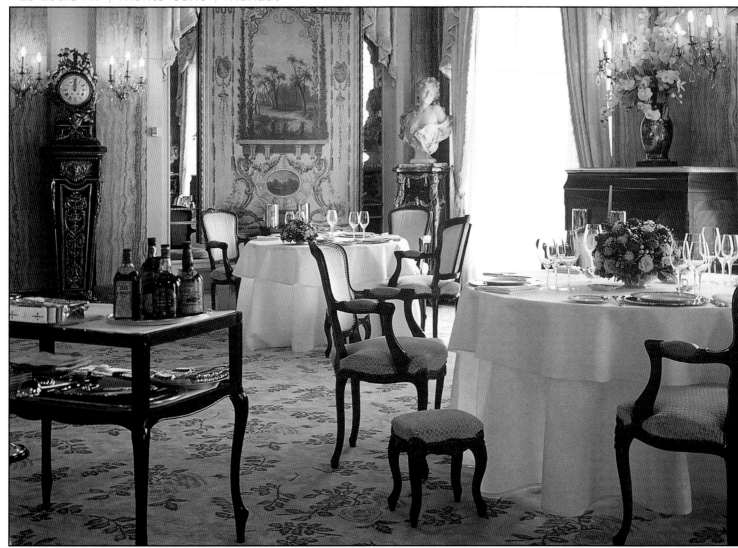

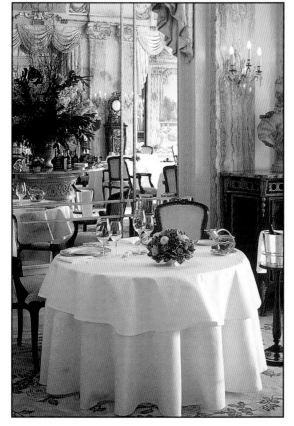

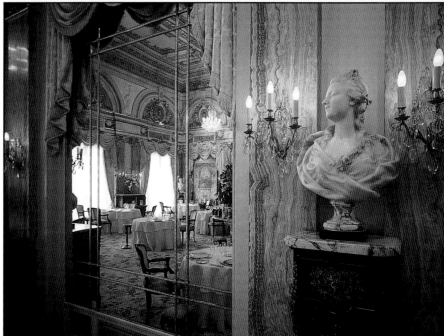

Gold and light are omnipresent in a Versailles-style dining room, where guests enjoy French Riviera cuisine by Alain Ducasse. *Courtesy of Hôtel de Paris*

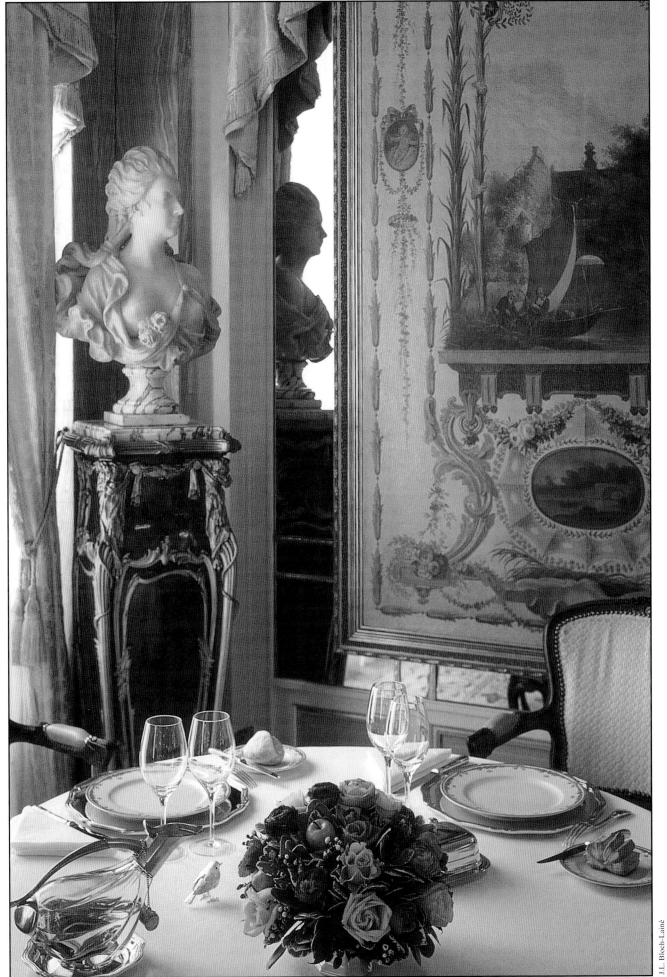

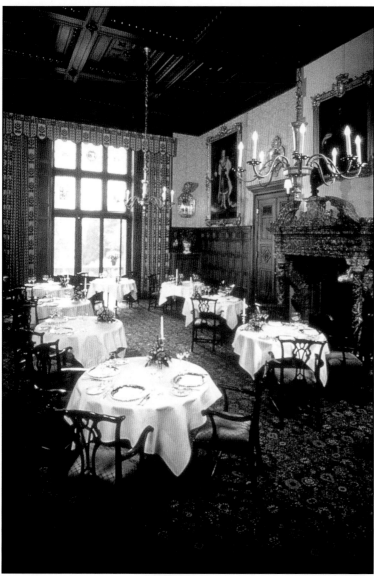

An empress's former dining room was transformed into an elegant restaurant, still graced by original architectural details and artwork. Artwork collected by the Empress Frederick, daughter of England's Queen Victoria adds charm. Contemporary lighting has been installed above classic paneling in her 1894 castle. *Courtesy of Schlosshotel Kronberg*

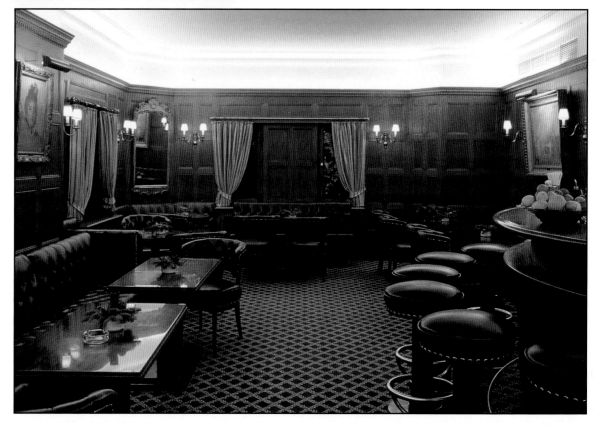

Colony Club | Royal Caribbean International's Radiance of the Seas

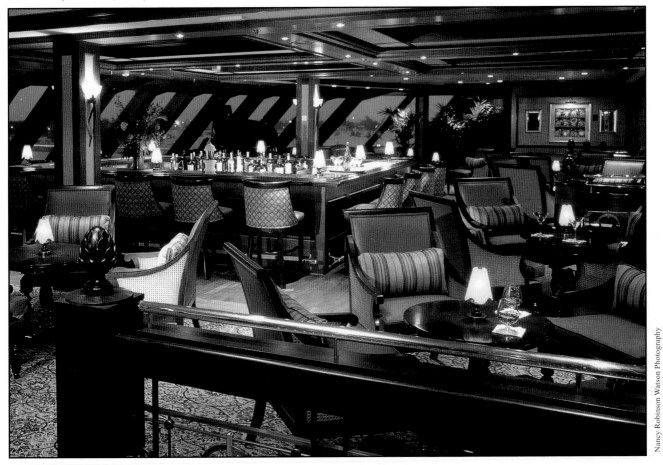

Pub-style paneling and comfy chairs soften the contrast of a contemporary wall of windows with an ever-changing waterfront view. *Courtesy of RTKL*

The Beach Club |
The Ocean Club at Key
Biscayne | Florida

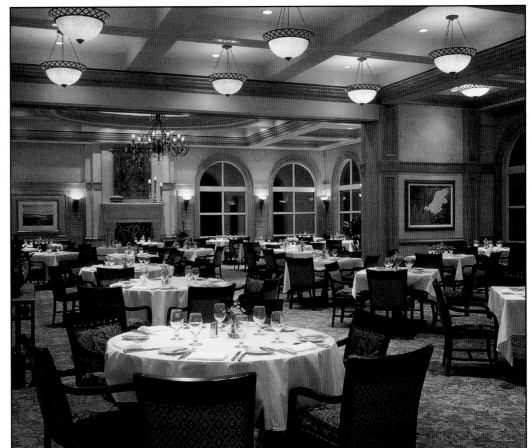

Old World dining elegance is created in an expansive, open dining room. *Courtesy of RTKL*

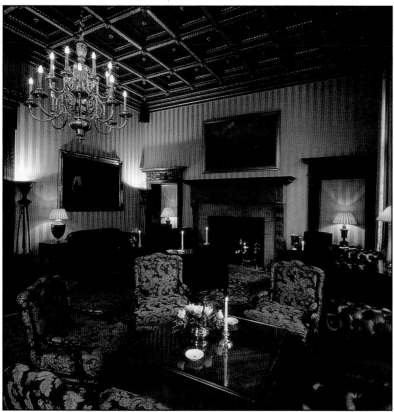

The Bar Le Tire Bouchon, designed by Karl Lagerfeld, presents dark corners and warm firelight where guests can relax in comfort. *Courtesy of The Regent Schlosshotel*

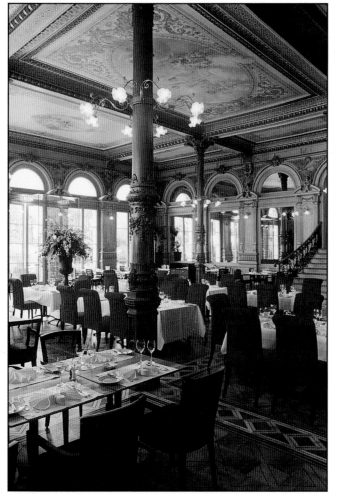

Wall paneling and lowered ceiling concealed the original 1895 belle époque decor, revealed thanks to a $4 million restoration. The opulent room is distinguished by ornate stucco work, rich carvings, and exquisite paintings by leading artists Hans and Otto Haberer – a room that merited mention in A Tramp Abroad, Mark Twain's famous travelogue. *Courtesy of Victoria-Jungfrau Grand Hotel & Spa Interlaken*

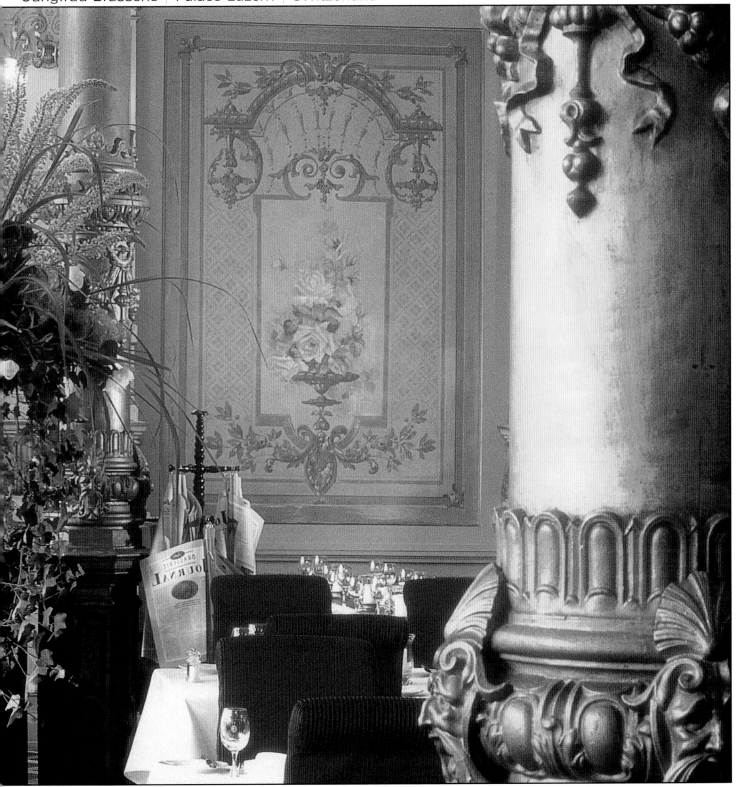

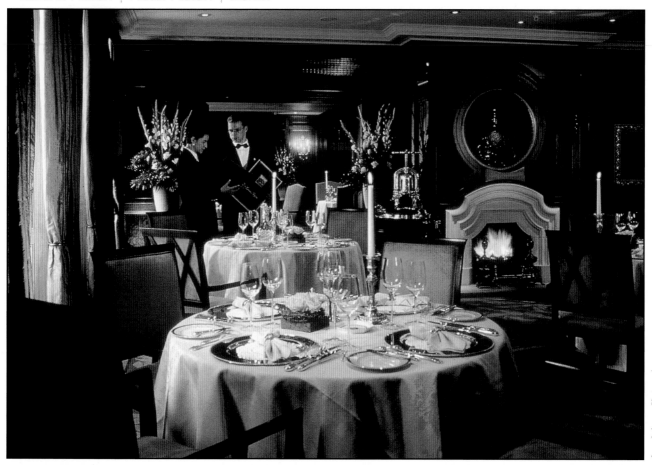

Rich tonal contrasts were incorporated for this award-winning gourmet restaurant overlooking Brandenburg Gate. An open fireplace casts a glow over the intimate seating area. *Courtesy of Hotel Adlon, Berlin*

The Bristol | Florence

Luscious burgundy red walls provide a delicious background to fine dining. *Courtesy of Helvetia & Bristol*

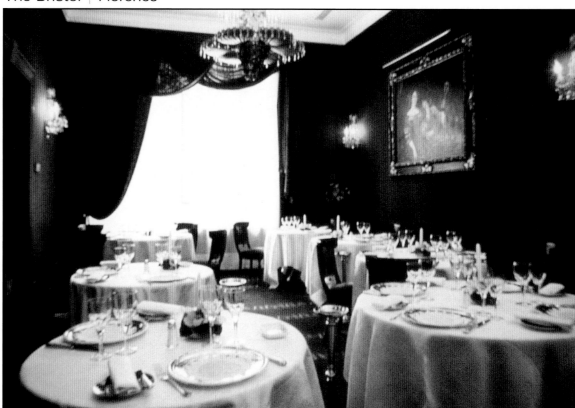

Waves Restaurant | Ritz Carlton | Egypt

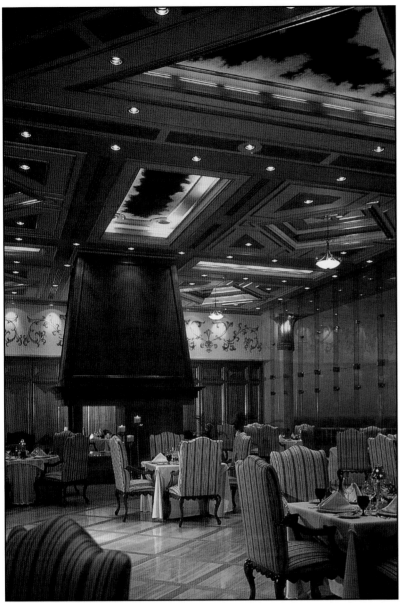

A dramatic pyramid sky window lends an ethereal touch to dining on the Sinai Penninsula, surrounded by intricate molding on the ceiling. A wall of windows provides a view of the Red Sea. *Courtesy of DiLeonardo International, Inc.*

Warren Jagger Photography, Inc.

Lounge | Madeira | Portugal

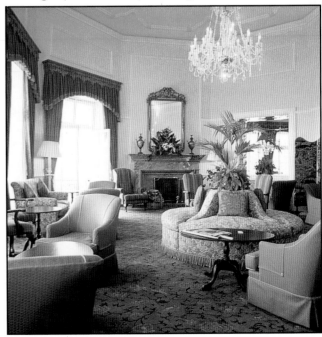

Comfort and European elegance team up for a stylish place to relax with a drink.
Courtesy of Reid's Palace

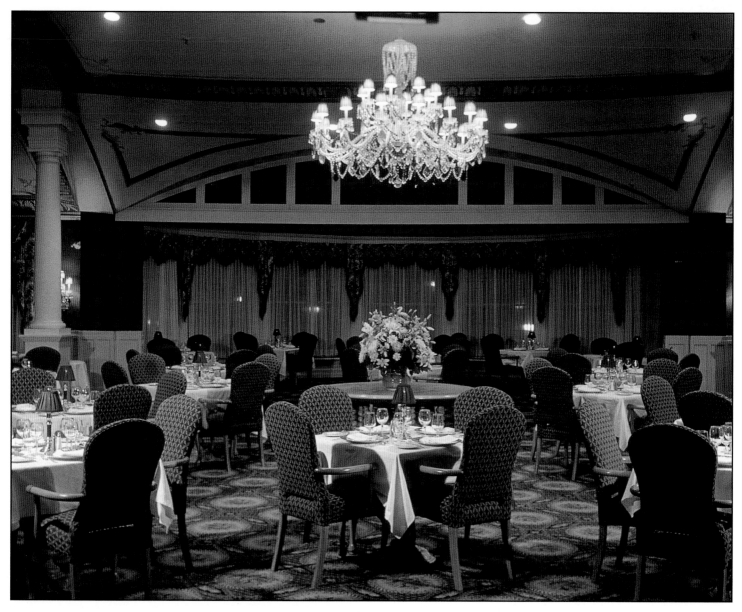

An expansive bay window was crowned with molding, making it the focal point of an elegant dining experience. *Courtesy of The Equinox*

Opposite page: Here is the bar area of a casual restaurant designed for both family and group dining. Brushed steel and stone combine for an unusual and shiny backdrop. *Courtesy of Fugleberg Koch Architects*

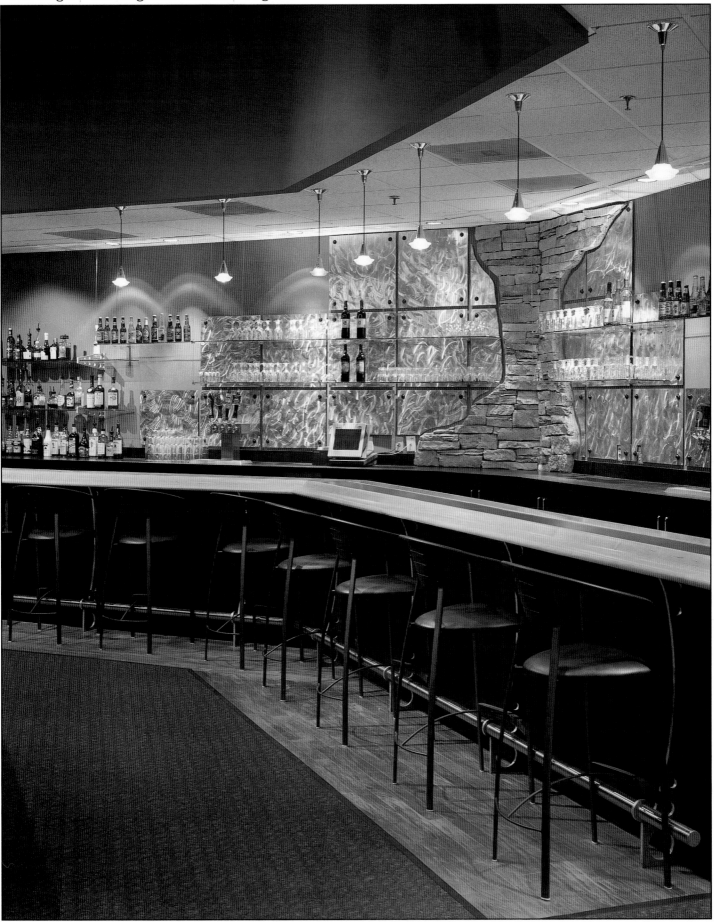

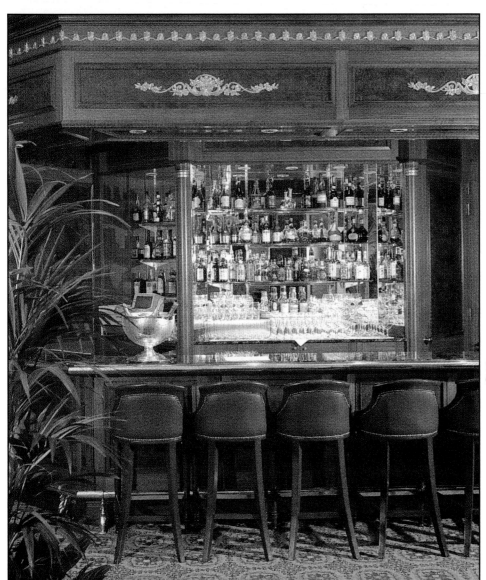

Cocktail bar | Conrad
International Brussels | Belgium

Fancy scrollwork tops an English-style pub.
Courtesy of Graham-Kim International, Inc.

The Bosphorous | Regent Almaty | Kazakhstan

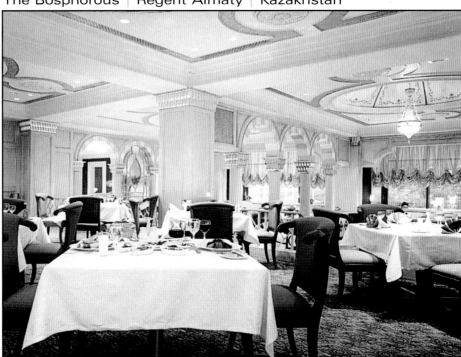

Gold tones in ornate domed ceilings, columns,
and paneling recall a regal era. Courtesy of
Graham-Kim International, Inc.

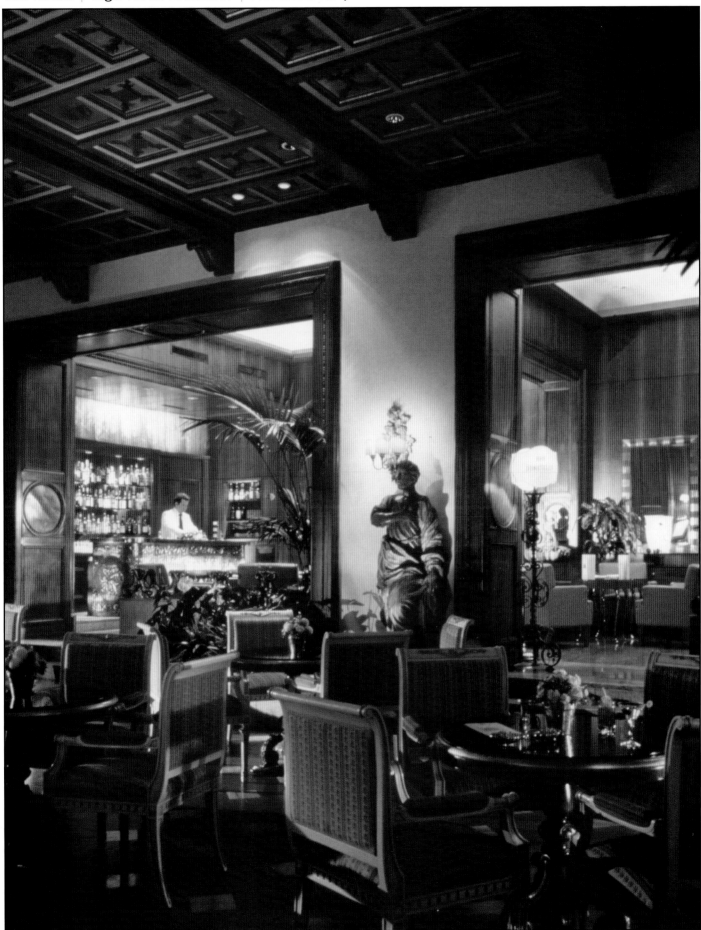

A restored dining room was lushly paneled, replete in golden tones.
Courtesy of Graham-Kim International, Inc.

Bridge Restaurant | The Carlton Hotel | Edinburgh

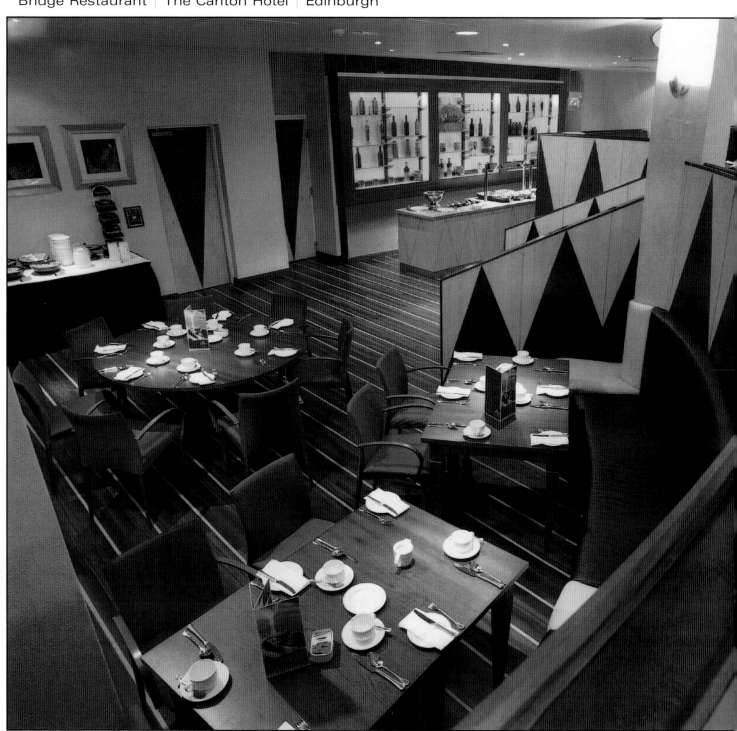

Light and dark zones help guide traffic in a restaurant designed to accommodate a rush-hour of early morning business clientele. *Courtesy of The Ransley Group*

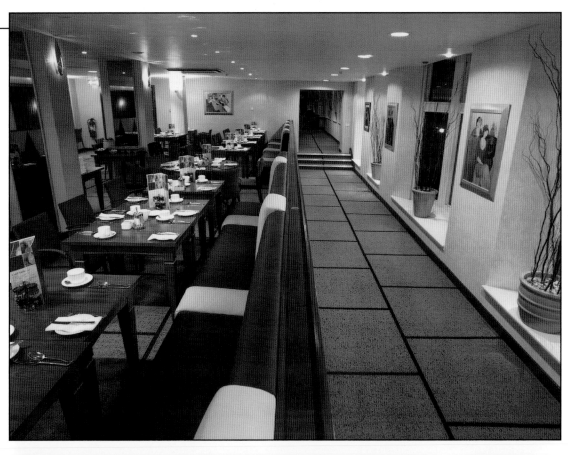

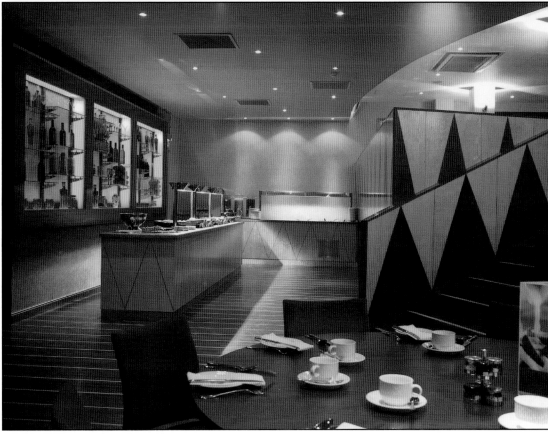

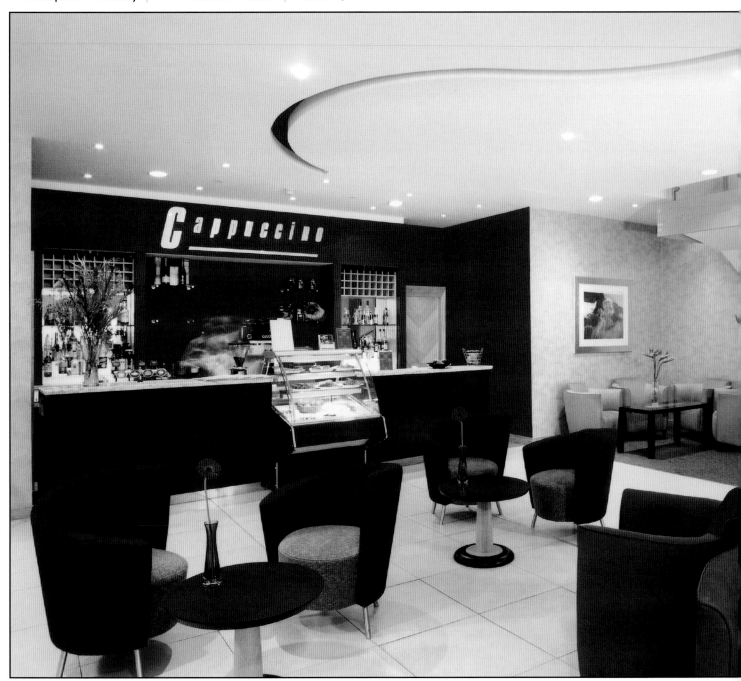

Lobby loungers are welcome to hot roasted coffee and refreshments.
Courtesy of The Ransley Group

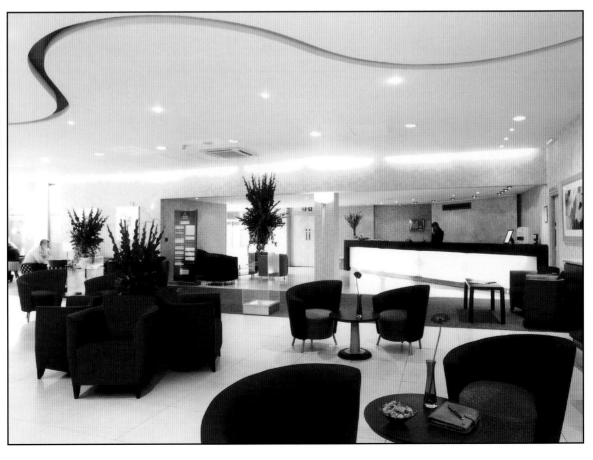

Towers Restaurant | Surf and Sand Resort | Laguna Beach, California

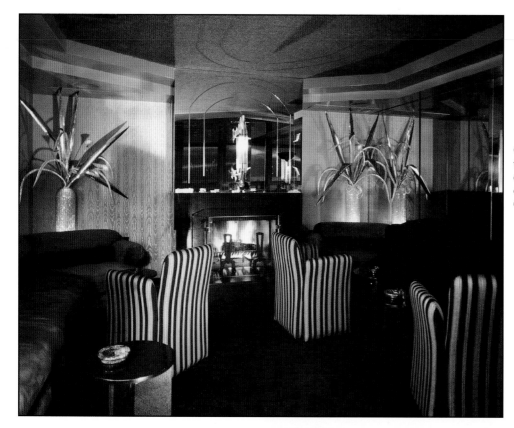

Golden tones were used to infuse warmth in this Art Deco-themed lounge. A mirrored ceiling doubles the ocean exposure in this ocean-front dining room. *Courtesy of Edward Carson Beall and Assoc.*

Towers Restaurant | Surf and Sand Resort | Laguna Beach, California

A mirrored ceiling doubles the ocean exposure in this ocean-front dining room. Courtesy of Edward Carson Beall and Assoc.

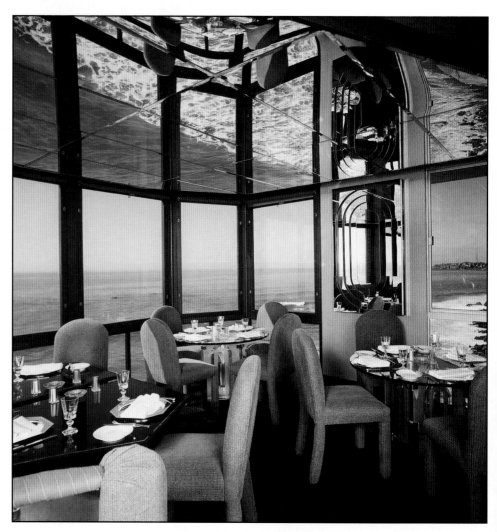

Bacara Bar |
Santa Barbara,
California

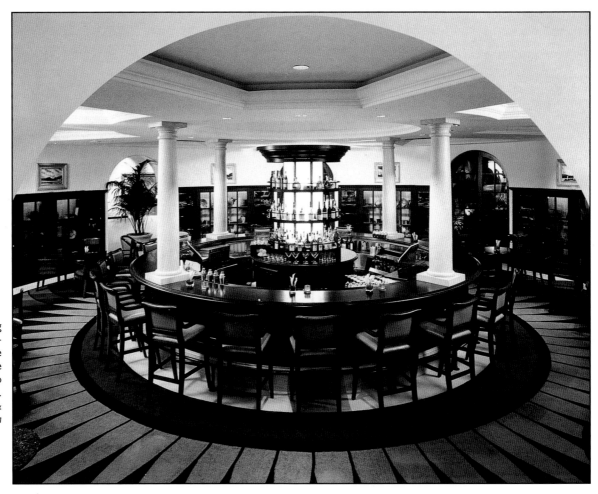

A central bar and seating
area encourages round-
table discussion, while
those with more private
conversations can move to
more remote tables.
*Courtesy of Bacara Resort &
Spa*

The Magpie & Stump | The Old Bailey | London

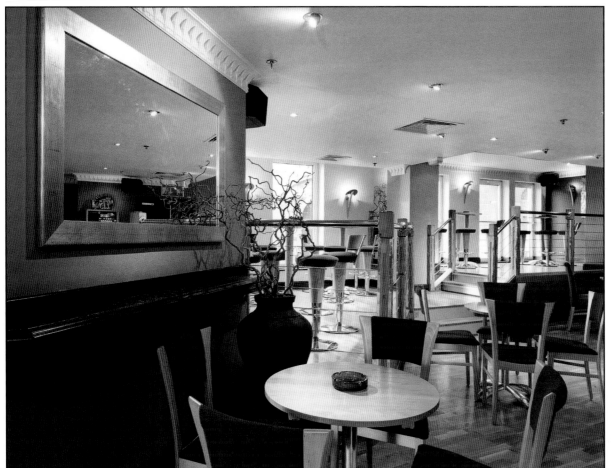

The traditional pub
once located here is
unrecognizable today.
Simplicity of form and
furnishings were
employed for a
contemporary bar.
*Courtesy of Graham
Leonard Associates, Ltd.*

71

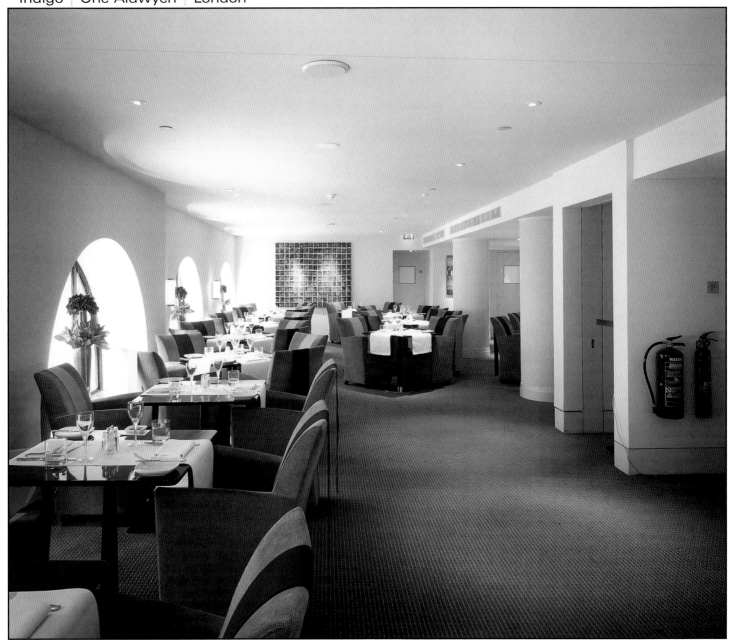

Art Deco is fused in a timeless, contemporary design that is at once casual and elegant. *Courtesy of Jestico + Whiles Architects*

Pedals Café | Shutters on the Beach | Santa Monica, California

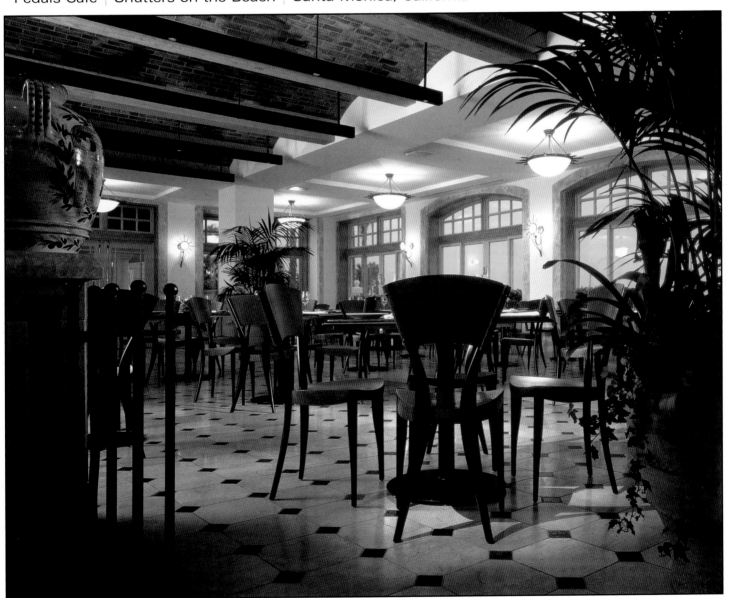

Stylish red chairs define a light airy café, topped by a vaulted brick ceiling, designed by Hill Glazier Architects. *Architecture by Hill Glazier Architects; interior design by Paul Draper & Associates*

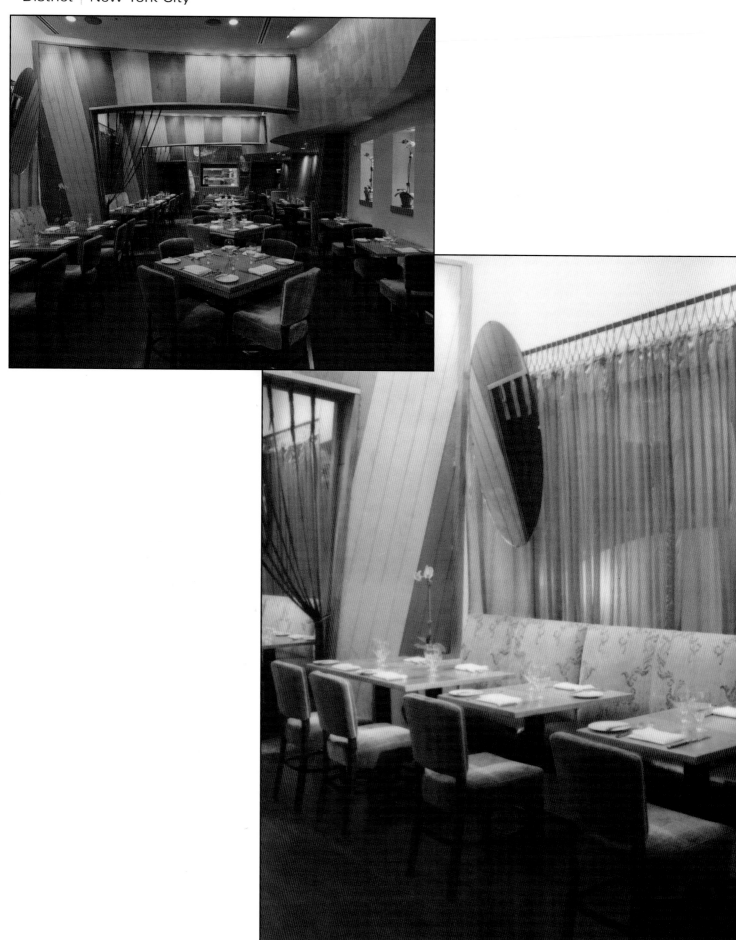

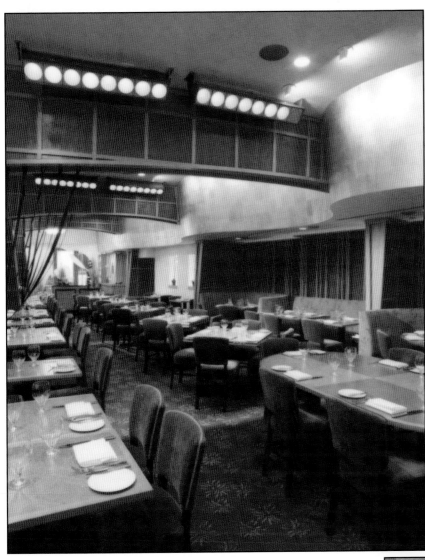

Designer David Rockwell mixed woods with stand-out textiles and lighting for an upscale, contemporary effect in this 85-seat restaurant. *Courtesy of The Muse Hotel*

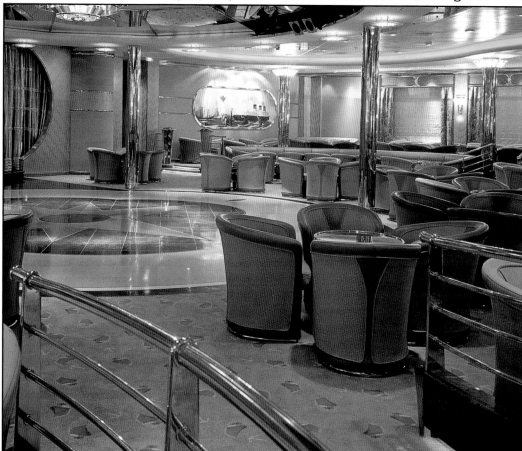

Man's oldest means of intercontinental conveyance is outfitted with the most contemporary of decor in this belowboard hot spot. *Courtesy of RTKL*

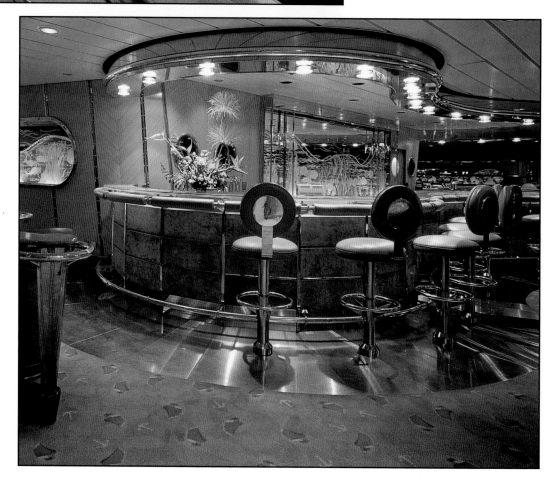

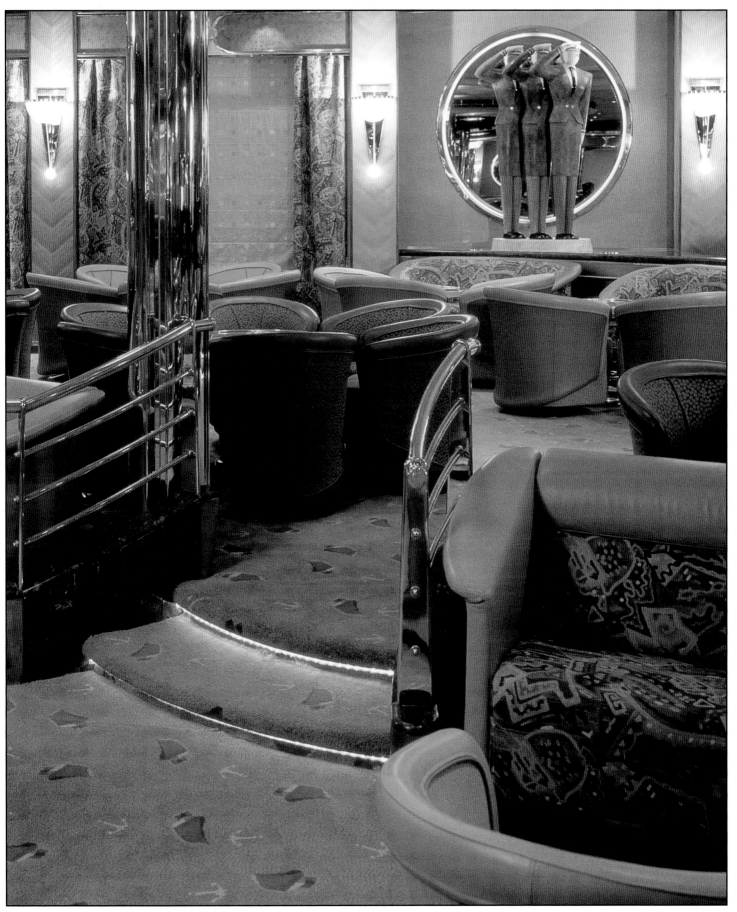

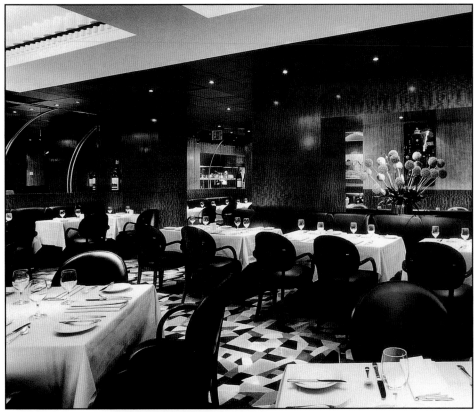

Tom Crane Photography

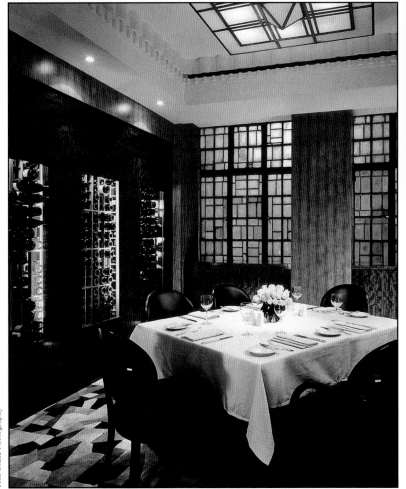

Tom Crane Photography

Tom Crane Photography

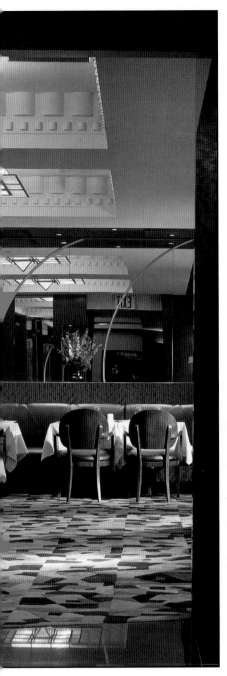

Designed to reflect modern elegance through a clean, crisp contemporary look splashed with color, this beautiful dining room also showcases the American cuisine of renowned chef Larry Forgione. The restaurant features mahogany panels, vibrant persimmon painted walls, large window panels with semi-sheer curtains, custom-made light fixtures, black leather and mahogany furnishings, and a signature, hand-knotted primary colored carpet. *Courtesy of Di Leonardo International, Inc.*

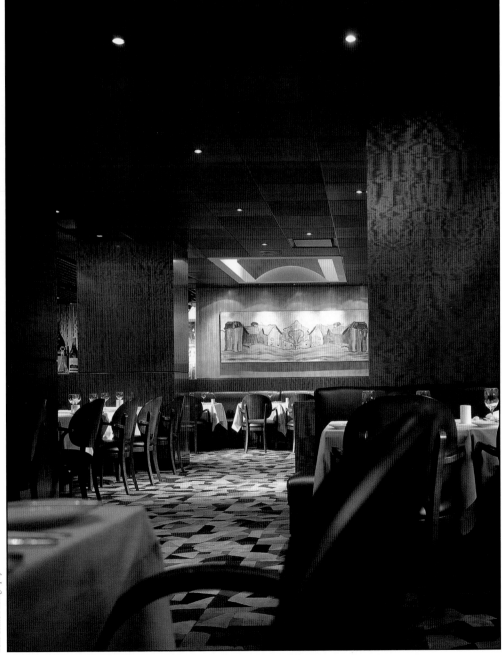

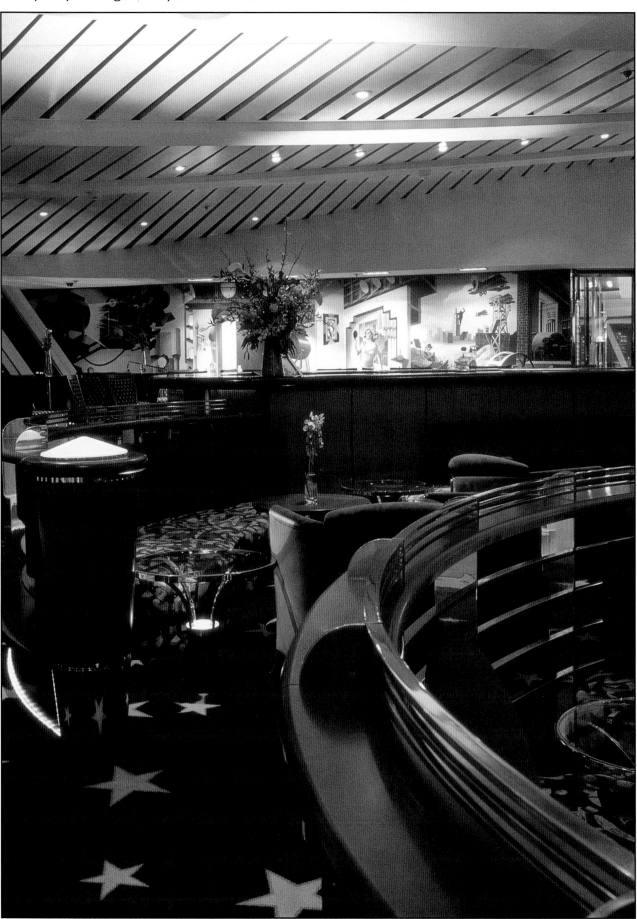

The 1930s get a sleek and colorful update in this timeless lounge. *Courtesy of RTKL*

Nancy Robinson Watson Photography

Tropical

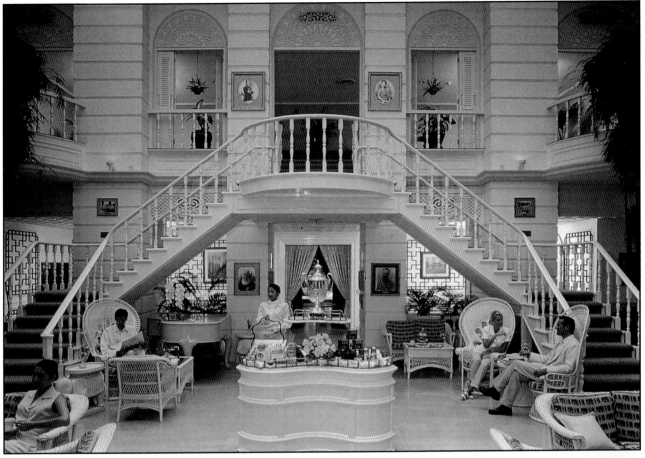

At one time or another, The Oriental Bangkok has hosted writers Joseph Conrad, Somerset Maugham, Noel Coward, James Michener, Barbara Cartland, Gore Vidal, Graham Greene, Wilbur Smith, John le Carré, Norman Mailer, and Kukrit Pramoj. This tropical indoor lounge is dedicated to their memory, and the lifestyle they sought there. *Courtesy of The Oriental Bangkok*

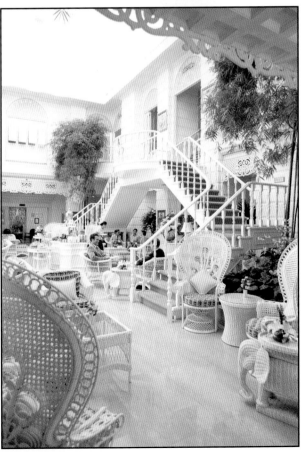

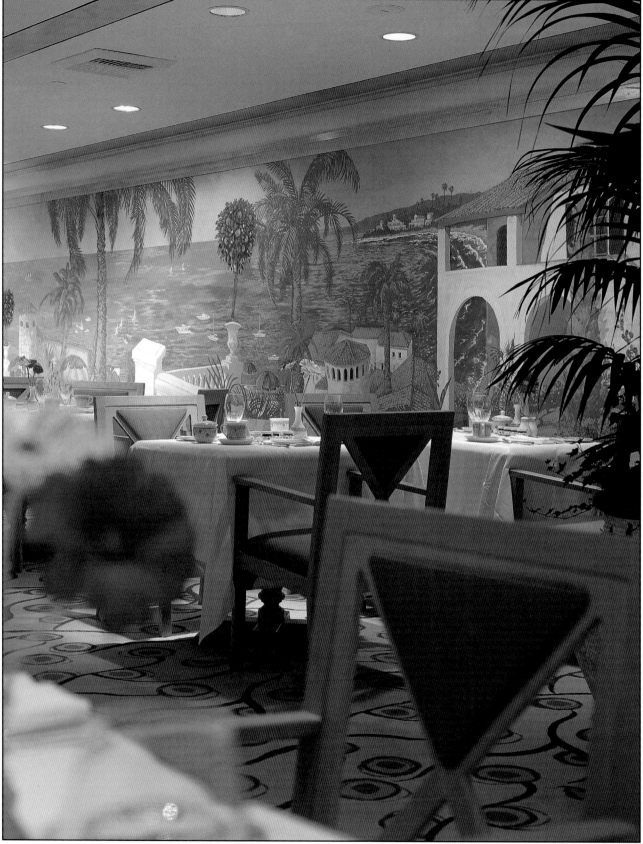

A wall mural transports diners to the Mediterranean while the view out the windows is strictly California coast. Artful effect in the free-flowing carpet design and custom chairs complement a creative menu. *Courtesy of DiLeonardo International, Inc.*

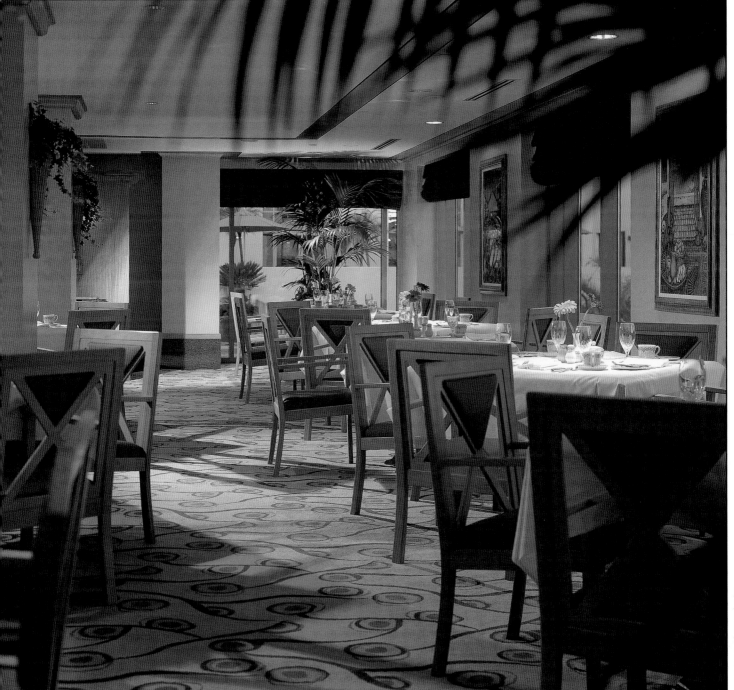

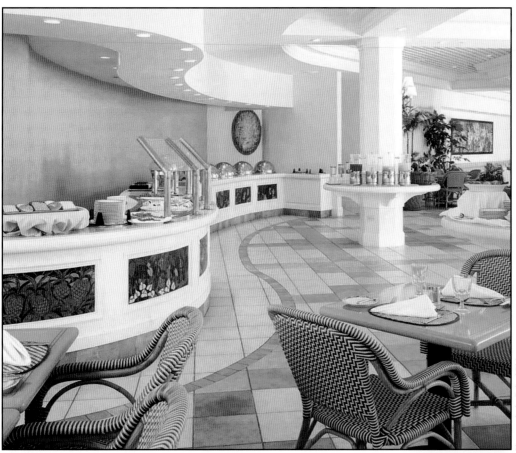

A bright palette adds sunshine to the morning's mocha java. A serpentine buffet creates separate stations and lots of elbow room. *Courtesy of Carl Ross Design, Inc.*

Photography by Roland Bishop

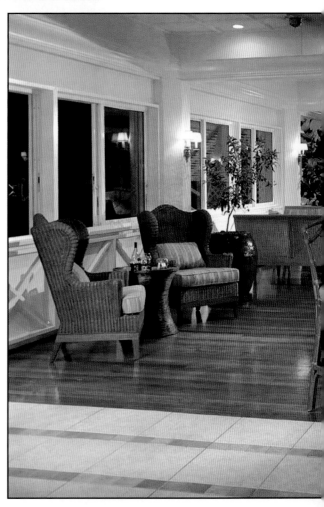

Palm Court | Hilton Resort |
Tobago, West Indies

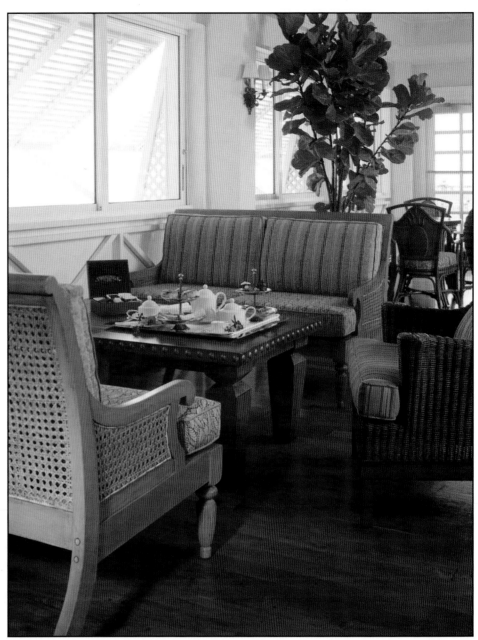

Photography by Roland Bishop

Wicker, white paneling, and Demerarra shutters, culture and
tropical comfort combine for a wonderful place to unwind.
Courtesy of Carl Ross Design, Inc.

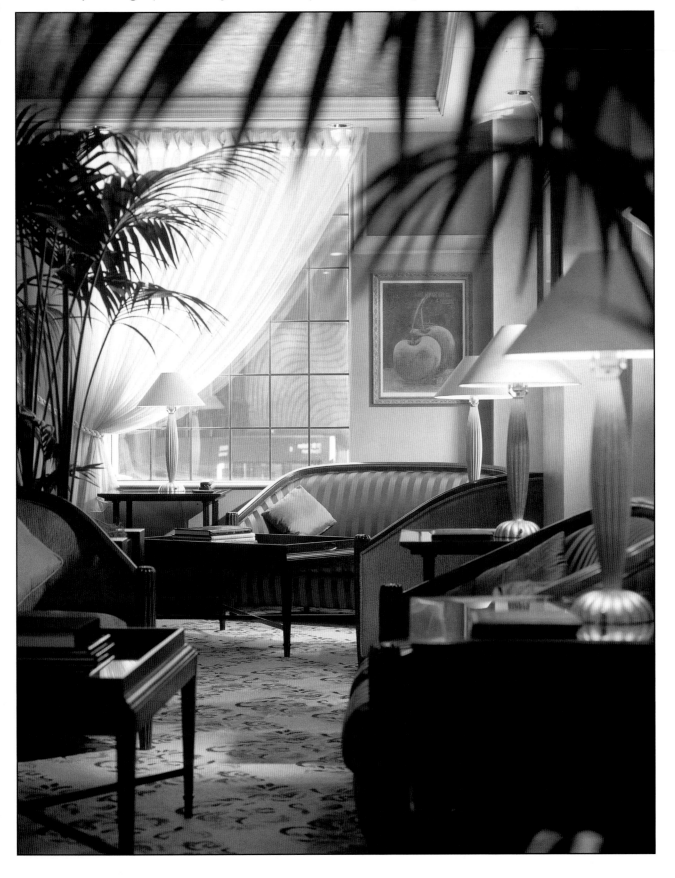

Almost home, a mix of furnishings, intimate table-lamp lighting, and domestic scale artwork create informal meeting places and space to relax. Sheer curtains soften city views. Courtesy of Di Leonardo International, Inc.

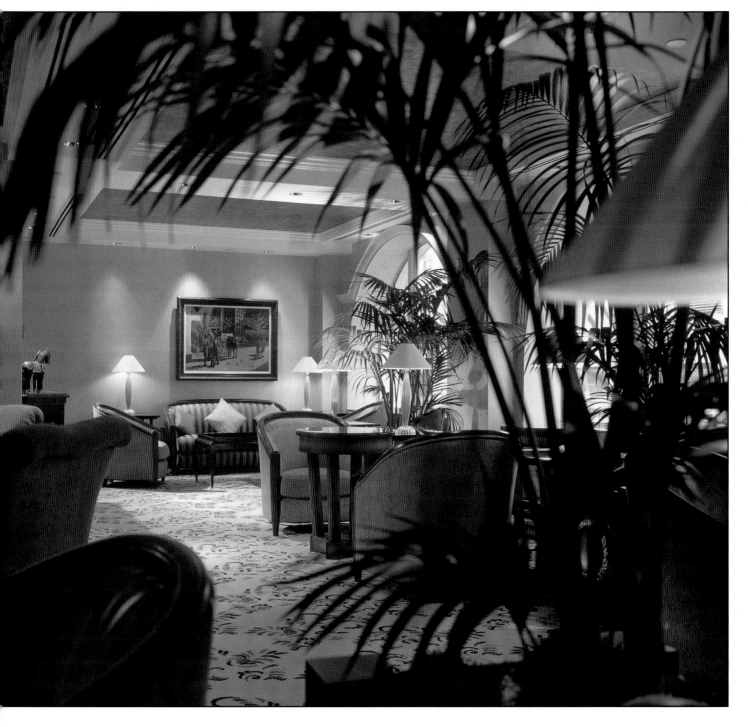

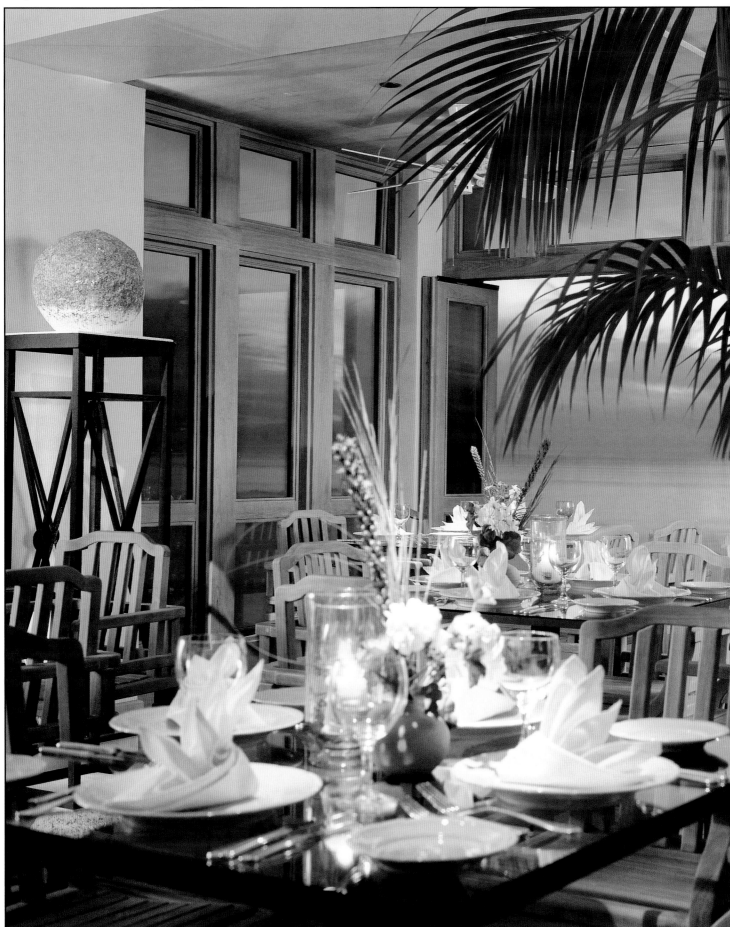

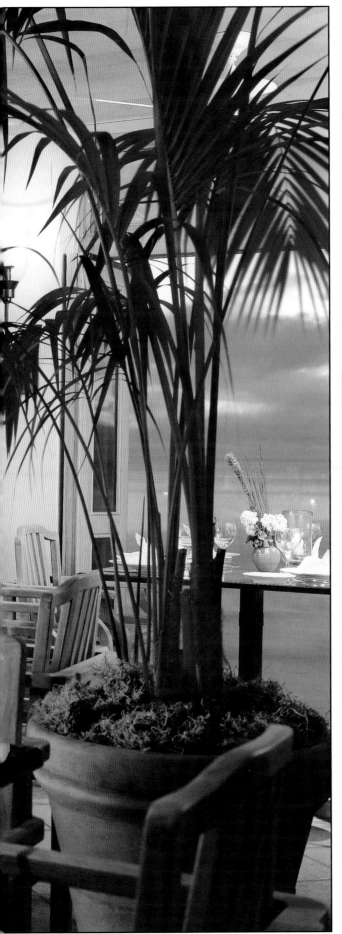

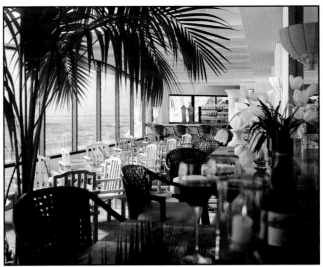

Diners sit two tables deep, keeping everyone close to a treasured seaside view. *Courtesy of Surf and Sand Resort*

Mulligan's Bar | DoubleTree Golf Resort | San Diego

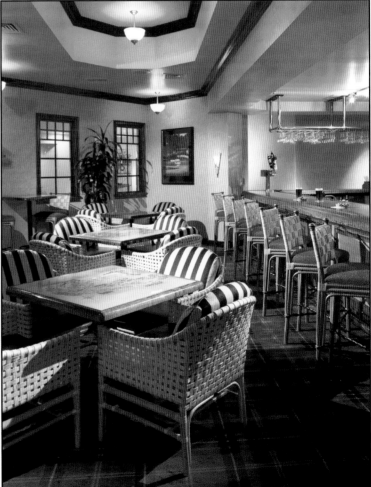

Photography by Roland Bishop

Designed to offer maximum views of the adjacent golf course, this rich, relaxing clubhouse atmosphere reflects the natural tones of the local stones, woods, and landscape elements found in the Southern California coastal region. *Courtesy of Carl Ross Design, Inc.*

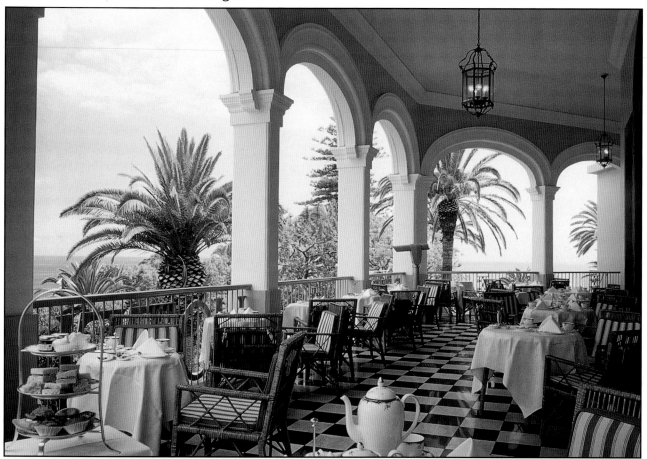

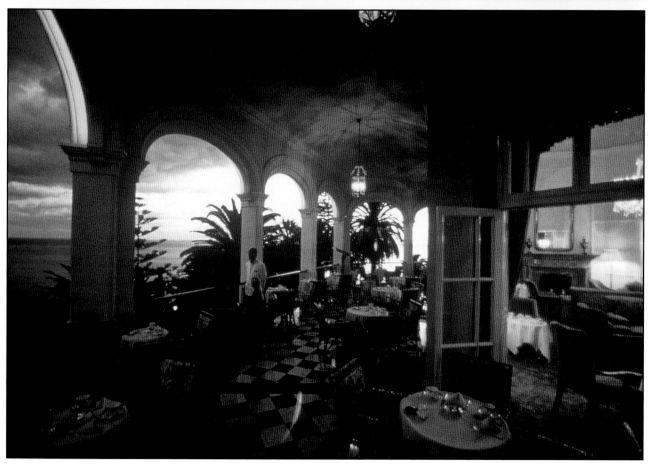

This wonderful broad balcony offers a place to shelter from the afternoon sun while taking in afternoon tea and evening cocktails. Lighting provided via a stunning sunset transforms the space.
Courtesy of Reid's Palace

Atrium Lounge | The Annabelle | Cyprus

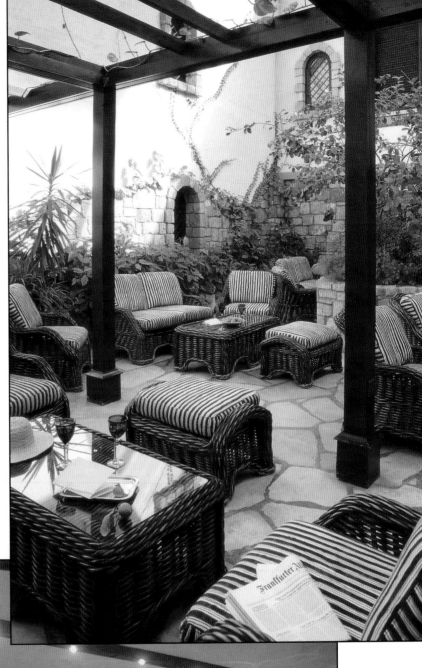

An indoor patio creates a bright lounge when the sun is not cooperating outdoors. *Courtesy of The Annabelle*

La Colombaia | Capri, Italy

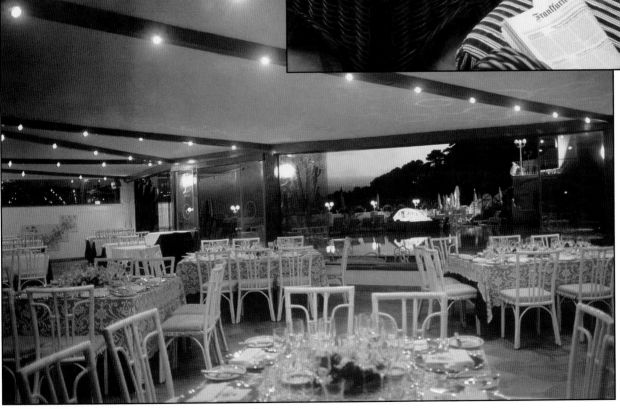

Tinted glass adds magic to the atmosphere, overlooking the pool and outdoor recreation area. *Courtesy of Grand Hotel Quisisana*

Spa Cafe | Santa Barbara, California

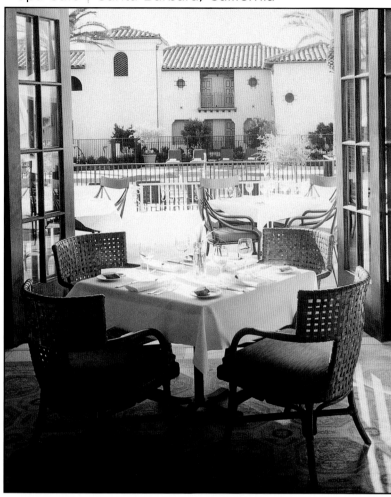

A casual eatery opens out on pool and patio, offering health-conscious clientele low-fat, healthy menu options. *Courtesy of Bacara Resort & Spa*

Brasserie on the Park | Hotel Inter-Continental | Tashkent, Uzbekistan

Tiled floors and columns add clean sparkle to an open restaurant. Wooden framework repeats the oversize block motif in the columns, framing entries in false transoms. *Courtesy of Graham-Kim International, Inc.*

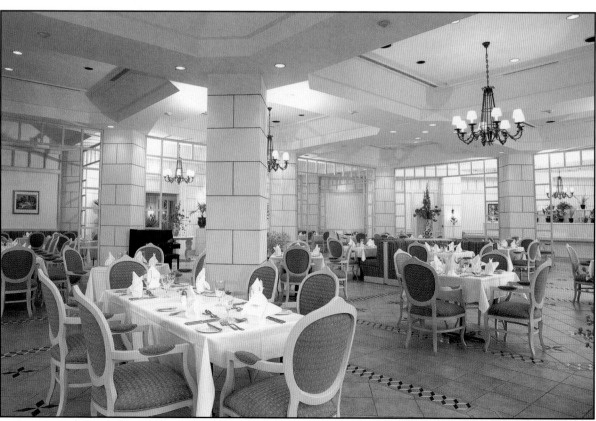

Sunroom/Conservatory

Wintergarden | Hotel Adlon | Berlin

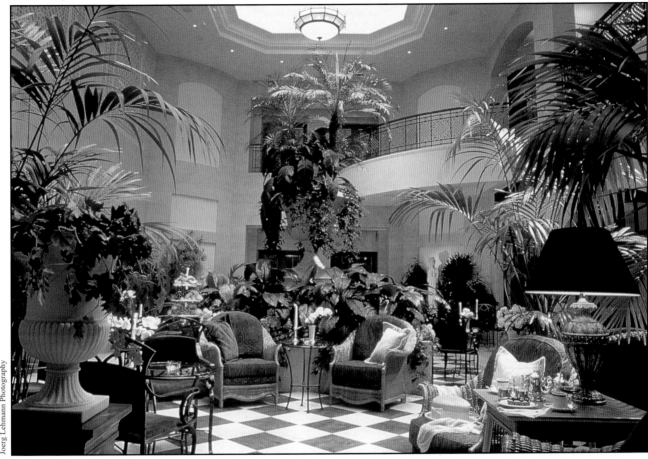

Joerg Lehmann Photography

Germans love their beer, and when the weather isn't accommodating, they move inside. Here plants provide intimacy and a garden atmosphere year-round. *Courtesy of Hotel Adlon, Berlin*

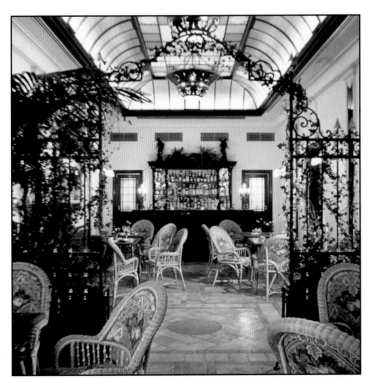

Winter Garden | Florence

Wicker and wrought iron capture summer's spirit while a conservatory roof keeps foul weather at bay. *Courtesy of Helvetia & Bristol*

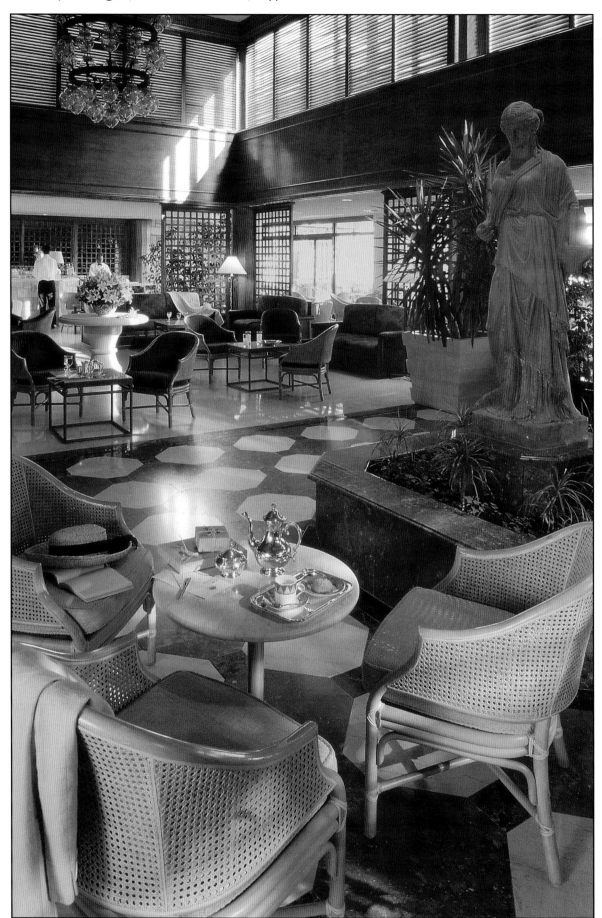

Venus watches over diners in a spacious, casual lobby where resort guests can meet over tea, cocktails, and light refreshments.
Courtesy of The Annabelle

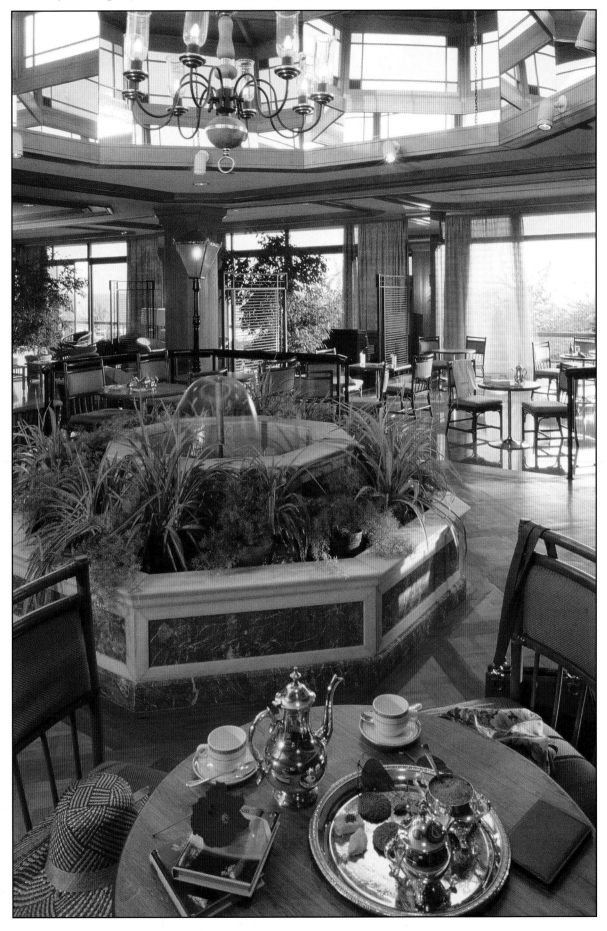

A central fountain and a seaside vista make the lobby a favorite hangout at this resort hotel.
Courtesy of Paphos Beach Hotel

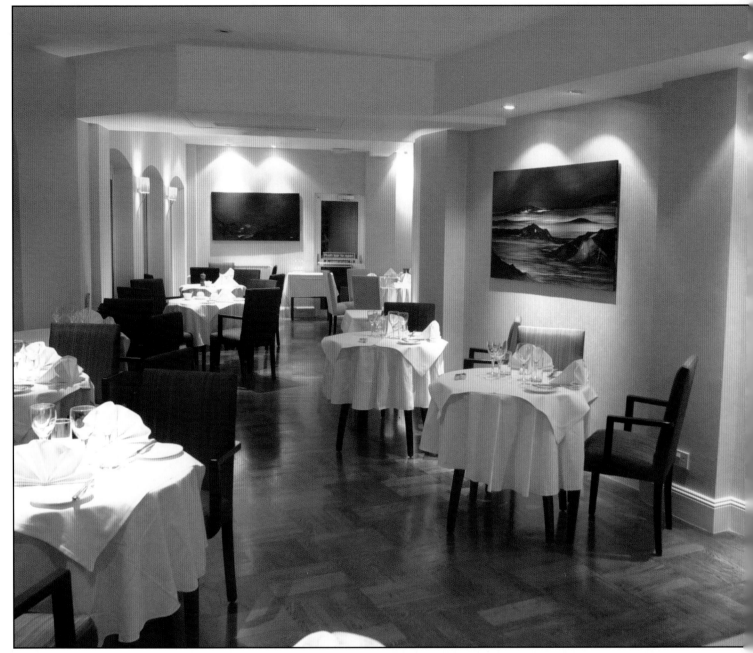

Stephen Hyde at London Photography

Windows and seating maximize a waterfront view. The inside wall showcases artists' interpretations of the surf beyond. *Courtesy of Portfolio Design International*

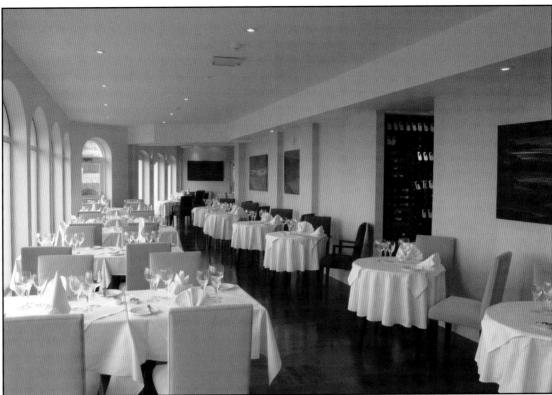

Stephen Hyde at London Photography

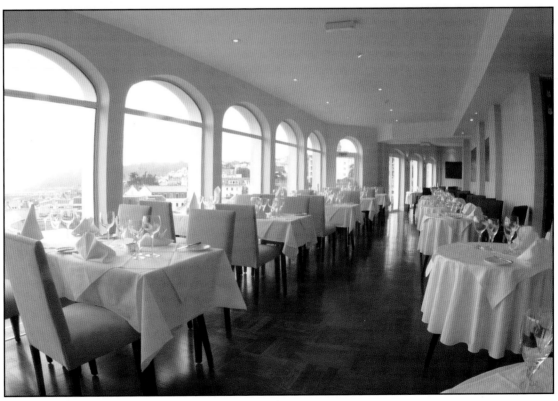

Stephen Hyde at London Photography

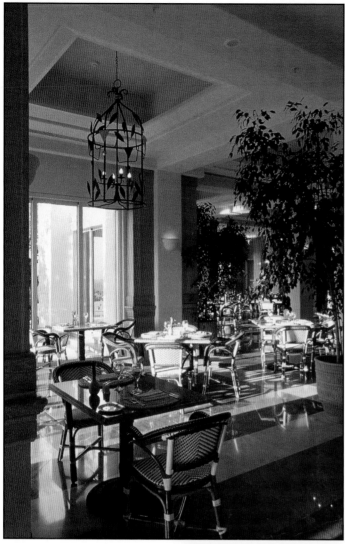

Amphora Restaurant | Anassa, Cyprus

A gilded color scheme adds glamour to an informal restaurant, flattering patrons with a sunlit glow. *Courtesy of Anassa Resort*

Copper Mine Restaurant | Wintergreen Resort | Virginia

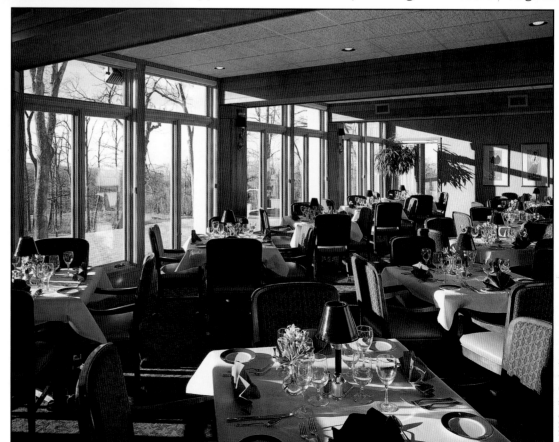

Luxury dining affords an Appalachian view for resort guests, the emphasis being on the wall of windows and the fine food. *Courtesy of Fugleberg Koch Architects*

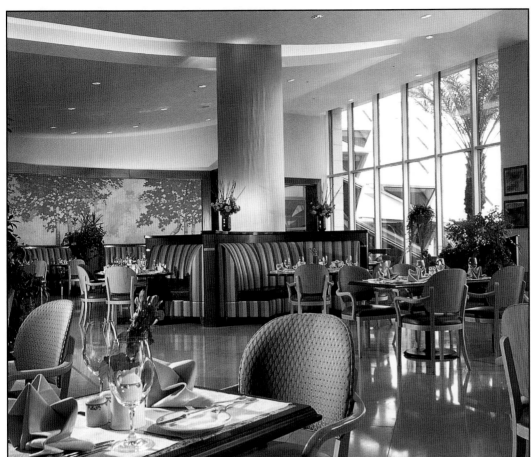

Mike Wilson Photography

A warm interior accented by contemporary wood panels radiates toward the outdoors, where a ceiling swoops up toward a bank of windows.
Courtesy of DiLeonardo International, Inc.

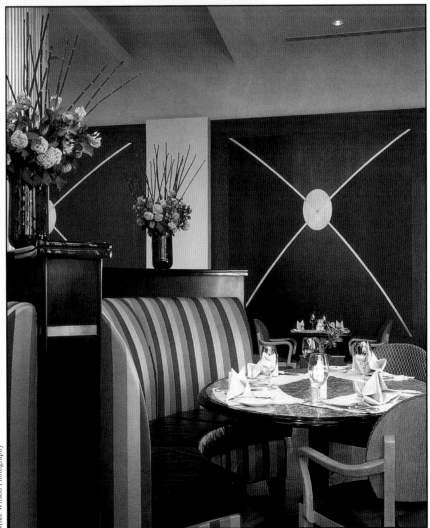

Mike Wilson Photography

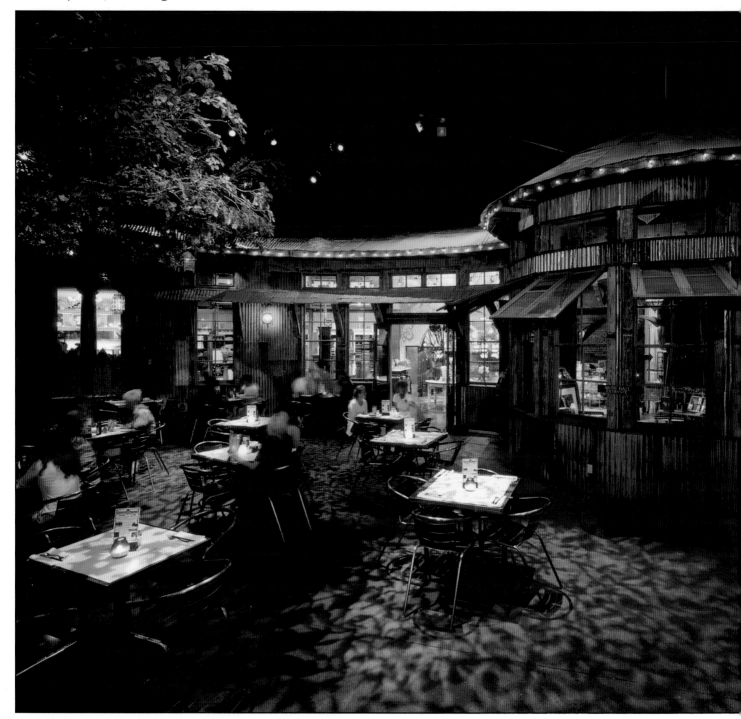

A courtyard needn't feel the sun when lighting can do the job just as well. In fact, lighting is one of the more inspired aspects of this eclectic design, with punchwork lanterns filling the trees and multi-colored lights ringing the boardwalk around the dining area, where customers are served breakfast, lunch, dinner, and late-night cocktails. *Courtesy of House of Blues*

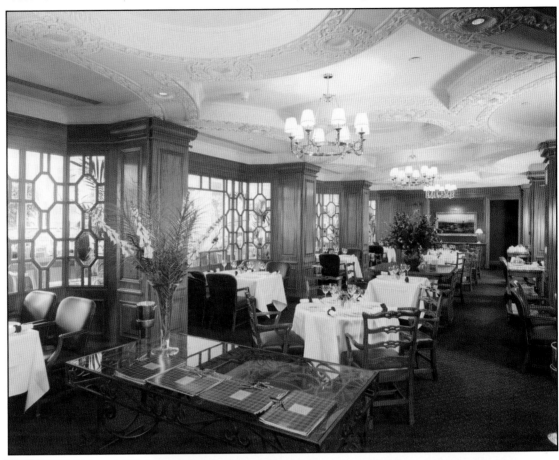

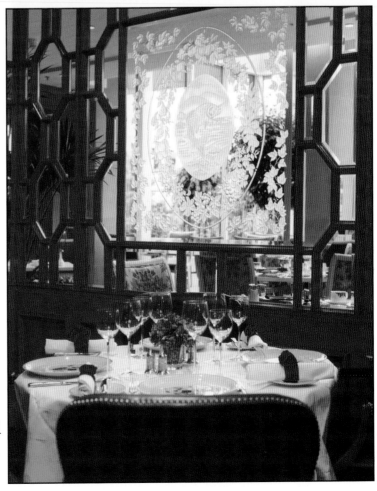

Ornate touches in window paneling and plaster ceiling moldings add fancy to a bright restaurant. *Courtesy of Graham-Kim International, Inc.*

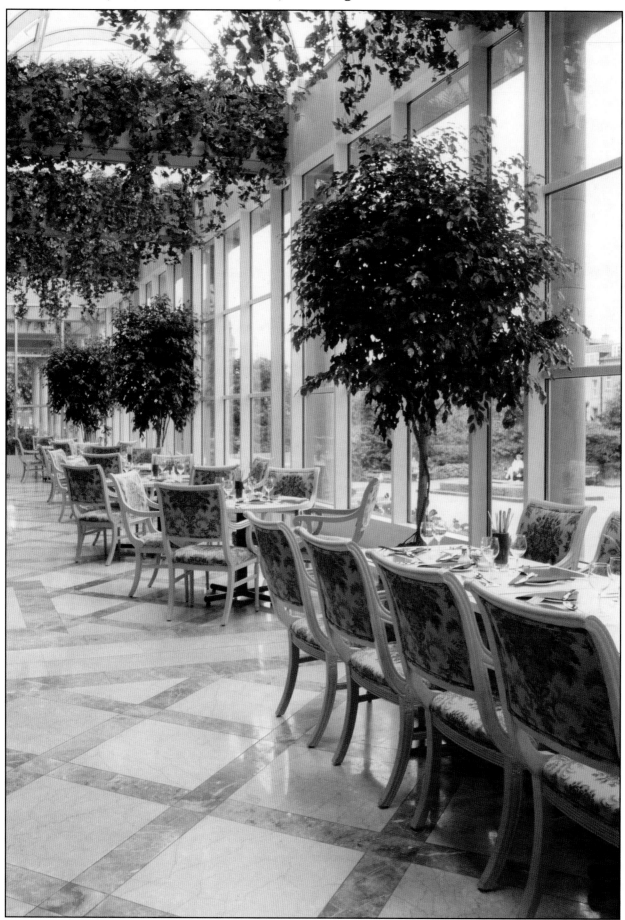

A glass room puts everyone in the sunlight, filtered through lush foliage and sweetened by air conditioning. *Courtesy of Graham-Kim International, Inc.*

Wine Cellars

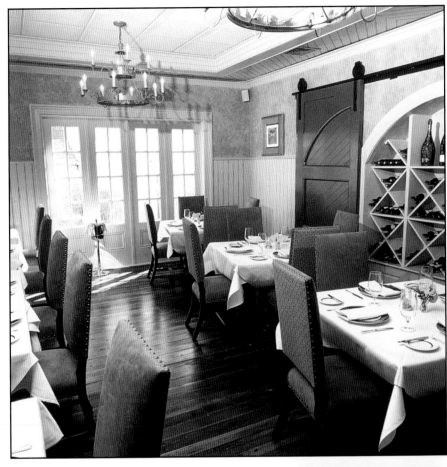

Circa 1886 Charleston | South Carolina

One of Charleston's newest fine dining establishments is located in a carriage house on the grounds of a beautiful Victorian mansion. The original stable doors complement authentic features such as a kitchen fireplace and heart of pine floors. *Courtesy of Wentworth Mansion*

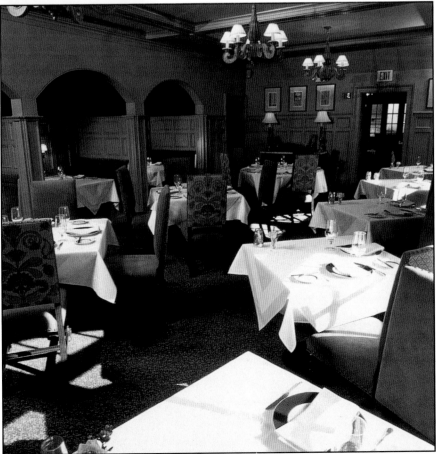

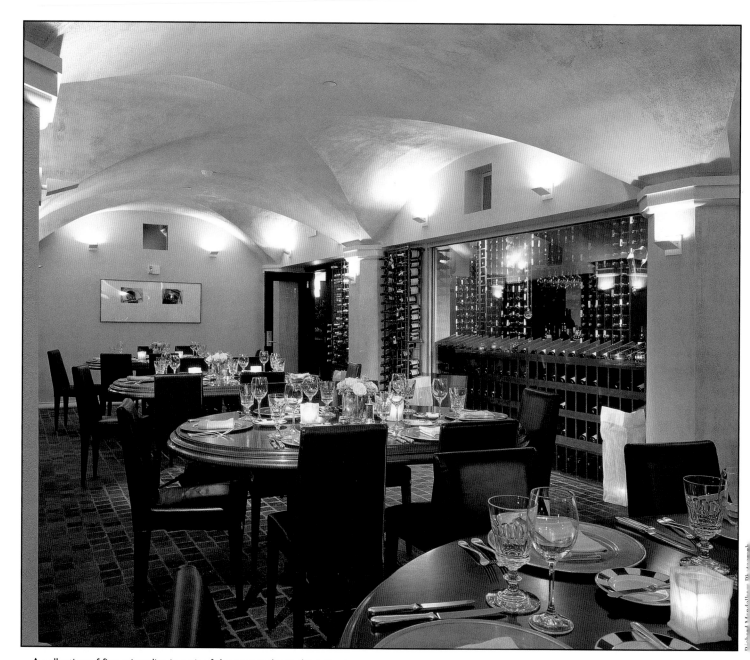

A collection of fine wines lies in wait of the next order in this intimate, vaulted space. *Courtesy of Fifteen Beacon*

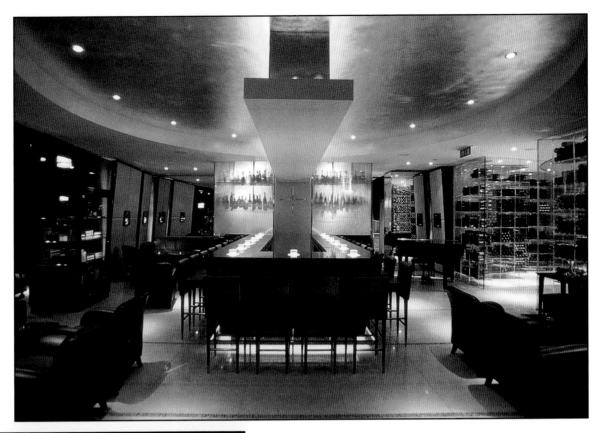

The bar itself captures immediate attention in this design by Adam Tihany. The bar staff enter a catwalk from behind a glass-back wall, flanked on either side by high bar stools. The furnishings include a diverse mix of textures to ensure a residential feel – leather armchairs and mohair complemented by marble finishes, glass, mirrors, and wood. The beige silk walls include a series of showcases displaying individually crafted cocktail accessories.
Courtesy of Mandarin Oriental Hyde Park

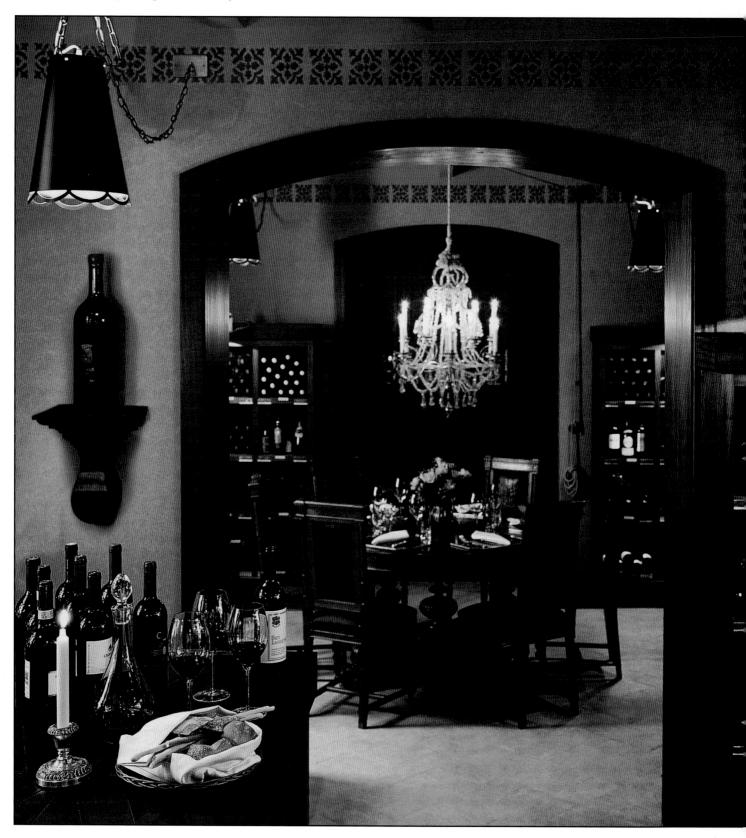

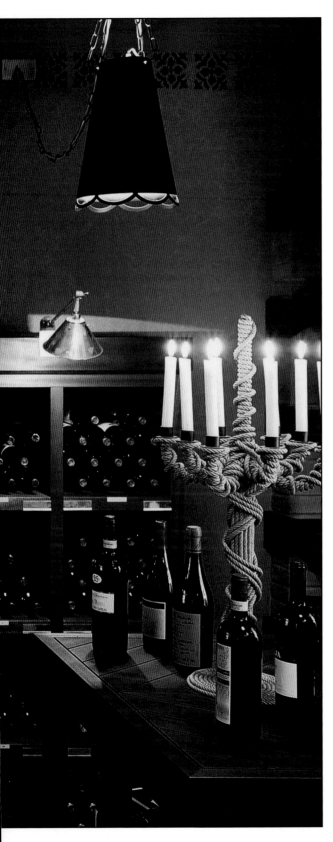

A fully-stocked wine cellar hosts intimate gatherings amidst more than a thousand bottles, predominately of Italian origin. Courtesy of Grand Hotel a Villa Feltrinelli

The Westin Hotel Library | Providence, Rhode Island

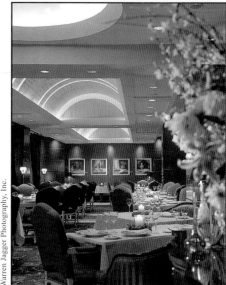

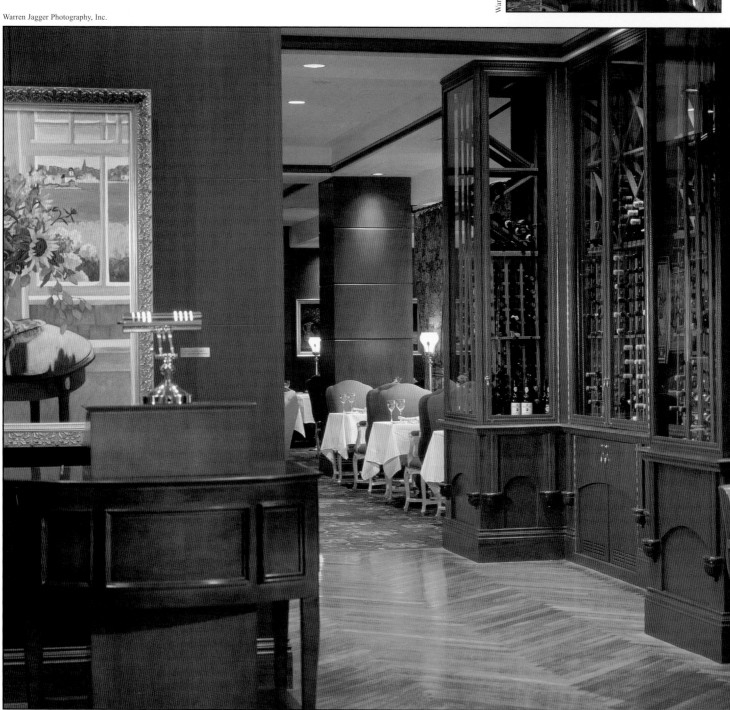

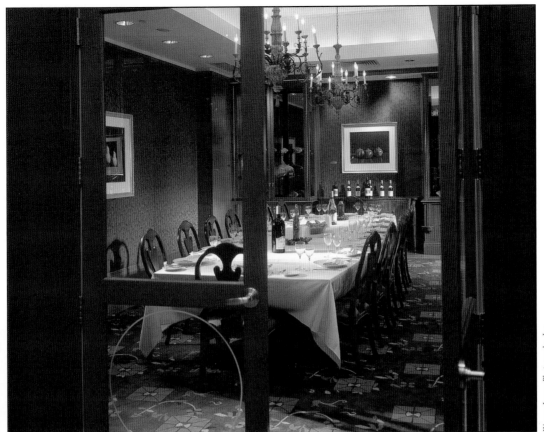

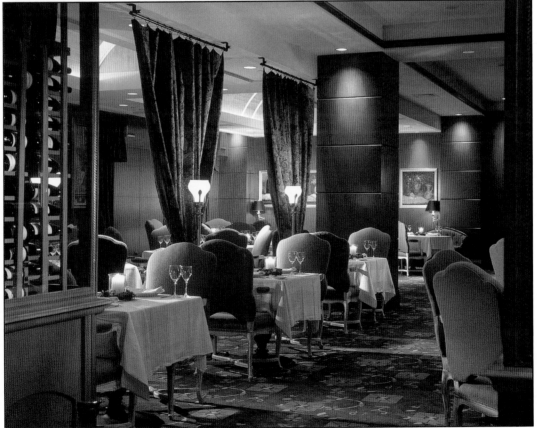

A parquet floor provides entry, past a towering wine rack with a glimpse of a private dining room. The dining room beyond is rich with domed ceilings, warm wood paneling, and original still-life artwork. *Courtesy of Di Leonardo International, Inc.*

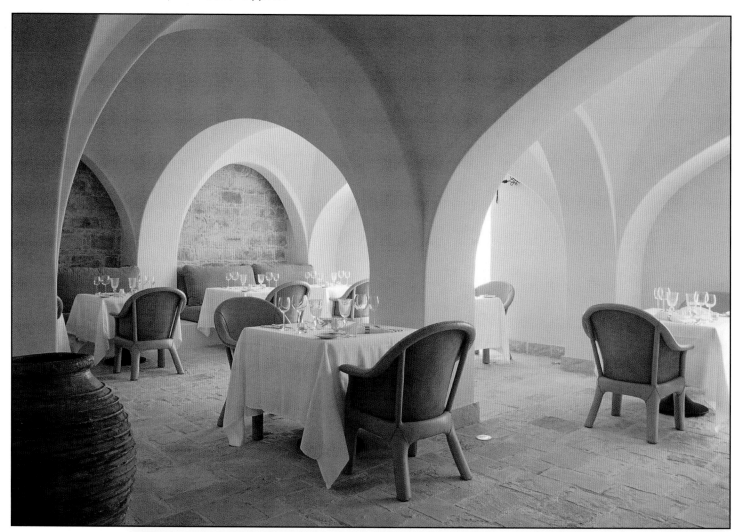

An unforgettable
dining experience
beckons beneath
vaulted stone ceilings
and exposed stone
floors and walls. A
romantic escape is as
near as ocean breezes
in a shroud of filmy
mosquito netting.
*Courtesy of Anassa
Resort*

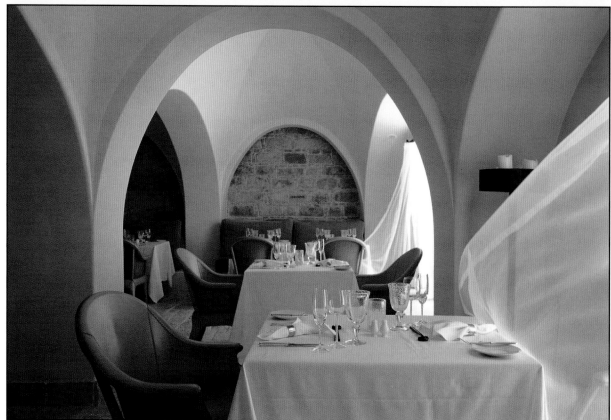

Men's Lounge | The Lodge at Sea Island Golf Club | Georgia

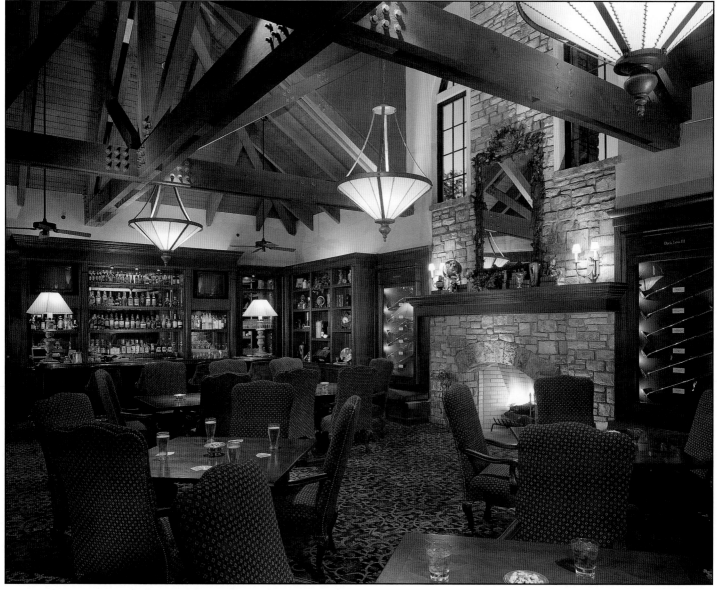

© Rion Rizzo, Creative Sources, Atlanta

The walls are lined with spirits, while open ceiling trusses allow spirits
to soar in a room dedicated to unwinding after a good round of golf.
Courtesy of Cole Martinez Curtis and Associates

Libraries/Private Dens

The Library Bar | Dallas

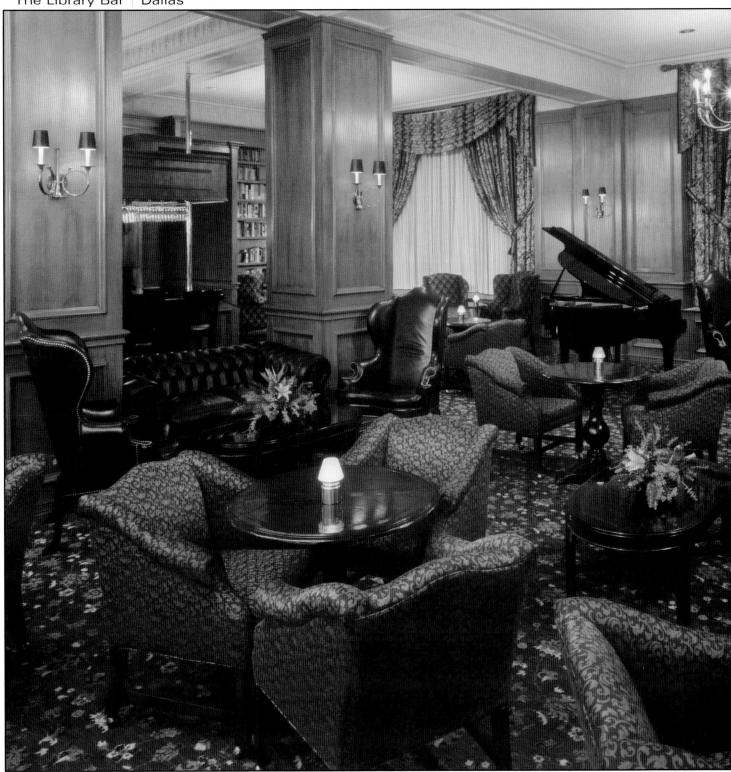

Named by the Wall Street Journal as one of the nation's top spots to "sip and sup," The Library Bar is consistently voted the most popular piano and conversation bar in Dallas. *Courtesy of The Melrose Hotel*

The Library Bar | Washington, D.C.

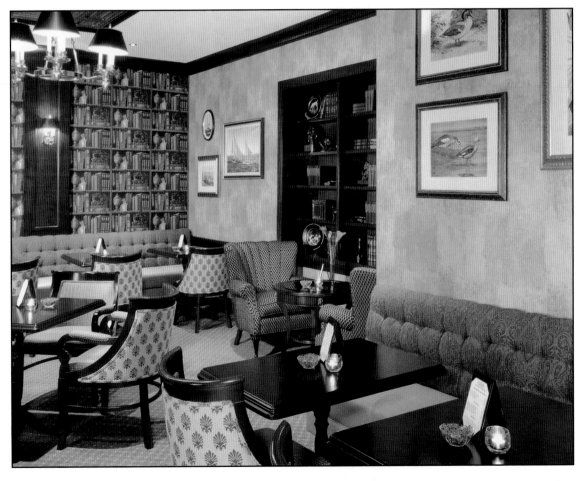

When they set out to create a brand new hotel, the design firm of BBGM was instructed to recreate the ambiance of the Library Bar in Dallas, Texas. What was needed was a piano area, dark, intimate seating along with a stand-up bar where people felt comfortable gathering to talk and watch the news. *Courtesy of The Melrose Hotel*

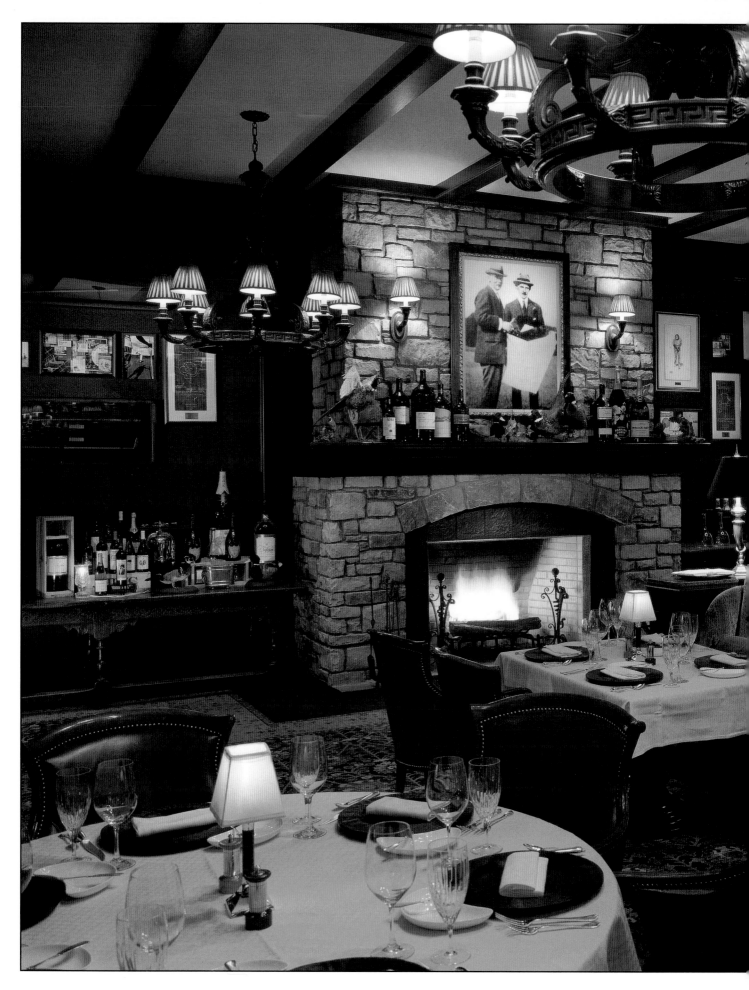

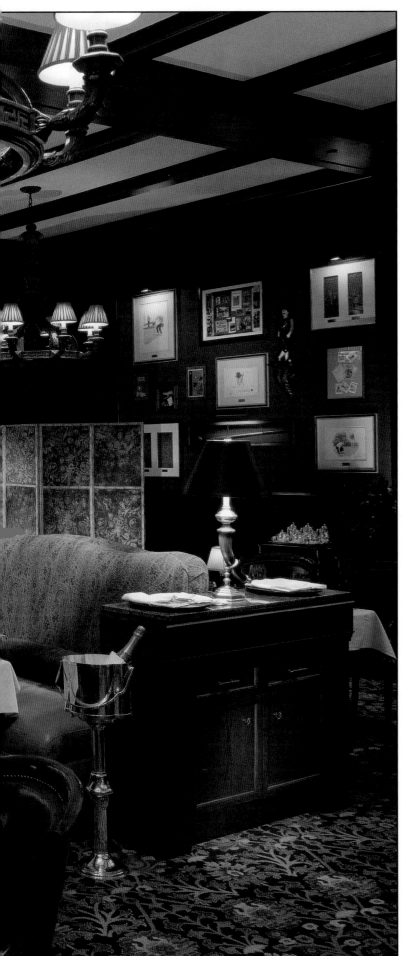

Artifacts from a collection of golf memorabilia are conversation
starters in a resort that draws guests first to the greens.
Courtesy of Cole Martinez Curtis and Associates

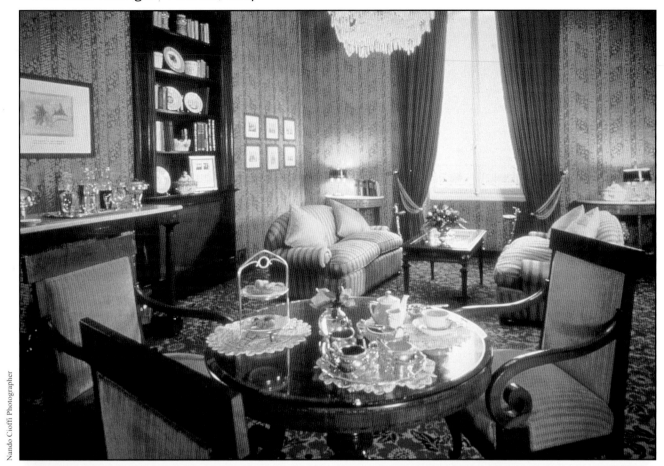

An elegant parlor atmosphere pervades this lounge area, where furnishings create zones within a larger context. *Courtesy of Hotel Regency*

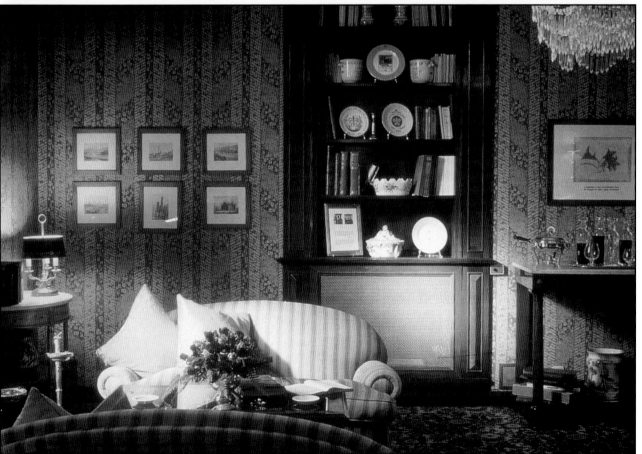

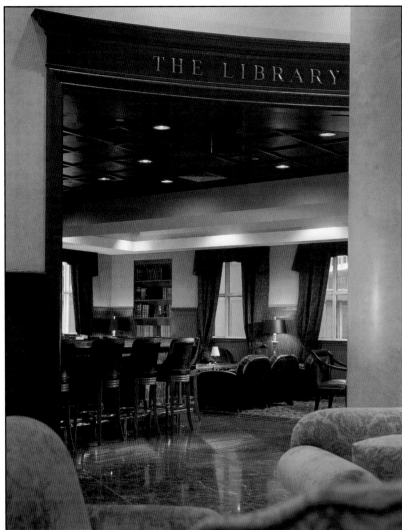

Foley's Restaurant & Bar |
The Renaissance Hotel | New York City

A studious atmosphere becomes this picture-perfect "library," with wood paneling, leather bound books and chairs, and a series of studied portraits in gilded frames. *Courtesy of Di Leonardo International, Inc.*

Warren Jagger Photography, Inc.

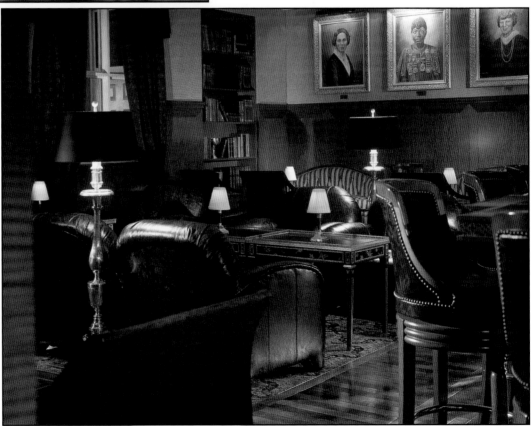

Warren Jagger Photography, Inc.

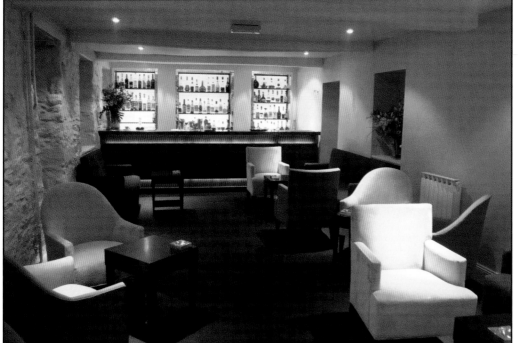

Stephen Hyde at London Photography

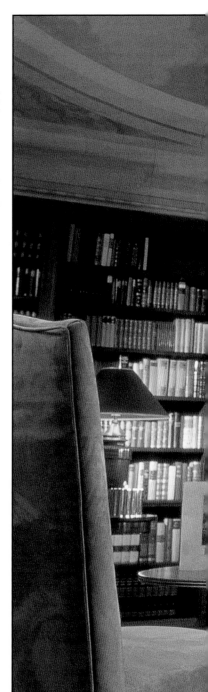

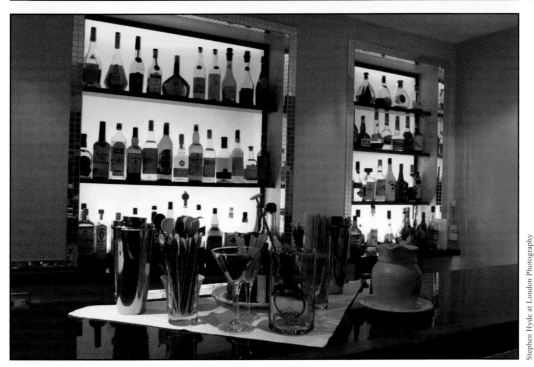

Stephen Hyde at London Photography

Backlighting highlights the merchandise and casts a warm glow over an intimate lounge area. Stucco adds texture and an atmosphere of age to the contemporary surroundings. *Courtesy of Portfolio Design International*

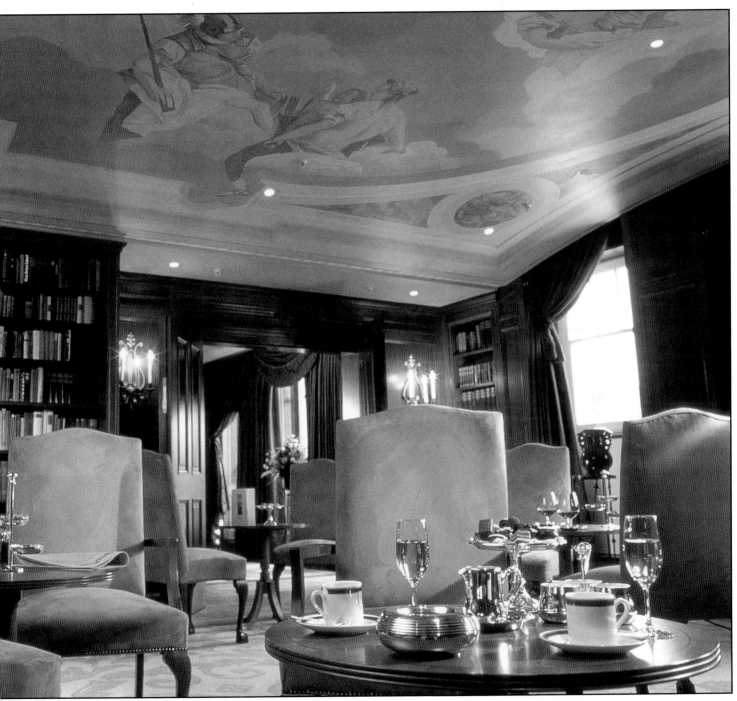

Leather-bound books and high-backed chairs add classic formality to a library designed for private conference or quiet reflection. Overlooking all is a ceiling mural in the style of Ticpolo by Paul Treasure. *Courtesy of Hotel Adlon, Berlin*

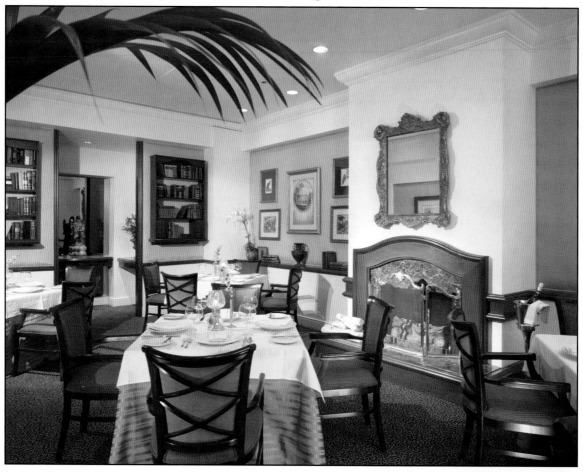

Fine dining atmosphere features a mahogany and etched glass entry architrave, an edge-lit decorative glass panel, soft gold upholstered wall fabric, beveled mirror walls, and patterned carpeting. *Courtesy of Carl Ross Design, Inc.*

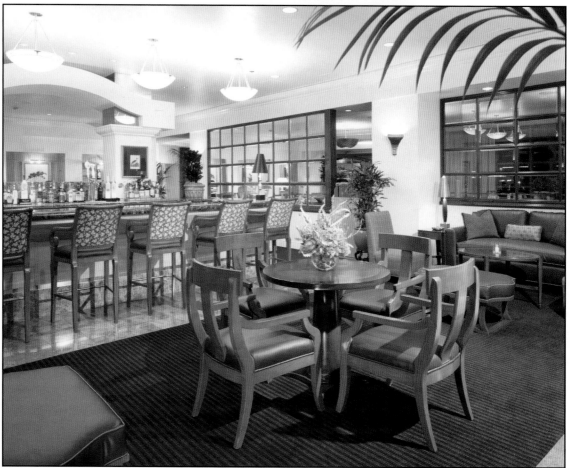

Photography by Philip Nilsson

Zonal

A drop ceiling adds texture and shape, its curve in contrast to the more angular bar below. *Courtesy of Adache Group Architects, Inc.*

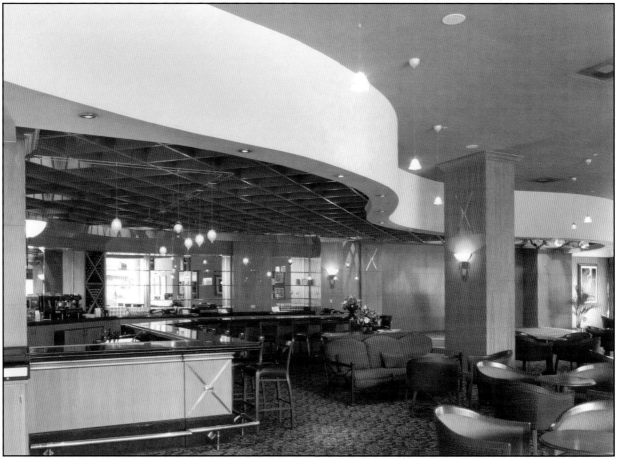

Lobby-Bar | Hotel Adlon | Berlin

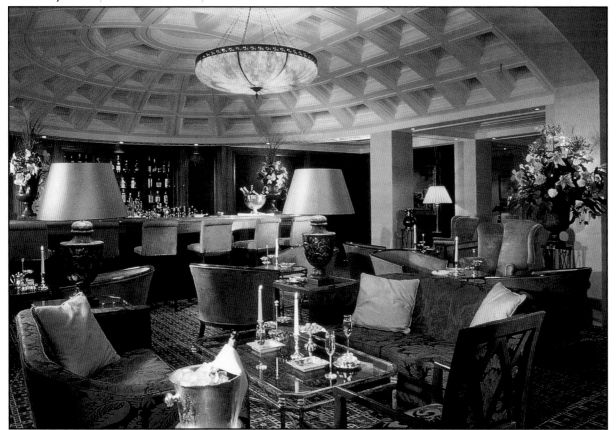

Mixed seating provides zones of homey comfort and intimacy in a lounge area. Intricate layers of molding create a waffled dome ceiling. *Courtesy of Hotel Adlon, Berlin*

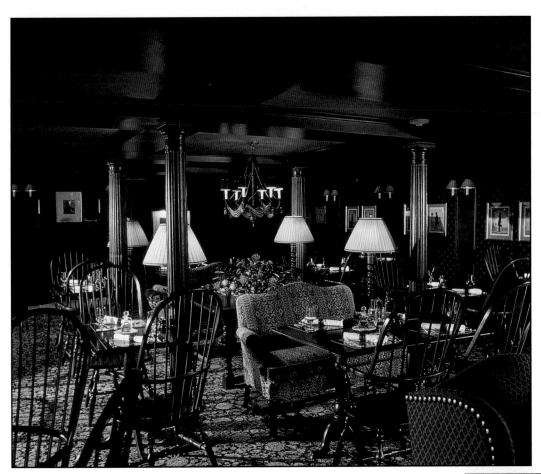

An original tavern was incorporated into a resort, and now serves as a place to enjoy fine spirits and regional cuisine. *Courtesy of The Equinox*

Enjoying the elegance of a former patrician villa, this elegant lobby lounge harbors nooks for quick rendezvous or slowly savored cocktails. *Courtesy of Hotel Lord Byron*

Moreno Maggi Photographer

Lobby Lounge | Hotel Lord Byron | Rome

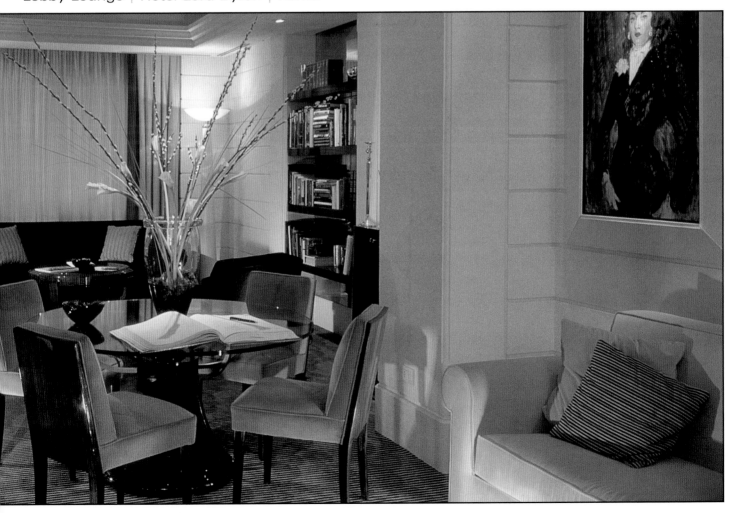

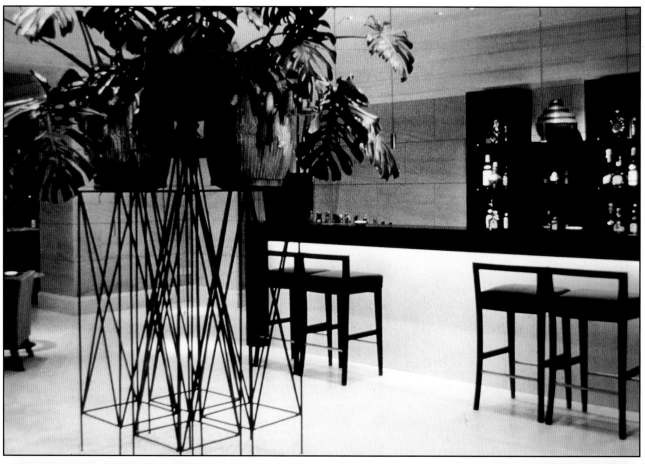

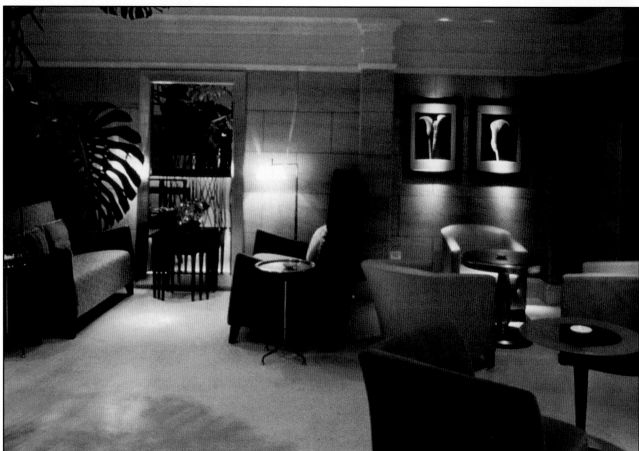

Rose Garden Bar & Lounge | Rome

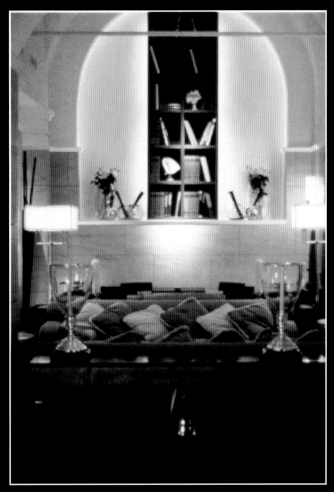

Massive marble block, soaring ceilings, and innovative lighting establish intimate zones within a powerful setting. *Courtesy of Empire Palace Hotel*

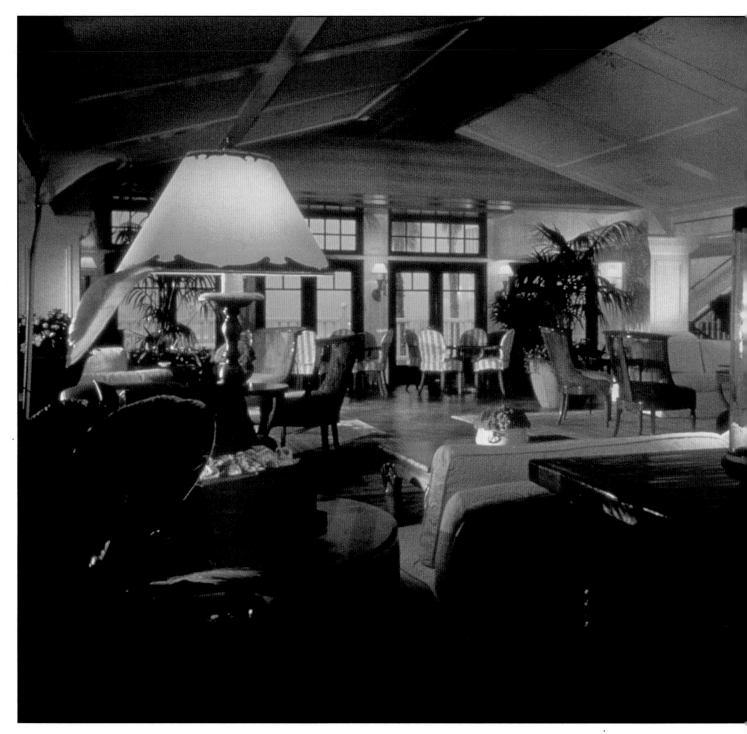

Inviting, residential-style seating allows for intimate gatherings with ocean views in the hotel lobby lounge.
Architecture by Hill Glazier Architects; interior design by Intradesign

explora Lobby Lounge | Santiago, Chile

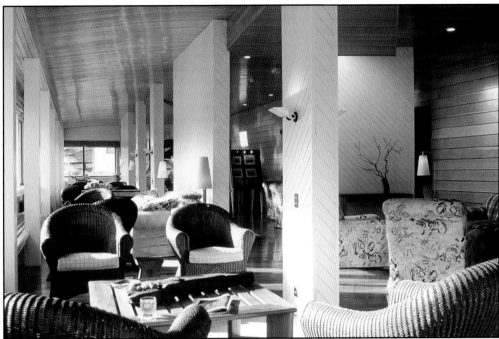

Conversations pits were created through the use of varied furnishings and bead-board dividers.
Courtesy of explora Hotel Salto Chico

Members Lounge | Valdoro Mountain Lodge | Breckenridge, Colorado

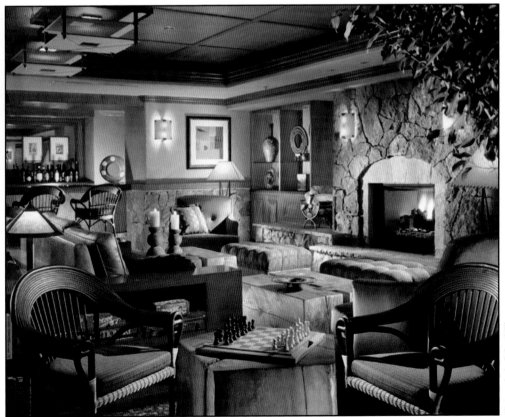

Dark woods mix with a massive stone fireplace for an aura of warmth. The stained millwork paneling was made using local Aspen veneer. The furnishings are upholstered in rich, textural fabrics and leathers to add contrast to the rough-sawn architectural details. *Courtesy of Carl Ross Design, Inc.*

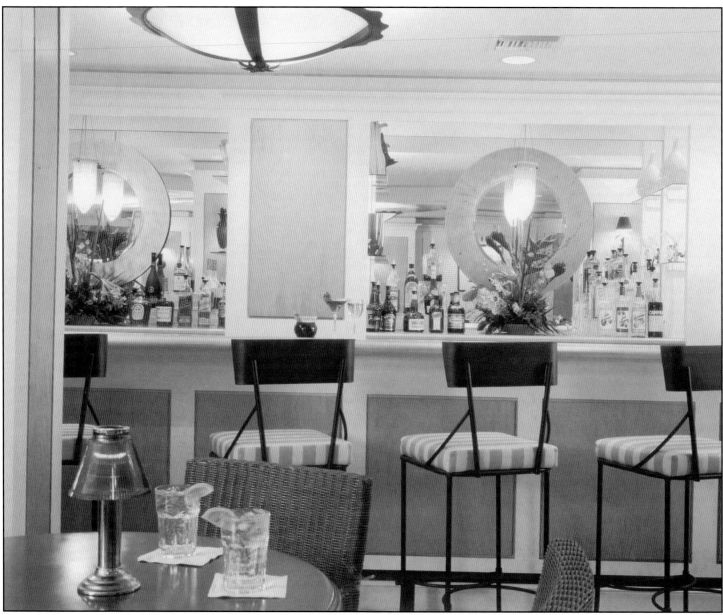

Whitney Cox Photography

A casual, ocean-front bar was designed with different zones where small groups can stake out a conversation pit and linger over cocktails. *Courtesy of R.D. Jones & Associates*

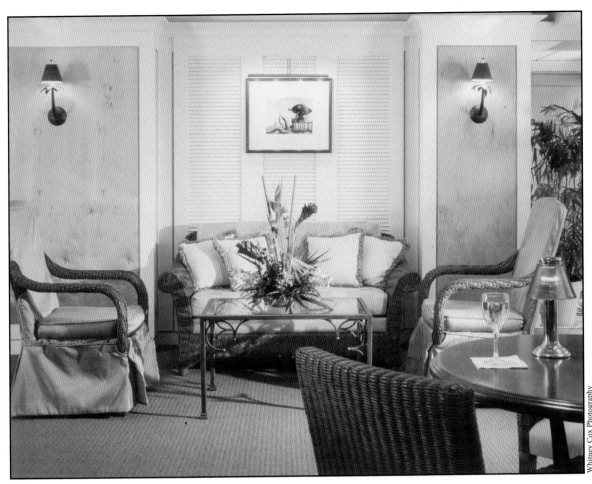

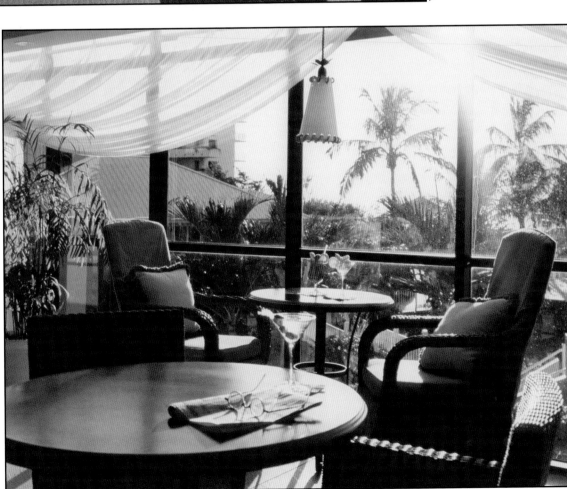

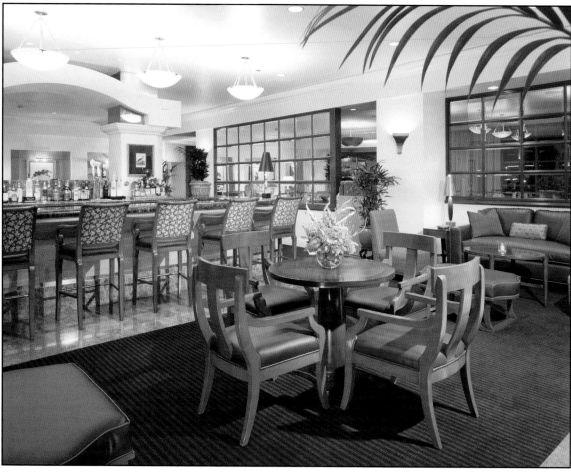

Eggplant-colored leather sofa seating groups, custom wood tables, and leather ottomans are reflected in beveled mirror millwork panels. *Courtesy of Carl Ross Design, Inc.*

Photography by Philip Nilsson

Rockwell | The Trafalgar | London

A long low bar invites patrons to select from a specialty offering of over 100 brands of Bourbon. Nearby, bright upholstery beckons drinkers to relax in a lobby/bar area decisively divided by a bold row of columns. *Courtesy of Harper Mackay Architects*

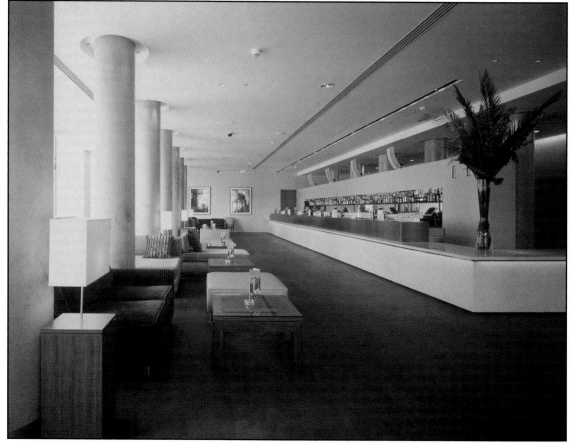

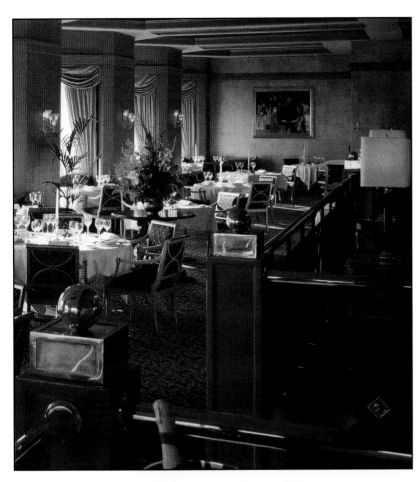

Bosphorus Restaurant | Bosphorus
Swissotel | Istanbul

A zig-zag wall creates extra window seats with a measure of privacy, a much appreciated patron benefit. *Courtesy of Graham-Kim International, Inc.*

Lobby Lounge | The Westin Waltham | Boston

A seemingly casual assortment of unmatched living room and tea sets is an artful arrangement for creating private rendezvous points. *Courtesy of Graham-Kim International, Inc.*

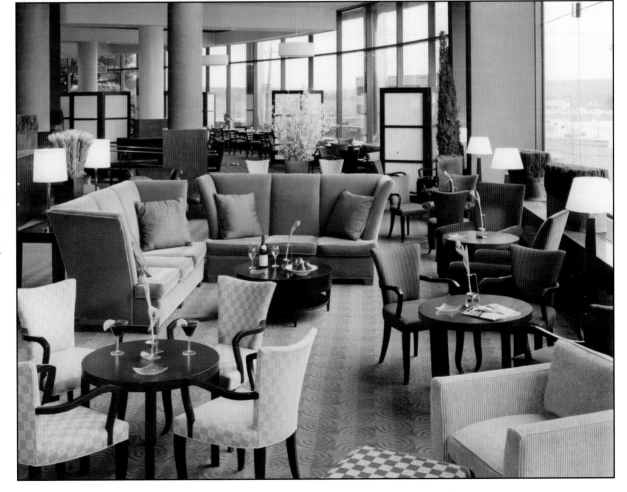

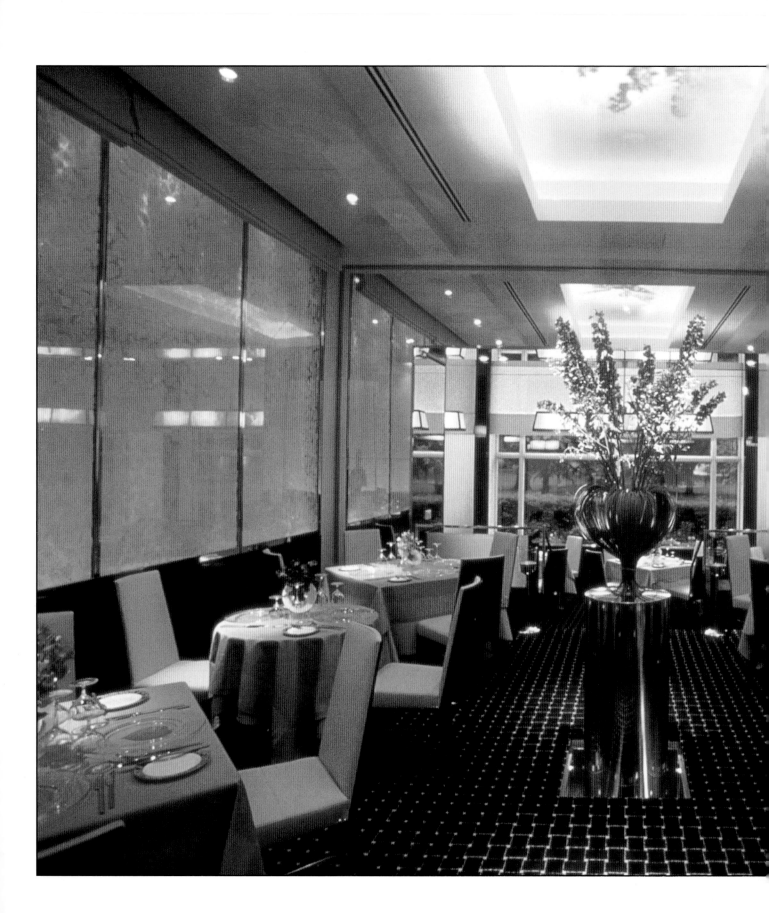

Designer Adam Tihany teamed up with chef David Nicholls to design this dining space, set on a raised floor to command spectacular views of Hyde Park. A leaf theme was employed throughout, from freshly picked leaves displayed under glass dinner plates to a life-size photograph of a tree on one wall. *Courtesy of Mandarin Oriental Hyde Park*

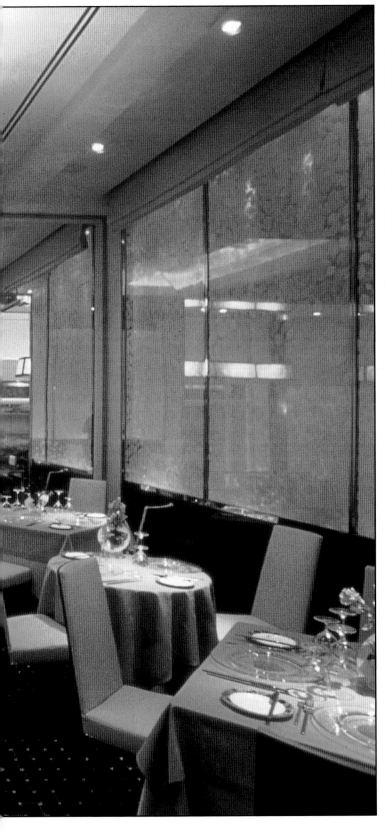

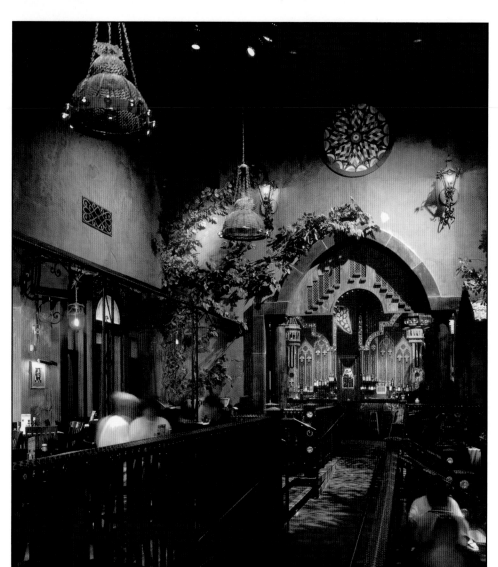

Napoleon Patio | Las Vegas

Eating can be a sacred experience, and here one sits just outside a chapel complete with a shrine where you can belly up to the wet bar. *Courtesy of House of Blues*

Robinson Crusoe Pub | Hilton Resort | Tobago, West Indies

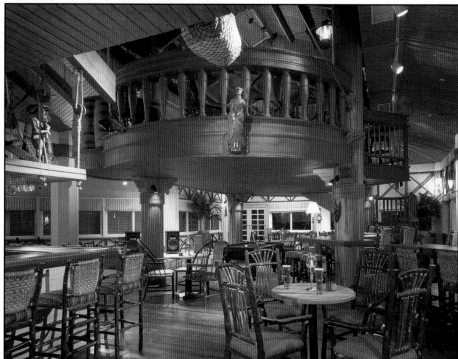

Natural carved wood furnishings, planked ceilings with circular balcony, and nautical netting and roping adds seaside charm to the Robinson Crusoe Pub. *Courtesy of Carl Ross Designs, Inc.*

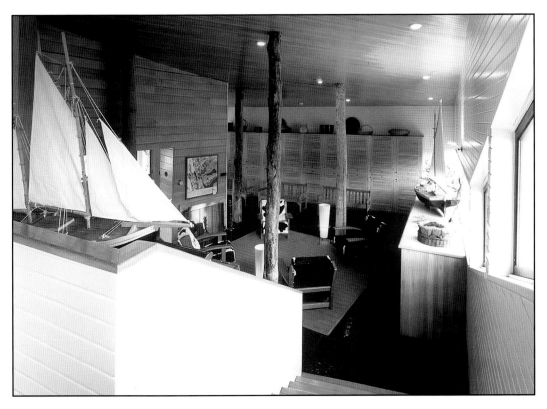

Explora Bar | Santiago, Chile

Local themes and materials were incorporated for this open gathering space, including a nautical theme reflecting the nearby lakes and a collection of pottery and basketry by natives. *Courtesy of explora Hotel Salto Chico*

A checkerboard floor and half wall establish the wood-rich color scheme for a casual, open bar area. *Courtesy of The Ransley Group*

Looking Glass Bar | De Vere Daresbury Park | Daresbury, UK

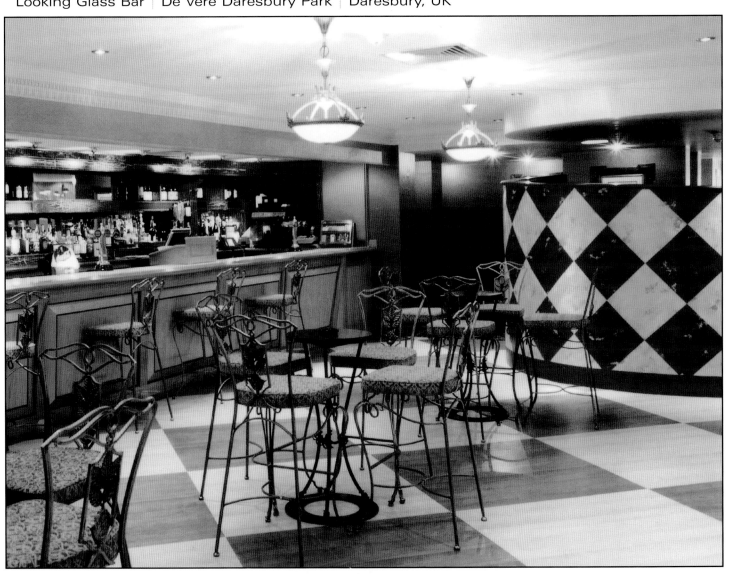

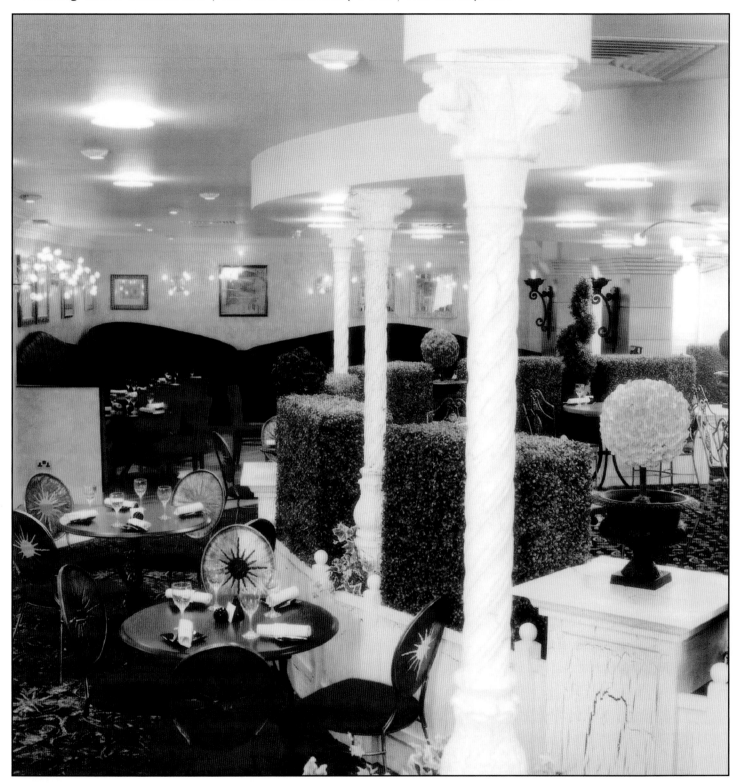

The interior designers were inspired by the fantasy world of home-towner Lewis Carroll when they created this garden-themed dining space. *Courtesy of The Ransley Group*

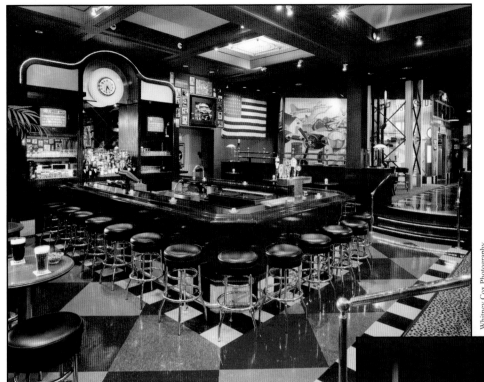

Rickenbacker's | Sheraton |
Colorado Springs, Colorado

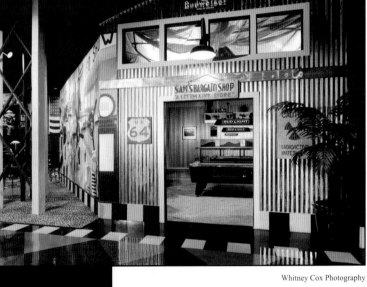

The nightclub was conceived with four different "energy zones," using a retro-American motif throughout the renovation project. *Courtesy of R.D. Jones & Associates*

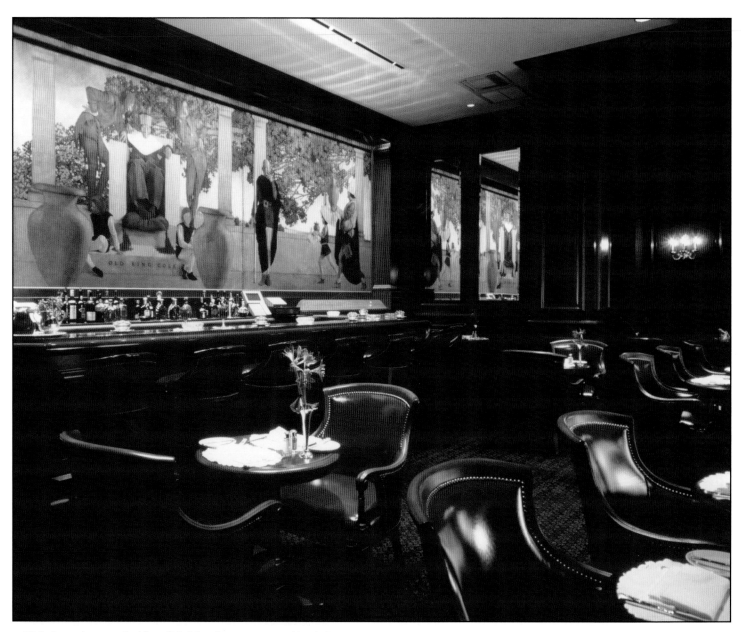

High drama is created with well-lit fairytale scenes set amidst dark
paneling and leather. *Courtesy of Graham-Kim International, Inc.*

Regional/Ethnic

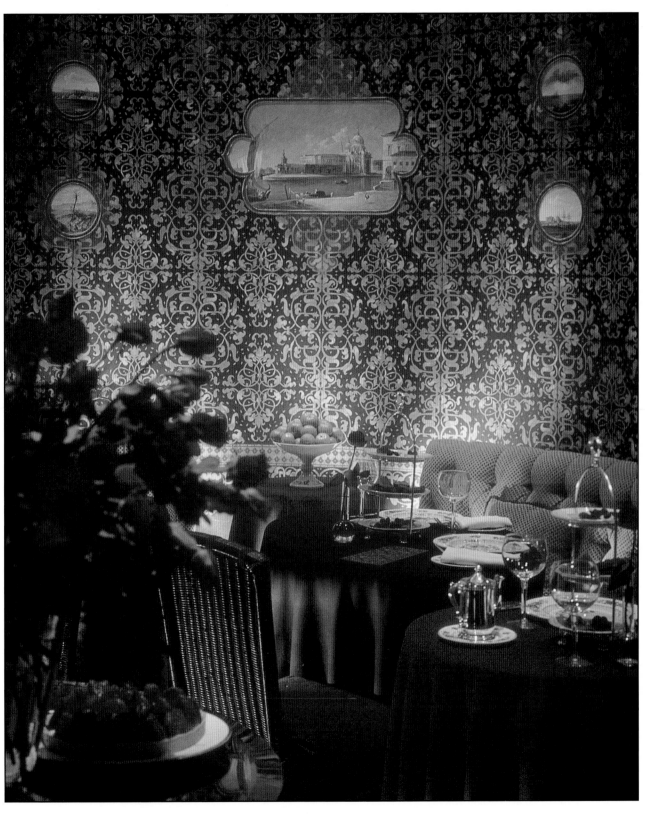

A mood of quiet elegance was conceived for the entryway to the Carlyle Restaurant, with a royal play of gold, purple, and scarlet upon linen, upholstery, velvet covered walls, and original artworks. *Courtesy of The Carlyle*

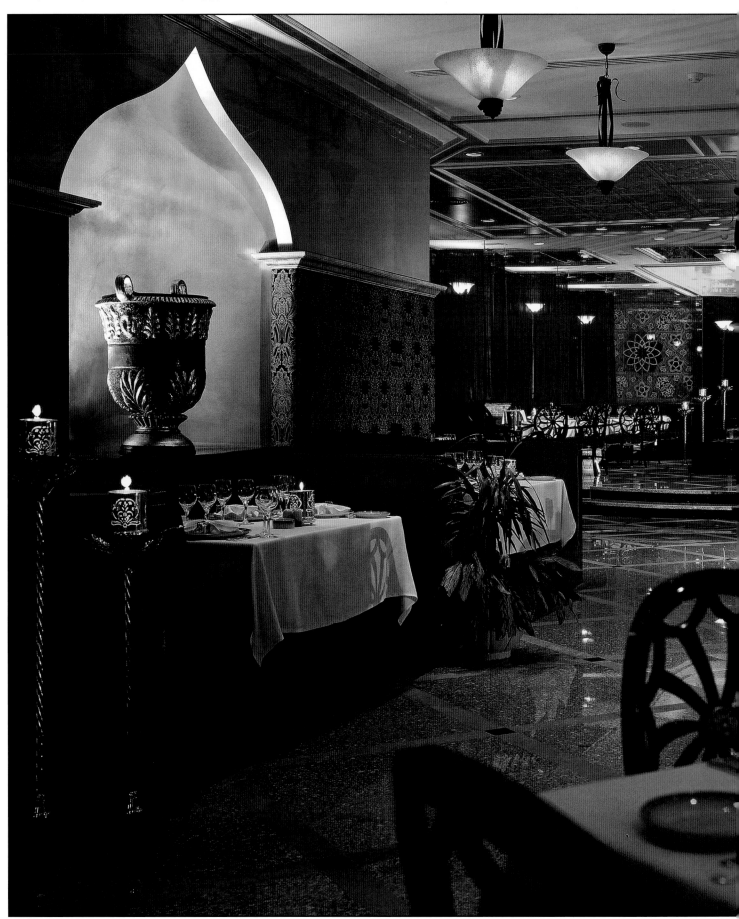

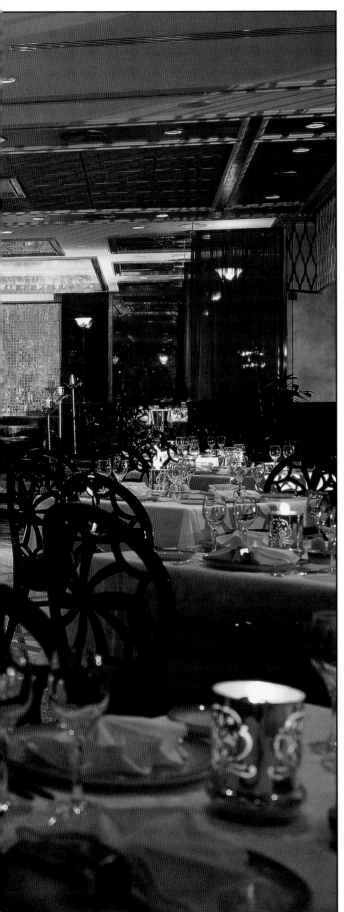

A showcase for regional Lebanese/Middle Eastern Cuisine, this design reflects regional tastes, as well. Cozy booths, expansive aisles, and soft lighting create an atmosphere where guests linger to savor their Turkish coffee. Courtesy of DiLeonardo International, Inc.

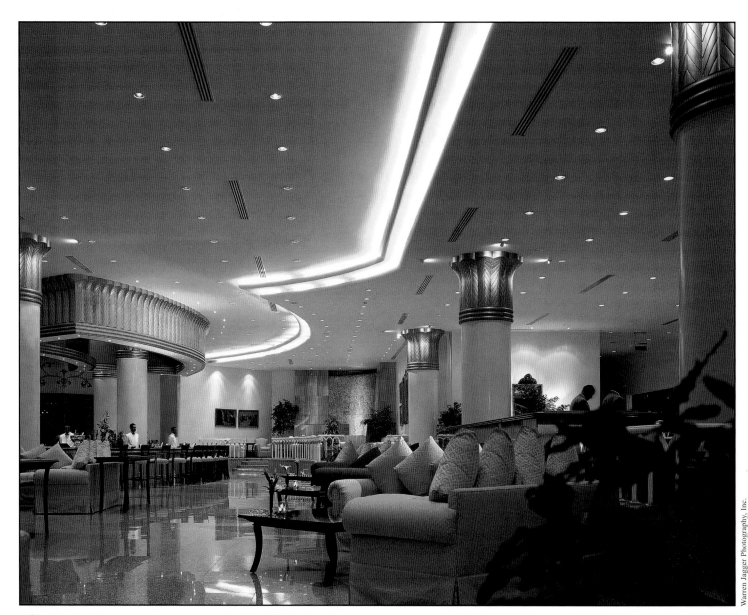

Size and grandeur create a first impression in a hotel lobby, waterfalls, lush foliage, and comfortable seating lure them back after they've settled into their rooms. Here afternoon tea, and an extensive menu of wines, beverages, and cigars are offered to guests. *Courtesy of DiLeonardo International, Inc.*

Warren Jagger Photography, Inc.

Tenet Grill | Temecula Creek Inn | Temecula, California

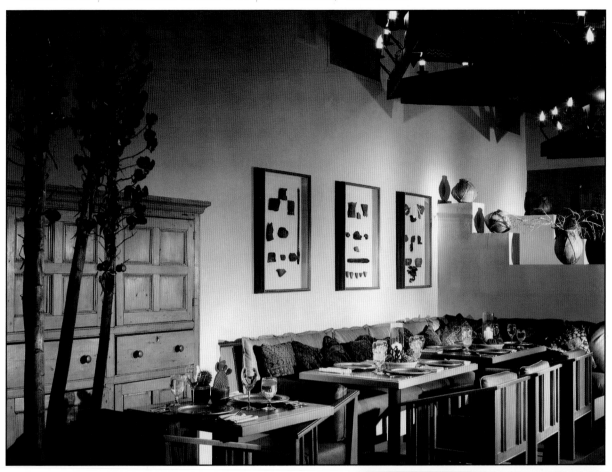

Indian artifacts, native pottery, dried native plants, and even a wildcat skin add atmosphere to a wine-country restaurant. *Courtesy of Edward Carson Beall and Assoc.*

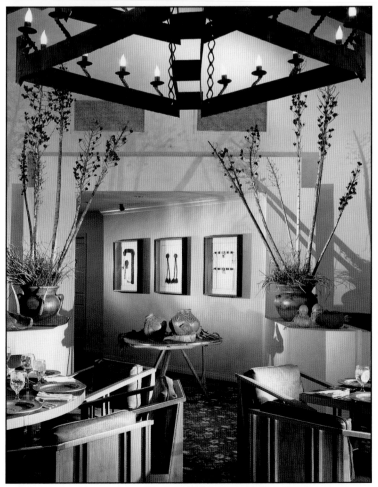

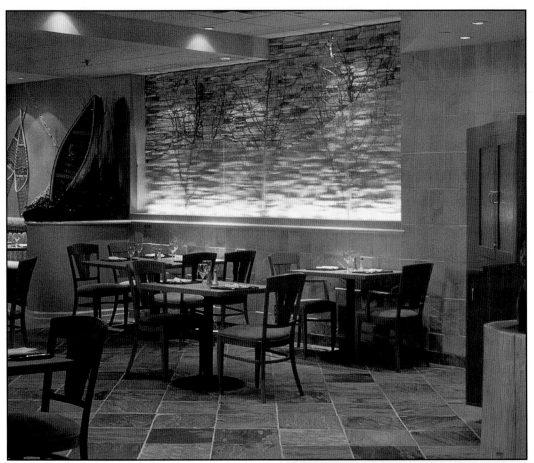

Interior Images/Richard Johnson

Canada's distinct heritage is reflected in a collection of canoes, snowshoes, and other artifacts, along with artful impressions, such as an abstract winter forest created with sculptural glass and birch branches, river rock murals, and slate flooring. A neutral color palette was used to support the naturalistic concept. In addition to the visual smorgasbord, patrons sample from a menu of Canadian food. *Courtesy of Hirschberg Design Group, Inc.*

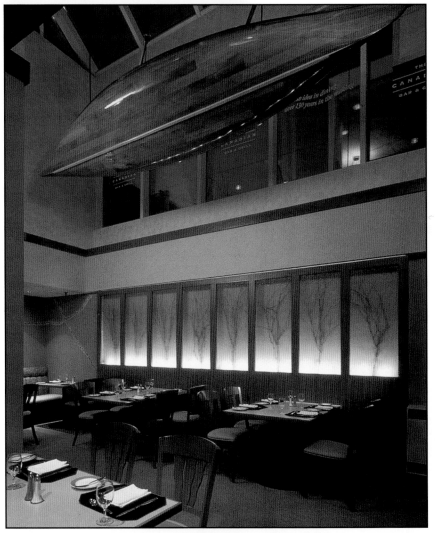

Interior Images/Richard Johnson

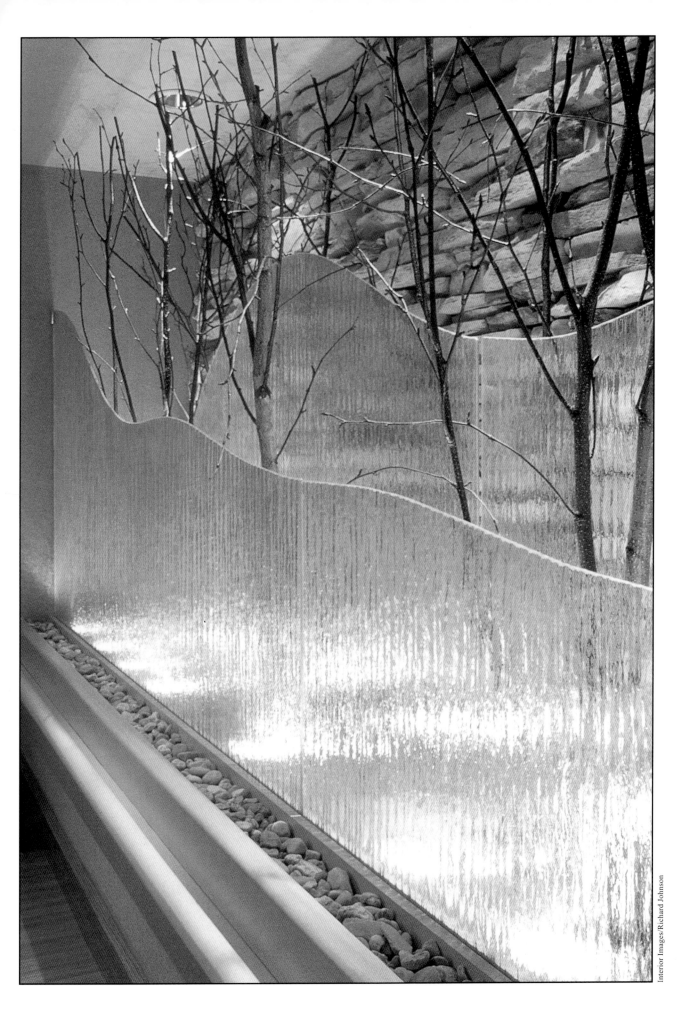

145

Ling and Javier | Houston, Texas

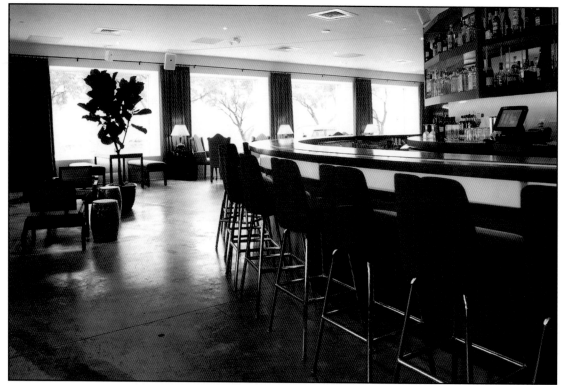

Overstuffed chairs invite guests to check out the street scene or, better perhaps, to be checked out by those on the street. *Courtesy of Hotel Derek*

Ka Yeung

Blue Ginger | Ritz Carlton | Egypt

The tastes, arts, and cultures of Asia — including Malaysia, Korea, China, Thailand, and Japan — were melded into this contemporary dining space. *Courtesy of DiLeonardo International, Inc.*

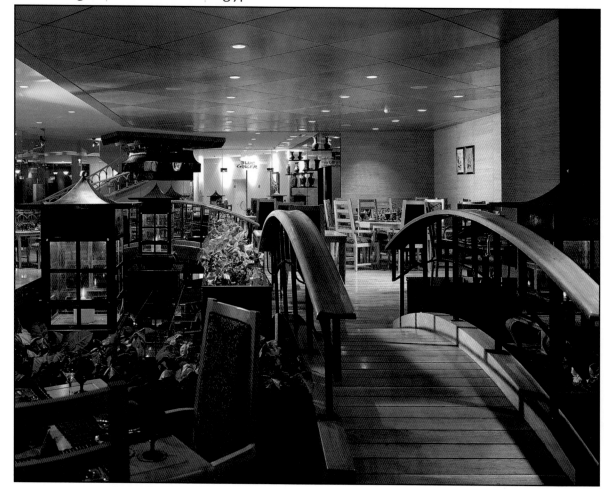

Warren Jagger Photography, Inc.

Dragon Palace Restaurant | Beijing

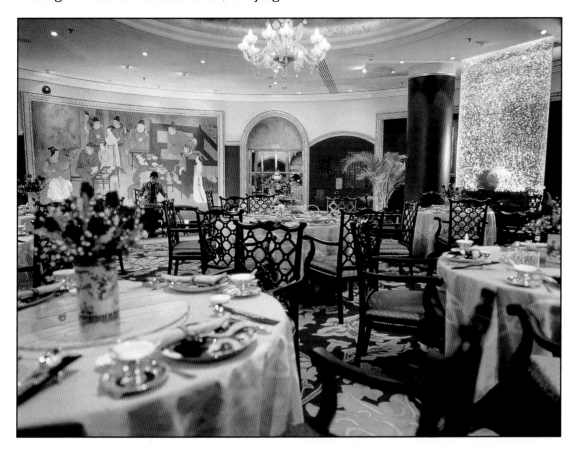

Traditional Chinese style is elegantly accomplished on home soil, with a rich palette of reds and gold and a palace-scene mural on one wall. *Courtesy of Kempinski Hotel, Beijing*

Honzen Restaurant | Beijing

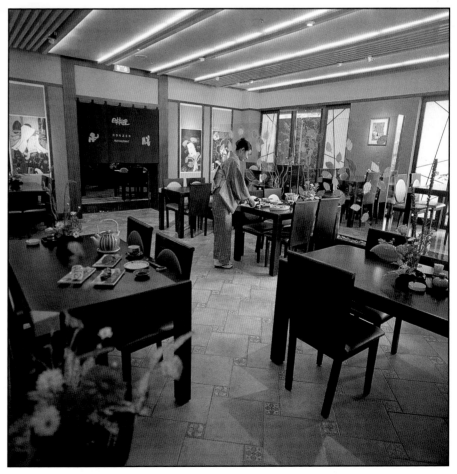

Moon-back chairs, glazed windows, and straight, clean lines lend to the atmosphere of this authentic Japanease restaurant. *Courtesy of Kempinski Hotel, Beijing*

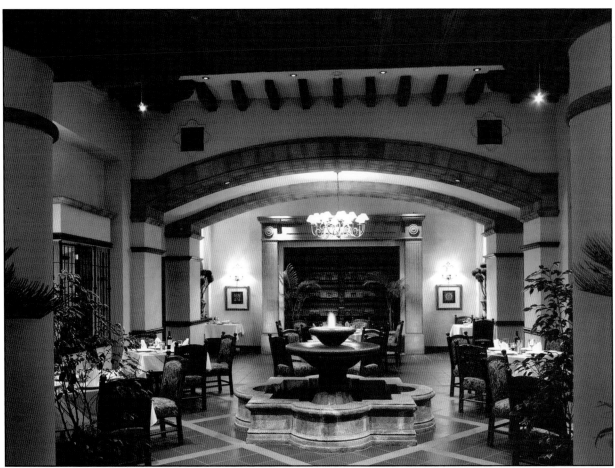

Exposed timbers, tile work, and a plaza-like fountain are in keeping with the local Spanish cultural influences. A private dining area follows with matching woodwork and complementary lighting. *Courtesy of Adache Group Architects, Inc.*

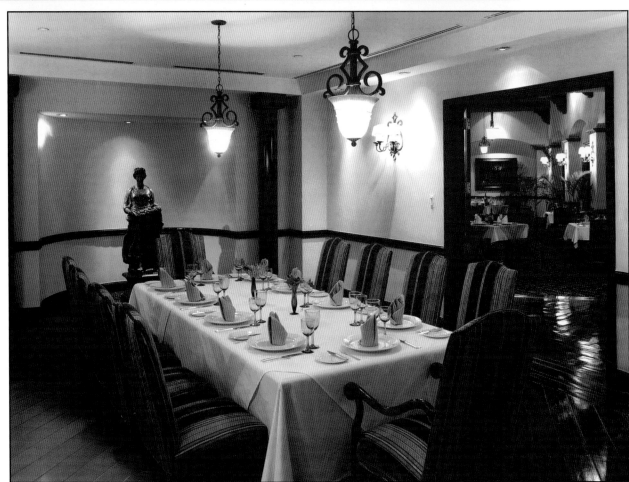

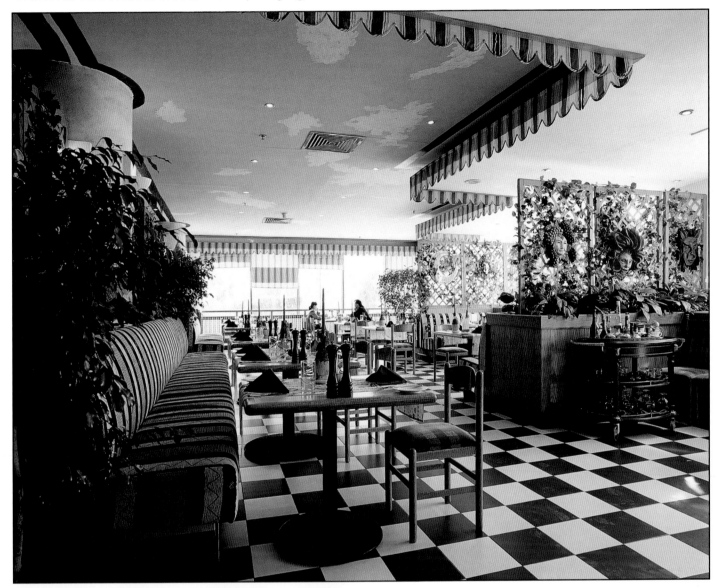

A drop ceiling opens on blue sky in a colorful evocation of an Italian Plaza.
Courtesy of Kempinski Hotel, Beijing

Lounge | Shangri-La | Bangkok

Red columns, gold leafing on ornate walls, and thematic accouterments signal that diners are in for an exotic feast. *Courtesy of Graham-Kim International, Inc.*

Eccentric

The Landmark Restaurant | Dallas

The Federalist | Boston

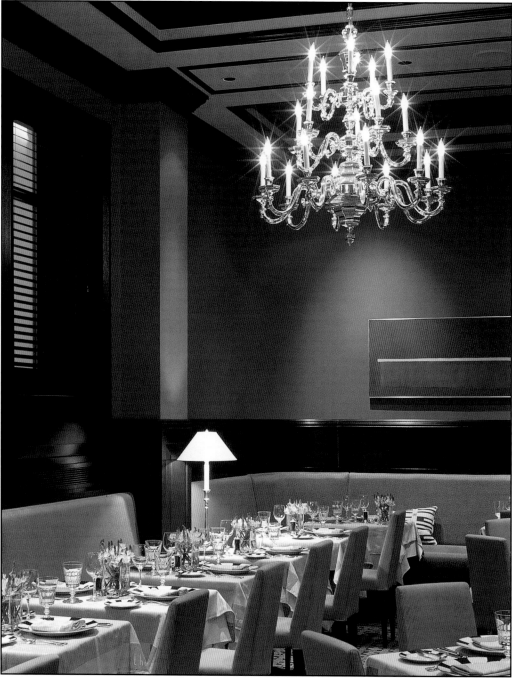

Richard Mandelkorn Photography

Classic mahogany molding is painted a sleek black and contrasted against a solid background of taupe for contemporary effect. A slash of red art adds an exclamation point. *Courtesy of Fifteen Beacon*

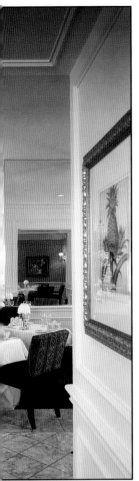

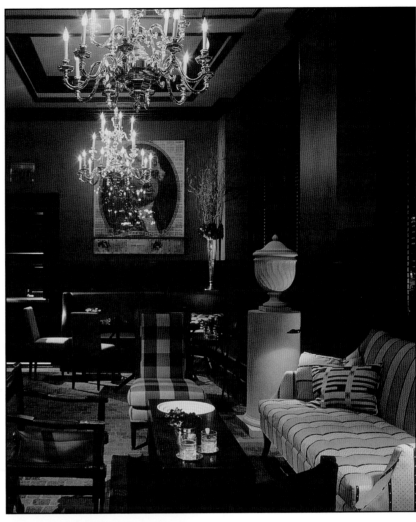

A palette of bright, sunny tones by the Duncan & Miller design firm, as well as excellent food and service, earned this restaurant a reputation as the place to go for power breakfasts in the Dallas area. *Courtesy of The Melrose Hotel*

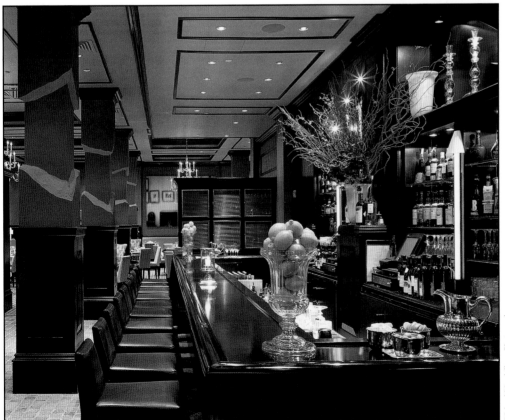

Masculine and classic, this bar and lounge area combines sleek, contemporary design with traces of a Colonial past in elaborate chandeliers, Federalist busts, and cut glass and silver tableware. *Courtesy of Fifteen Beacon*

Richard Mandelkorn Photography

151

Bar Quisi | Capri, Italy

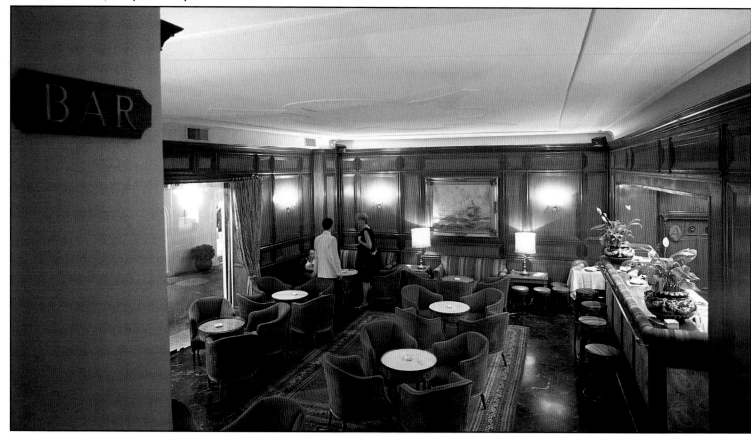

A traditional English bar provides a familiar refuge for
northern guests at a Mediterranean resort hotel.
Courtesy of Grand Hotel Quisisana

The Water Bar | Sydney, Australia

Mood lighting, and a mono-
chromatic blue and steel gray
palette focus on a central
circle in this engaging arena
for meeting new people while
unwinding with a drink.
Courtesy of W Sydney

Brellas Cafe | **Crowne Plaza Resort** | **Hilton Head, South Carolina**

Bright tile tabletops and striped window treatments add festive air to an open, casual eatery. *Courtesy of Fugleberg Koch Architects*

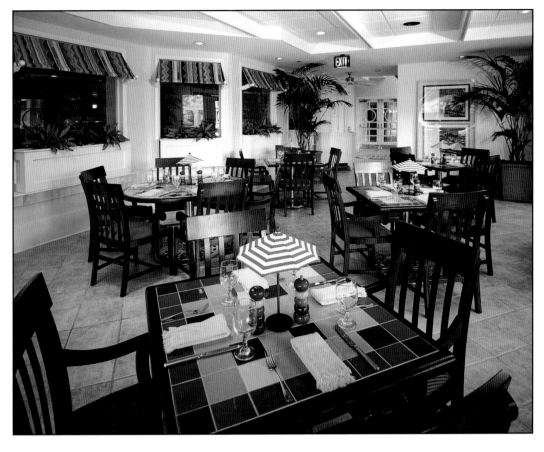

Cocktail Lounge | **Le Merigot** | **Santa Monica, California**

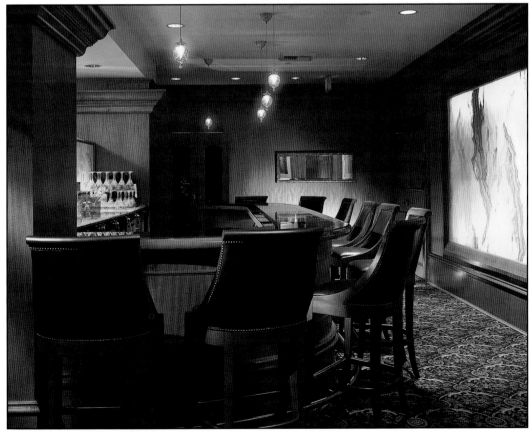

An intimate, wood-paneled gathering place basks in the glow of a rear-lit onyx installation. *Courtesy of DiLeonardo International, Inc.*

Warren Jagger Photography, Inc.

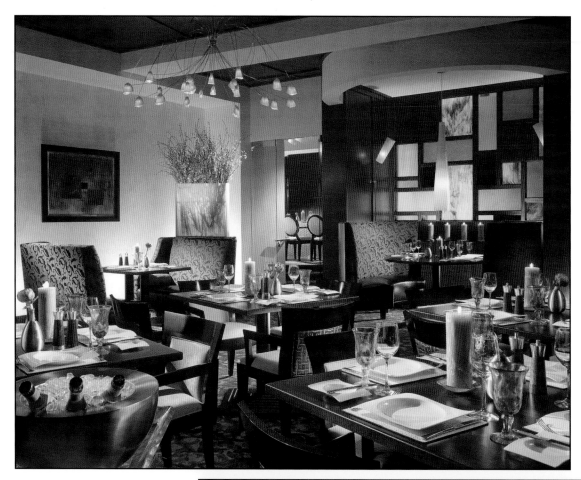

Incorporating creative lighting, vivid colors, and an intriguing bar/culinary station, this $3 million restaurant project brought new life to downtown Houston. The restaurant was designed to present three meals and after-hours entertainment to a sophisticated patronage. *Courtesy of Four Seasons Hotels and Resorts*

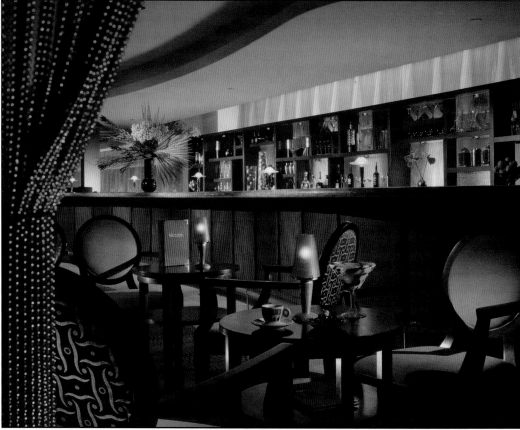

Le Neptune | Geneva

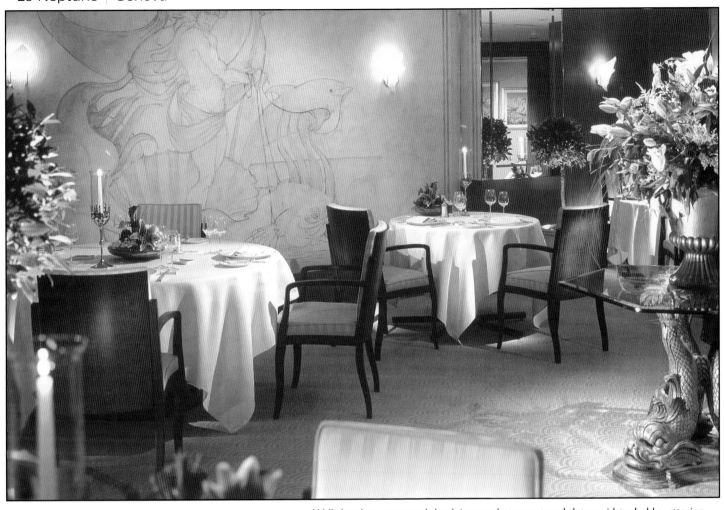

Wall sketches upon a subdued, ivory palette create subtlety amidst a bold spattering of rich red. *Courtesy of Mandarin Oriental Hotel Du Rhône*

Sports Bar | Royal Caribbean International's Radiance of the Seas

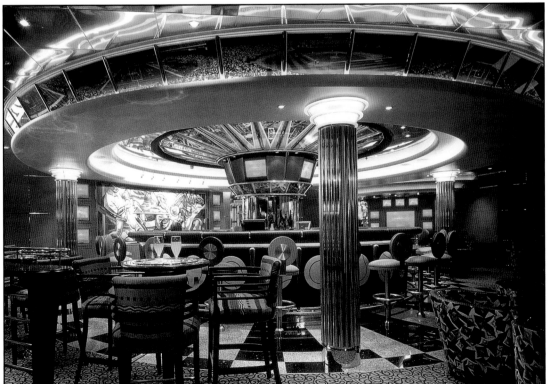

Space-age effects in a neon-lit canopy and gilded columns reflect colorful furnishings, combined for lively atmosphere. *Courtesy of RTKL*

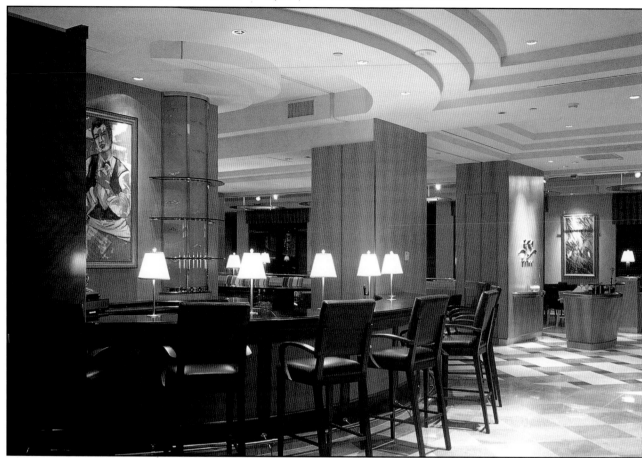

Neutral colors add texture to this seafood bar. *Courtesy of RTKL*

Nancy Robinson Watson Photography

Marriott's Harbor Beach Resort & Spa | Ft. Lauderdale, Florida

Bench seating and wide columns create comfortable zones within this expansive, casual dining room. *Courtesy of RTKL*

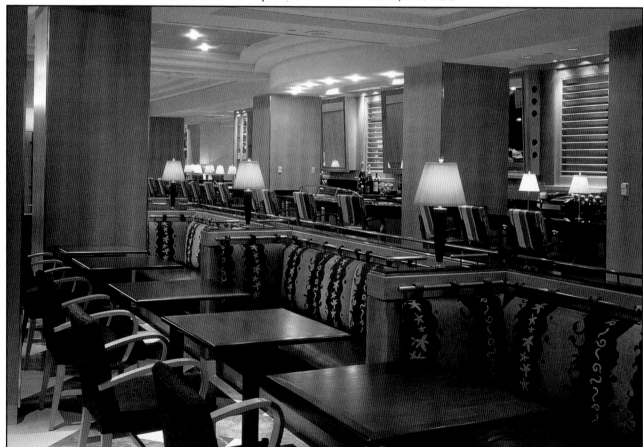

Roy Quesada Photography

Coral Reef Restaurant | Hilton Resort | Tobago, West Indies

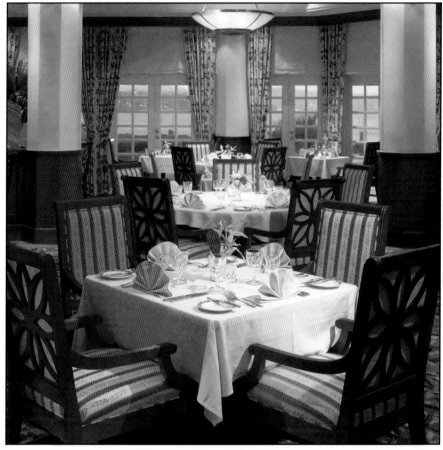

Elegant wood-frame chairs with classic olive branch upholstery allow guests to dine comfortably while focusing on the oceanic landscape just beyond a wall of beautiful French doors. *Courtesy of Carl Ross Design, Inc.*

Photography by Roland Bishop

Cézanne | Le Merigot | Santa Monica, California

Whimsical upholstered booths snuggle diners around round tables. Above, bold glass globes flame in expansive chandeliers. *Courtesy of DiLeonardo International, Inc.*

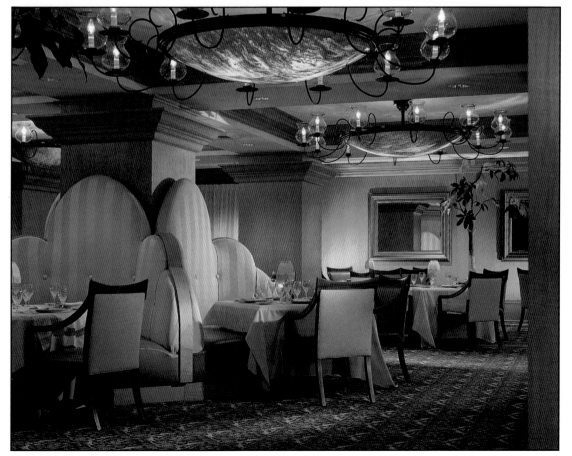

Warren Jagger Photography, Inc.

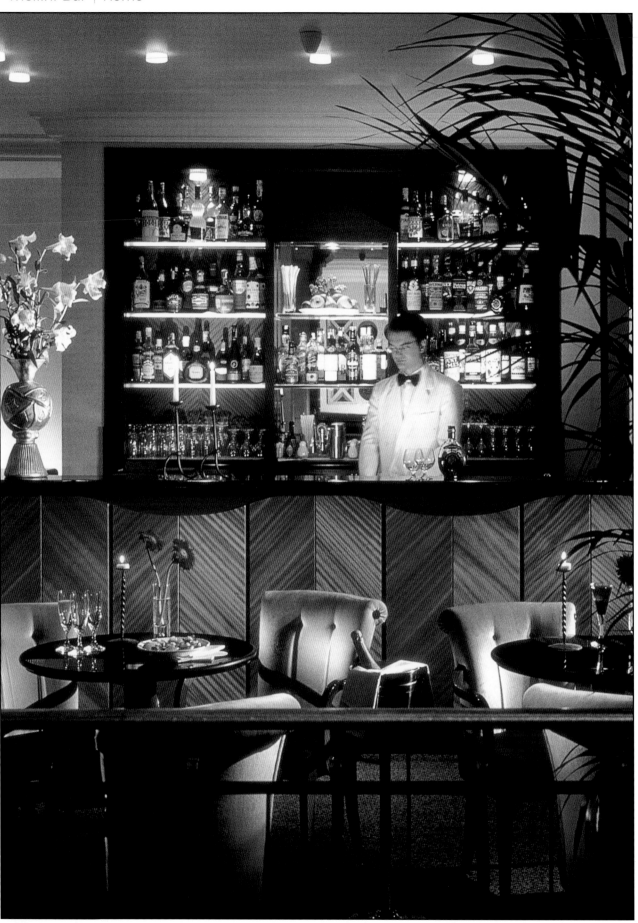

Rather than inviting gatherings at the serving counter, this bar provides a beautiful visual backdrop for the tables beyond. *Courtesy of Hotel dei Mellini*

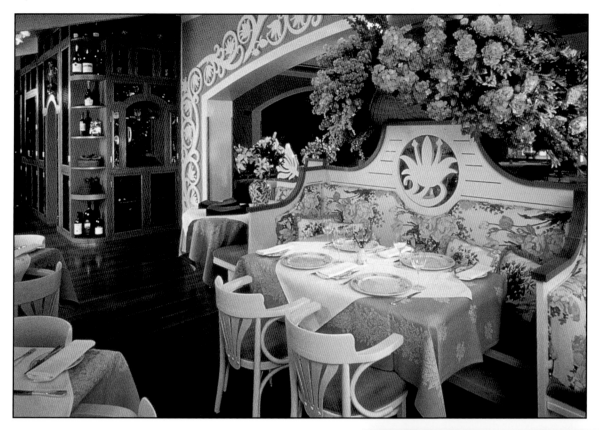

Wildflower Restaurant | Vail, Colorado

Fresh design, including hand-painted murals and ever-present flowers overflowing giant baskets complement a creative menu culled from the freshest ingredients available. *Courtesy of The Lodge at Vail*

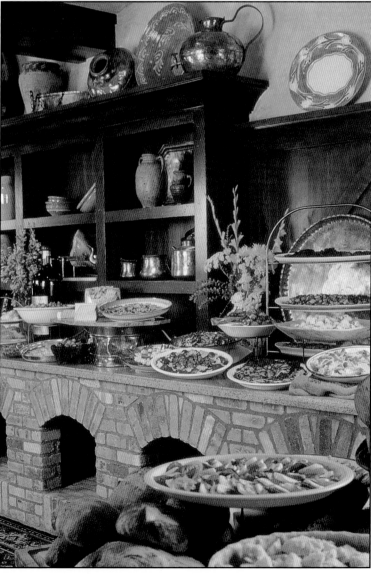

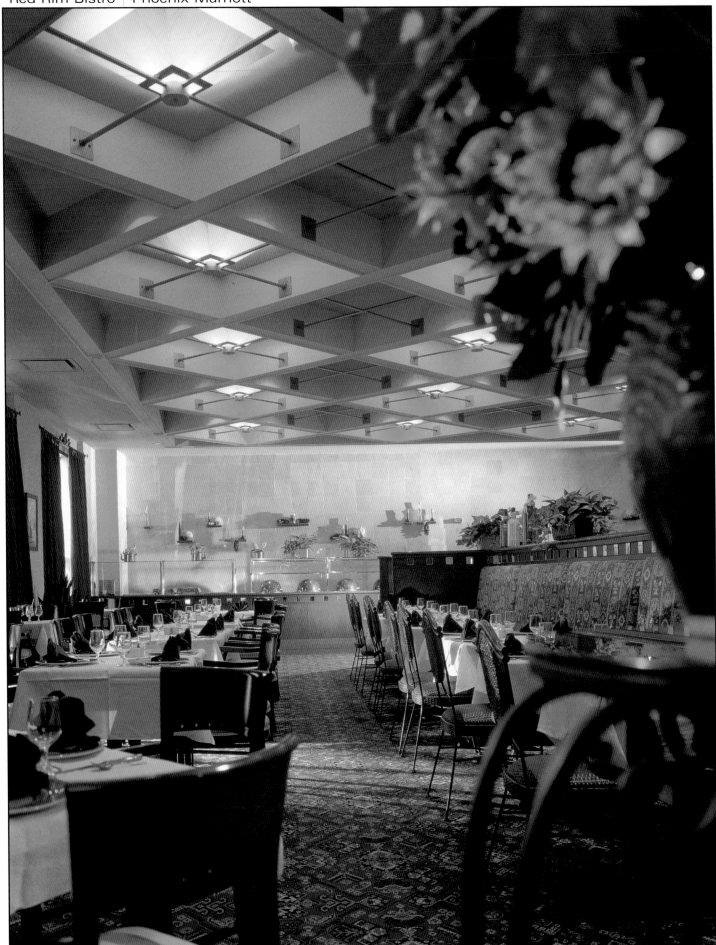

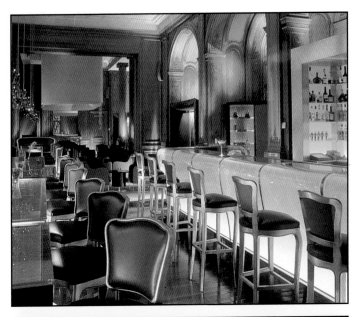

A frosted glass custom bar beckons patrons toward the light, where tenders whip up exotic "3-D Cocktail" creations for patrons. A separate seating area breaks into the future, superimposing silver screen-like images of old Paris over classic wood paneling to separate an ultra-modern seating area. *Courtesy of Hôtel Plaza Athénée*

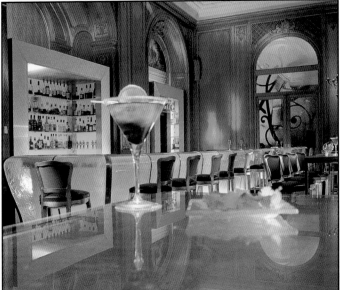

Opposite page: A unique and artful integration of recessed ceiling and lighting characterizes this restaurant. Upholstered bench seats buffer sightlines and temper the volume. *Courtesy of DiLeonardo International, Inc.*

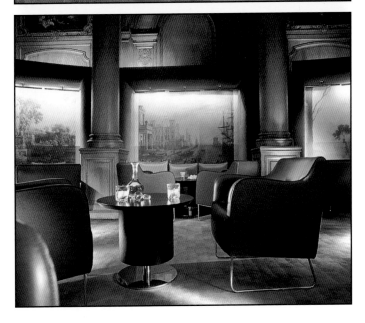

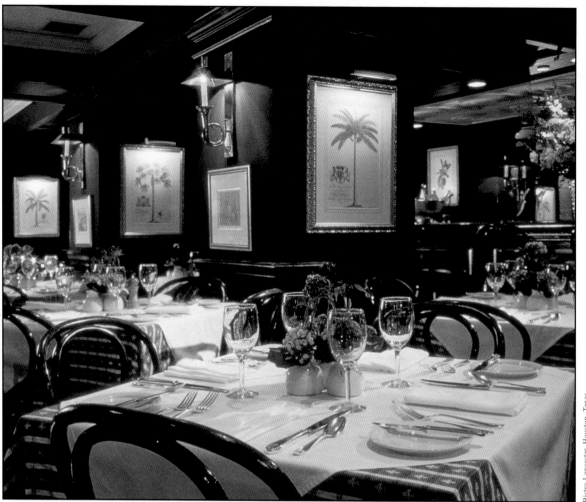

Dark, hunter green walls and overstuffed upholstered banquettes create an intimate, "clubby" English style bistro overlooking downtown Houston. *Courtesy of The Lancaster Hotel*

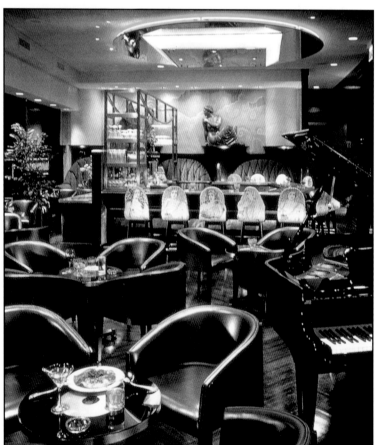

Bistro Lancaster
Houston, Texas

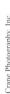

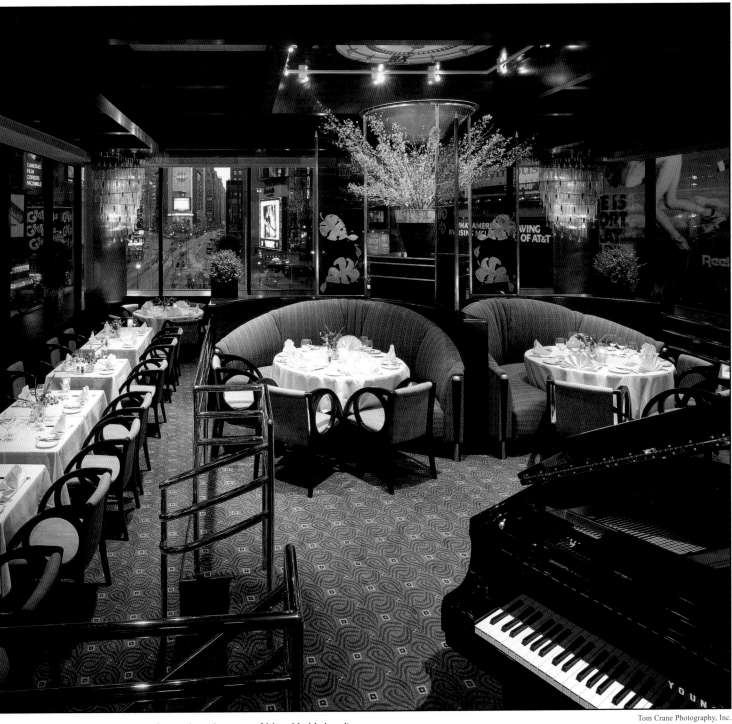

A three-sided dining area is focused on the view of New York's bustling Times Square. Beyond, Greek sirens beckon patrons to the bar, where they grace the molded barstools and overlook casual seating around the piano. *Courtesy of Di Leonardo International, Inc.*

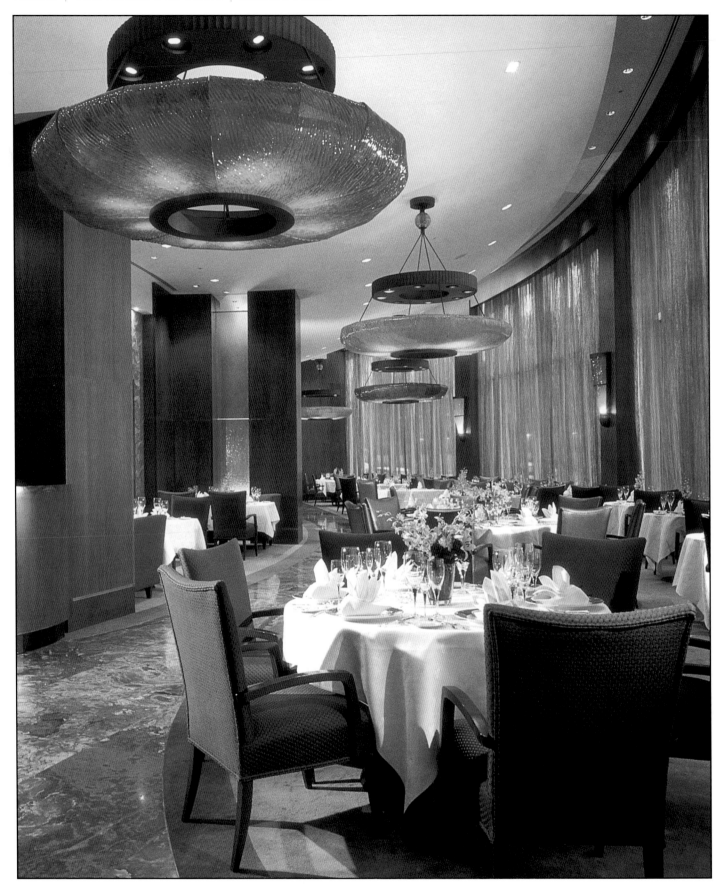

Mike Wilson Photography

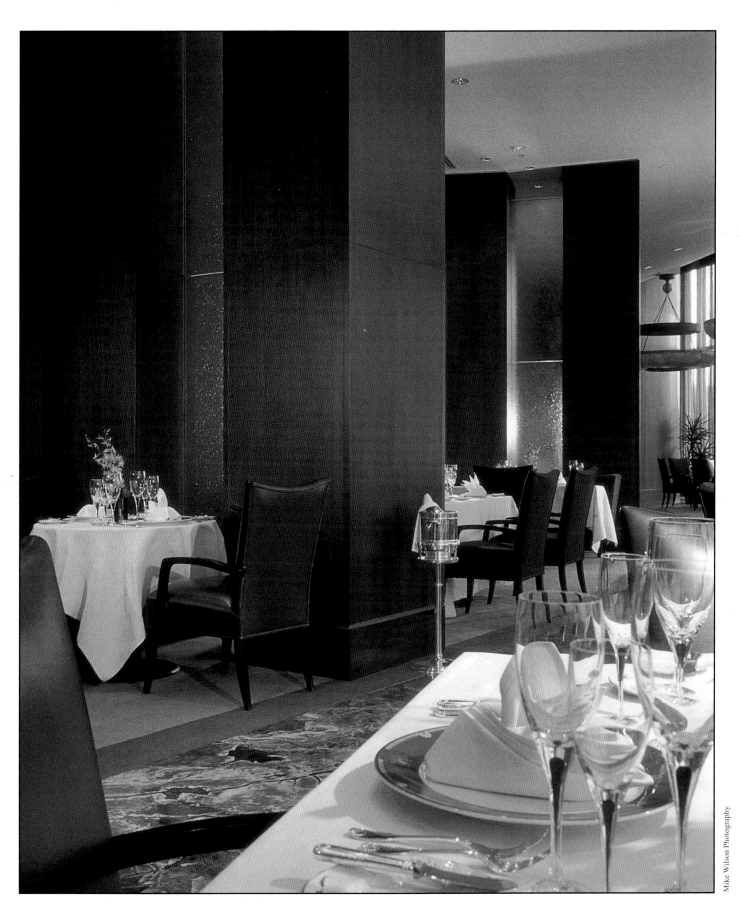

Hand-crafted glass chandeliers punctuate an elegant, modern dining hall, where great wooden columns look out on a semi-circular wall of windows. *Courtesy of DiLeonardo International, Inc.*

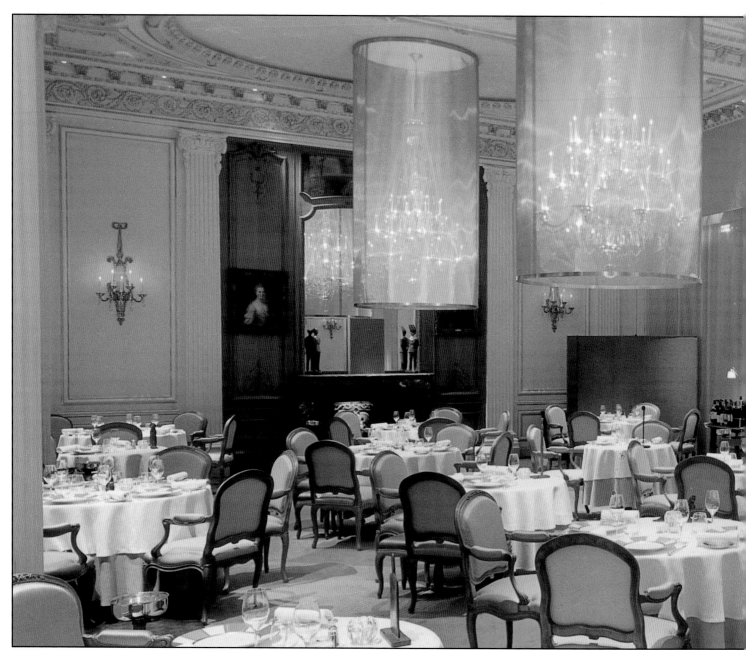

Restaurant Plaza Athénée | Paris

Patrick Jouin designed this combination of innovative and traditional to frame the culinary arts of Chef Alain Ducasse, here serving contemporary French cuisine. *Courtesy of Hôtel Plaza Athénée*

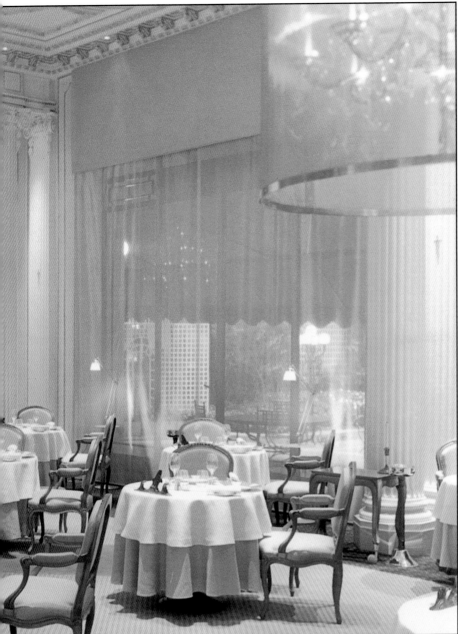

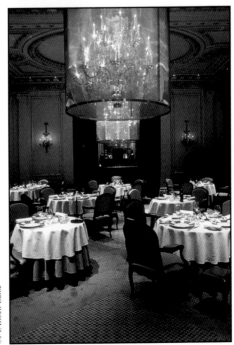

167

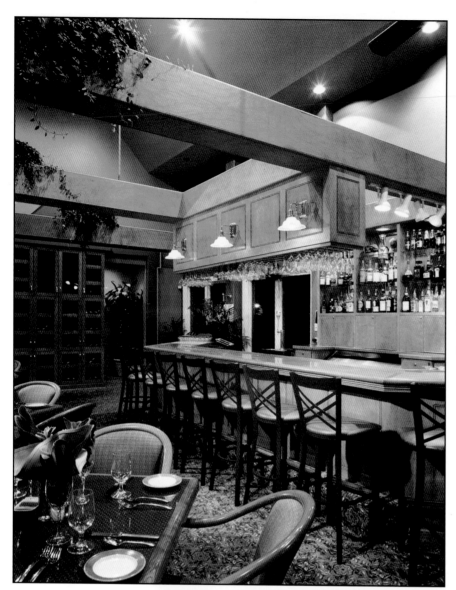

Café Verandah | Wintergreen Resort | Virginia

A casual bar and grill is anchored by great wooden beams below a soaring ceiling. *Courtesy of Fugleberg Koch Architects*

Bristol-Bar | Berlin

A classic piano bar is characterized by rich woodwork, brass accents, and leather furnishings. Carefully trained spotlights add sparkle to the room, and attract the eye to the merchandise behind the bar. *Courtesy of Kempinksi Hotel Bristol Berlin*

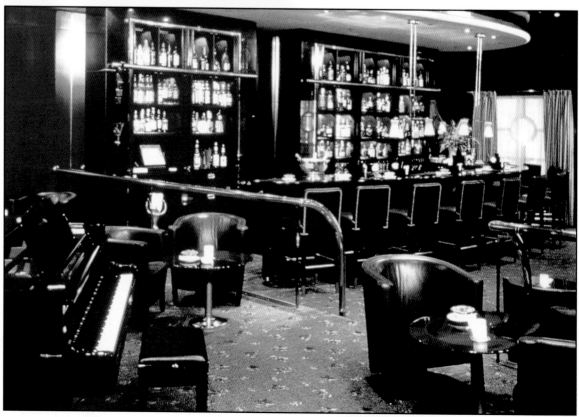

Gaartensaal | Berlin

Symmetry and line are exemplified in a dining room neatly divided into squared off zones. Honeyed tones and inviting furnishings soften the effect. *Courtesy of Kempinksi Hotel Bristol Berlin*

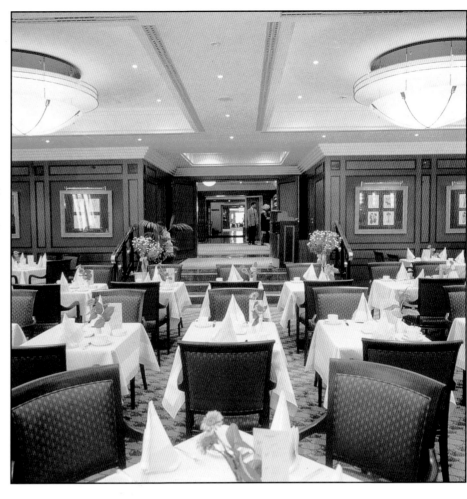

Kempinski Eck | Berlin

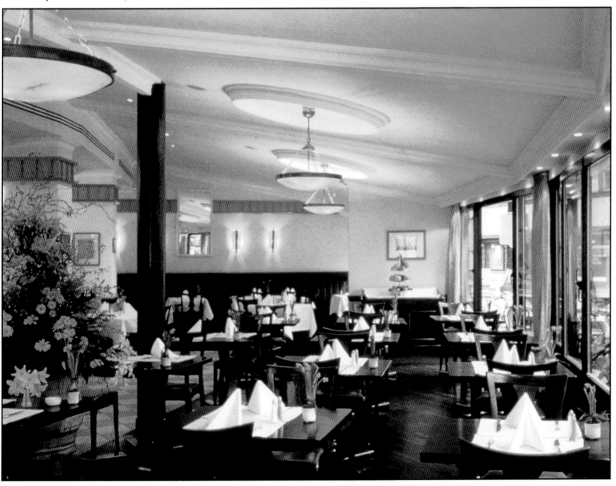

Diners enjoy regional specialties in a casual and informal restaurant designed in the tradition of the "Berliner Brasserie." The focus is on the terrace beyond, open during nice weather. *Courtesy of Kempinksi Hotel Bristol Berlin*

169

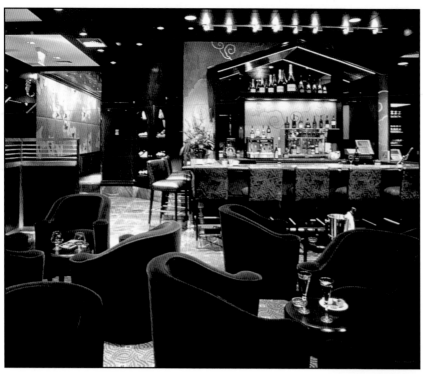

Cocktail Lounge | Renaissance Hotel |
New York City

Lights illuminate marble floor and bar backdrop, reflecting a
complementary golden glow into the private seating areas.
Courtesy of Di Leonardo International, Inc.

Tom Crane Photography

Blue Bar | Rome

Rough-hewn, a vaulted stone ceiling caps a
contemporary Roman forum for drink and
conversation. *Courtesy of Empire Palace Hotel*

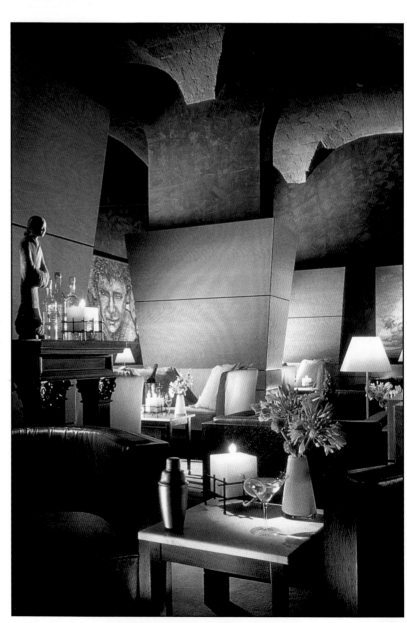

Contributors List

design firms that contributed to this book

Adache Group Architects, Inc.
550 South Federal Highway
Fort Lauderdale, FL 33301
954-525-8133
www.adache.com

Architectural Design Group, Inc.
745 West Johnson Street
Raleigh, NC 27603
919-755-8011
www.adgcentral.com

Brighton Premier Lodge
144 North Street
Brighton BN1 1DN UK
44 01273 746833

Bosphorus Swissotel
Bayildim Caddesi No. 2 Maçka
Besiktas, 80680 Istanbul, Turkey
90 212 326 1100
www.swissotel.com

Carl Ross Design, Inc.
115 Main Street
El Segundo, CA 90245
310-333-1982
www.carlrossdesign.com

Cole Martinez Curtis and Associates
4132-A Del Rey Avenue
Marina del Rey, CA 90292
310-827-7200
www.cmcadesign.com

Paul Draper & Associates
4106 Swiss Avenue
Dallas, TX 75204
214-824-8352

Di Leonardo International, Inc.
2348 Post Road, Suite 501
Warwick, RI 02886
401-732-2900
www.dileonardo.com

Edward Carson Beall, A.I.A. and Assoc.
23727 Hawthorne Boulevard
Torran-ce, CA 90505
310-378-1280

Fugleberg Koch Architects
2555 Temple Trail
Winter Park, FL 32789
407-629-0595
www.fugelbergkoch.com

Graham-Kim International, Inc.
282 Montvale Avenue
Woburn, MA 01801
781-935-3444

Graham Leonard Associates, Ltd.
Clayton House, 12 High Street
Great Dunmow, Essex CM6 1AG UK
44 (0)1371 877800

Harper Mackay Architects
33-37 Charterhouse Square
London EC1M 6EA
44 171 600 5151
www.harper-mackay.com

Hill Glazier Architects
925 Alma Street
Palo Alto, CA 94301
650-617-0366
www.hillglazier.com

Hirschberg Design Group, Inc.
334 Queen Street East
Toronto, Ontario M5A 1SB
416-868-1210
www.hirschbergdesign.com

Jestico + Whiles Architects
1 Cobourg Street
London NW1 2HP UK
020 7380 0382
www.jesticowhiles.co.uk

Mahmoudieh Design
Meinekestraße 7
10719 Berlin Germany
49 30 887 179 0
www.mahmoudieh.com

Peter Capone and Associates
3981 Roblar Avenue
Santa Ynez, CA 93460
805-688-9991

Portfolio Design International
5 Bream's Buildings
London EC4A 1DY UK
44 (0)20 7520 5000

Ransley Group
Weyvern House, Weyvern Park
Portsmouth Road, Peasmarsh
Guildford, Surrey GU3 1NA UK
44 (0) 1 483 301491
www.ransleygroup.com

Reardon Smith Architects
10-13 The Leathermarket, Weston Street
London SE1 3ER UK
44 (0)20 7403 6386
www.reardonsmith.com

RTKL Associates, Inc.
1500 San Remo Avenue, Ste. 350
Coral Gables, FL 33146
786-268-3200
www.rtkl.com

The Syntax Group
The Old Boathouse, Mill Lane, Taplow
Maidenhead, Berkshire SL6 OAA UK
44 (0)1628 789646
www.syntaxuk.com

hotels featured in this book

Alain Ducasse at the Essex House
155 West 58th Street
New York, NY 10019
212-265-7300
www.alain-ducasse.com

Anassa
PO Box 66006
CY-8830 Polis Cyprus
(357) 6-888000
www.thanos-hotels.com
(SDA International, NYC)

The Annabelle
PO Box 60401
CY-8102 Pyfos Cyprus
357 6 938333
www.thanos-hotels.com

Bacara Resort & Spa
8301 Hollister Avenue
Santa Barbara, CA 93117
805-968-0100
www.BacaraResort.com

The Benjamin Hotel
125 East 50th Street
New York, NY 10022
800-813-7624
www.thebenjamin.com

Carlton Hotel
19 North Bridge
Edinburgh EH1 1SD UK
44 (0) 131 472 3000

The Carlyle
Madison Avenue at 76th Street
New York, NY 10021
212-744-1600
www.rosewoodhotels.com

Ciga Hotel Excelsior
Piazza Ognissanti, 3
50123 Florence, Italy
39-55-2642-1

Conrad International Brussels
Place Louise 71
Brussels, Belgium 1060
32-2-542-4242
www.brussels.conradinternational.com

Crowne Plaza Resort
Holiday Inn Worldwide
3 Ravinia Drive, Suite 2900
Atlanta, GA 30346-2149
770-604-2000

De Vere Daresbury Park
Chester Road, Daresbury
Warrington, Cheshire WA4 4BB UK
44 (0) 1925 267331
www.devereonline.co.uk

DoubleTree Golf Resort
14455 Penasquitos Dr.
San Diego, CA 92129
858-672-9100
www.doubletree.com

Empire Palace Hotel
Via Aureliana 39
00187 Rome, Italy
39 (0)6421281
www.empirepalacehotel.com

The Equinox Resort & Spa
Historic Route 7A
Manchester Village, Vermont 05254
800-362-4747
www.equinoxresort.com

Fifteen Beacon
15 Beacon Street
Boston, MA 02108
617-670-1500
www.xvbeacon.com

Four Seasons Hotel
1300 Lamar Street
Houston, TX 77010
713-276-4700
www.fourseasons.com/houston

Grand Hotel Quisisana
Via Camerelle 2
80037 Capri Italy
39 (0)818 370788
www.quisi.com

Haus Rheinsberg Hotel am See
Donnersmarckweg
116831 Rheinsberg Germany
Tel.: 0049.33931-344-0
www.hausrheinsberg.de

Helvetia & Bristol
Via dei Pescioni 2
50123 Florence, Italy
39 (0)55287814

Hilton Tobago Resort
P.O. Box 633
Scarborough, Lowlands, Tobago
868-660-8500/2
www.hilton.com

Holiday Inn on King
370 King St. West
Toronto, Ontario M5V 1J9 Canada
416-599-4000
www.hiok.com

Hotel Adlon, Berlin
Kempinski Hotels & Resorts
Unter den Linden 77
D-10117 Berlin German
49 (0)30 2261-0
www.hotel-adlon.de

Hotel dei Mellini
Via Muzio Clementi 81
00193 Rome, Italy
39 (0)6324771
www.hotelmellini.com

Hôtel de Paris
Place du Casino
Monte-Carlo – MC 98000 Monaco
377-92-16-29-76
www.alain-ducasse.com

Hotel Derek
2525 West Loop South
Houston, Texas 77027
713 961 3000
www.hotelderek.com

Hotel Inter-Continental Tashkent
107 A Amir Temur Street
Tashkent 700084 Uzbekistan
998-71-1207000
www.tashkent.uzbekistan.intercontinental.com

Hotel Lord Byron
Via G. De Notaris 5
00197 Rome, Italy
39 063220404
www.lordbyronhotel.com

Hôtel Plaza Athénée
25, Avenue Montaigne
75008 Paris, France
33 (0)1 53 67 65 00
www.alain-ducasse.com

Hotel Regency
Piazza Massimo D'Azeglio 3
50121 Firenze, Italy
39 055245247
www.regency-hotel.com

Hotel Salto Chico
Américo Vespucio Sur 80
Pisco 5, Santiago, Chile
(562) 206 6060
www.explora.com

House of Blues
3950 Las Vegas Boulevard S.
Las Vegas, NV 89119
702-632-7600
www.houseofblues.com

JW Marriott Hotel
Av. Orellana 1172 y Av. Amazonas
Quito, Ecuador
593-22-972-000
www.marriott.com

Kempinski Hotel Beijing
50 Liangmaqiao Road
Chaoyang District
Beijing China 100016
(86 10) 6465 33 88
www.kempinski-beijing.com

Kempinski Hotel Bristol Berlin
Kurfürstendamm 27
D-10719 Berlin Germany
49 (0)30 8 84 34-0
www.kempinskiberlin.de

The Lancaster Hotel
701 Texas Avenue
Houston, TX 77002
713-228-9500
www.lancaster.com

La Frégate Hotel and Restaurant
Les Cotils, St. Peter Port
Guernsey GV1 1UT UK
44 (0)1481 724624
www.lafregate.guernsey.net

Le Merigot, A JW Marriott™ Beach Hotel and Spa
1740 Ocean Avenue
Santa Monica, CA 90401
888-539-7899
www.lemerigothotel.com

The Lodge at Sea Island Golf Club
100 Retreat Avenue
St. Simons Island, GA 31522
912-638-3611
www.golflodge.com

The Lodge at Vail
174 East Gore Creek Drive
Vail, Colorado 81657
970-476-5011
www.lodgeatvail.com

Malmaison Edinburgh
Malmaison Edinburgh Tower Place
Leith, Edinburgh, EH6 7DB, UK
(0)131 468 5000
www.malmaison.com

Mandarin Oriental Hotel Du Rhône Geneva
Quai Turrettini, Case Postale 2040
1211 Geneva 1, Switzerland
41 22 909 0000
www.mandarinoriental.com

Mandarin Oriental Hyde Park Ltd.
66 Knightsbridge
London SW1X 7LA UK
44 (0)20 7235 2000
www.mandarinoriental.com

Marriott Harbor Beach Resort & Spa
3030 Holiday Drive
Fort Lauderdale, FL 33316
800-222-6543
www.marriottharborbeach.com

The Melrose Hotel
3015 Oak Lawn Avenue
Dallas, TX 75219
214-521-5151
www.melrosehotel.com

The Melrose Hotel
2430 Pennsylvania Avenue, NW
Washington, D.C. 20037
202-955-6400
www.melrosehotel.com

The Muse Hotel
130 West 46th Street
New York, NY 10036
212-485-2400
www.themusehotel.com

New York Palace Hotel
455 Madison Avenue
New York, NY 10022
212-888-7000
www.newyorkpalace.com

NH Brussels Airport Hotel
De Kleetlaan 14
B1831 Brussels
0032 220 39252
www.nh-hoteles.com

One Aldwych
London WC2B 4RH, UK
Tel: (44-20) 7300-1000
www.lhw.com/onealdwych

"One" Sheraton Grand Hotel and Spa
8 Conference Square
Edinburgh EH3 8AN UK
44 (0)131 221 7770
www.one-spa.com

The Oriental Bangkok
48 Oriental Avenue
Bangkok 10500 Thailand
66 (0) 2659 9000
www.mandarinoriental.com

The Oxford Hotel
Godstow Road
Wolvercote, Oxford OX2 8AL UK
44 (0) 1865 489988
www.paramount-hotels.co.uk

Palmerston Golf Resort
Sporting Club Berlin
Parkallee 1
15526 Bad Saarow Germany
0049 33631-60
www.palmerston.de

Paphos Beach Hotel
P.O. Box 60136
CY-8125 Pafos, Cyprus
357 6 933091
www.thanos-hotels.com

The Peninsula Manila
1226 Makati City
Metro Manila, Philippines
63-2 887 288
www.peninsula.com

Phoenix Airport Marriott
1101 North 44th Street
Phoenix, AZ 85008
602-273-7373
www.marriotthotels.com

Radisson Suite Beach Resort on Marco Island
600 South Collier Blvd.
Marco Island, FL 34145
800-333-3333
www.marcobeachresort.com

Rancho Bernardo Inn
17550 Bernardo Oaks Drive
San Diego, CA 92128
877-517-9342
www.jcresorts.com

Regent Almaty
181 Zheltoksan Street
Almaty 480013
Republic of Kazakhstan
7-327- 581-1111
www.regenthotels.com

The Regent Schlosshotel
Brahmsstrasse 10
14193 Berlin Germany
49 (0)30 89584-0
www.regenthotels.com

Reid's Palace
Estrada Monumental 139
Funchal, Madeira 9000-098 Portugal
351 291 717 171
www.orient-expresshotels.com

The Renaissance Hotel Times Square
Two Times Square, 714 Seventh Avenue
New York, NY 10036
212-765-7676
www.renaissancehotels.com

Renaissance Los Angeles Hotel
9620 Airport Boulevard
Los Angeles, CA 90045
310-337-2800
www.renaissancehotels.com

Renaissance Seoul Hotel
676 Yeoksam-dong, Gangnam-Gu
Seoul, Korea 135-915
82-2-555-0501, 556-0601
www.renaissance-seoul.com

Rihga Royal Hotel
5-3-68, Nakanoshima, Kita-ku
Osaka 530, Japan
81-6-6448-1121
www.rihga.com/osaka

Rihga Royal Waseda
1-104-19, Totsuka-machi, Shinjuku-ku
Tokyo 169-8613, Japan
81-3-5285-1121
www.rihga.com/tokyo

Ritz Carlton Hotel & Resort
Sharm el Sheikh, Om El Seed
PO Box 72
South Sinai, Egypt
20-69-661-919
www.ritzcarlton.com

The Ritz, London
150 Piccadilly
London W1V 9DG
44 (0)207 493 8181
www.theritzhotel.co.uk

The Ritz-Carlton
4750 Amelia Island Pkwy.
Amelia Island, FL 32034
904-277-1100
www.ritzcarlton.com

The Ritz-Carlton Naples
280 Vanderbilt Beach Road
Naples, FL 34108
239-598-3300
www.ritzcarlton.com

The Rosewood Hotel @ Al-Faisaliah Complex
PO Box 4148; King Fahad Road
Olaya, Riyadh 11491 Saudi Arabia
966 1 273 2000
www.alfaisaliahhotel.com

Royal Caribbean International
800-398-9819
www.royalcaribbean.com

Shangri-La Hotel
89 Soi Wat Suan Plu, New Road
Bangrak, Bangkok, Thailand 10500
66-2-236-7777
www.planetholiday.com

Sheraton, Colorado Springs
2886 S. Circle Drive
Colorado Springs, CO 80906
800-981-4012
www.sheraton.com

Sheraton Edinburgh Hotel
1 Festival Square
Edinburgh, Scotland EH3 9SR
44-31-229-9131

Shutters on the Beach
1 Pico Boulevard
Santa Monica, CA 90405
301-458-0030
www.shuttersonthebeach.com

Surf and Sand Resort
1555 South Coast Hwy.
Laguna Beach, CA 92651
888-869-7569
www.jcresorts.com

St. Regis Hotel
Two East 55th Street at Fifth Ave.
New York, NY 10022
212-753-4500

Surf and Sand Resort
1555 South Coast Highway
Laguna Beach, CA 92651
888-869-7569
www.surfandsandresort.com

Temecula Creek Inn
44501 Rainbow Canyon Road
Temecula CA 92592
877-517-1823
www.temeculacreekinn.com

The Trafalgar London
2 Spring Gardens
Trafalgar Square
London SW1A 2TS UK
44-207-8702900
www.hilton.com

Valdoro Mountain Lodge
115 South Main Street
Breckenridge, CO 80424
970-547-2947
www.valdoro.com

Victoria-Jungfrau Grand Hotel & Spa Interlaken
Ch-3800 Interlaken
Palace Luzern Switzerland
41 (0)33 828 28 28
www.victoria-jungfrau.ch
(author contact: Rebecca Werner, Werner PR Inc.,
r.a.werner@worldnet.attlnet, fax: 212-355-5156)

The Westin Waltham-Boston
70 Third Avenue
Waltham, Massachusetts 02451
781-290-5600
www.starwood.com

W Los Angeles – Westwood
930 Hilgard Avenue
Los Angeles, CA 90024
310-208-8765
www.whotels.com

W Seattle
1112 Fourth Avenue
Seattle, WA 98101
206-264-6000
www.whotels.com/seattle

W Sydney
The Wharf at Woolloomooloo
Woolloomooloo, New South Wales, Australia 2011
(61 2) 9331-9000
www.whotels.com

Wintergreen Resort
PO Box 706
Wintergreen, VA 22958
800-266-2444
www.wintergreenresort.com

Wentworth Mansion
149 Wentworth Street
Charleston, SC 29401
www.wentworthmansion.com

The Westin Hotel
1 West Exchange Street
Providence, RI 02903
401-598-8000
www.starwood.com

The Westin Waltham-Boston
70 Third Avenue
Waltham, Massachusetts 02451
781-290-5600
www.starwood.com

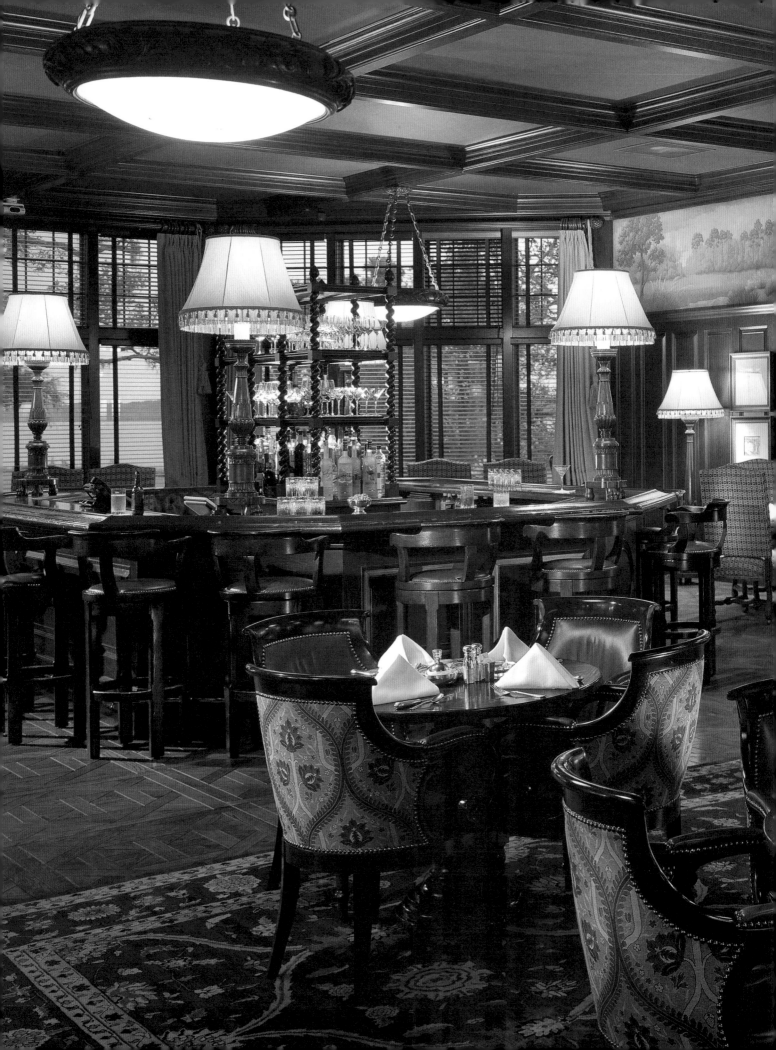